My Private Collection

of Original Pieces of Art

TO DIANE
BEST WISHES

Copyright © 1999
Nick Ligidakis
Published by Inkwell Productions
3370 N. Hayden Rd.. #123-276
Scottsdale, Arizona 85251
Phone (480) 315-9636
Fax (480) 315-9641
Website: www.selfpublishersgroup.com
Restaurant Website: www.cafenikos.com
E-mail: specialty@home.com

First printing: June 2000

ISBN
0-9658158-3-8

Contact Inkwell Productions to order any of Nick's books.

Additional work by Nick Ligidakis
"The Heroes of My Thoughts"
©1998 - ISBN: 0-9658158-5-4

"Nick's Creative Cooking"
©1987 - ISBN: 0-9658158-0-3

"5024 E. McDowell"
©1997 - ISBN: 0-9658158-0-3

"My Golden Collection"
©1993 - ISBN: 0-9615418-4-9

Coming in the Spring of 2001 Nick's newest book:
"Songs of Freedom"

Printed in the United States of America

My Private Collection

of Original Pieces of Art

A dessert book of
pure passion and
priceless creativity

Nick Ligidakis

Inkwell Productions

Credits and Acknowledgements

Photography by Gregg Mastorakos, Scottsdale, AZ (480) 951-3888
Design / Typesetting by Madalyn Johnson, Mesa, AZ (480) 962-5370
Jacket Design by Joann Kotyk, Scottsdale, AZ (480) 483-8858
Photo Design by Composing Arts, Scottsdale, AZ (480) 483-8858
Editorial Supervision by Nick Ligidakis
Printed by Biltmore ProPrint, Phoenix, AZ (602) 954-6517
Published by Inkwell Productions, Scottsdale, AZ
Edited by Lisa Ligidakis, Scottsdale, AZ
Sculpture in Photos by Jerry Cox, Paradise Valley, AZ (480) 998-5191
Developed by selfpublishersgroup.com
 www.selfpublishersgroup.com

I would like to thank my friend, Jerry Cox, for allowing me to use his sculpturing studio to shoot the unique photographs, from which one of them is used for the front cover;

To Gregg Mastorakos, a great photographer, who patiently worked to produce all the pictures included in this book;

To Madalyn Johnson whose ideas for graphics and type turned this project into a great book;

To my daughter, Lisa, who once again helped me with the editing of this book;

To Lisette Sacks for assisting with the jacket design;

To Joann Kotyk, of Composing Arts, who lost nights of sleep thinking about designing the photo pages and producing the one-of-a-kind jacket;

And a special thank you to my friend, Helene, for taking time from her busy schedule to proofread this book.

This book is dedicated to:

My Family

and
to the thousands who have become
addicted to my desserts, those who have inspired me
with love for this extraordinary
art of dessert making and to all the pastry chefs
around the world who, with their labor of love
for this great art, offer us a slice of heaven.

Table of Contents

*T*here comes a time in one's life when all the experiences of learning have to be incorporated into one's lifestyle. It's kind of like being in school. When one graduates, one has to transfer schooling theory to the reality of professional practice. Except in life, there is no set time for graduation. One never knows when the time of enlightenment will come. In fact, unfortunate many go through life without ever achieving complete fulfillment.

For me, maturity occurred around 1984, when I opened my first restaurant in a tiny spot on East McDowell Road. But, even before achieving that milestone, my life had been a succession of rich, high peaks that I knew would culminate in something great. The ordinary had always bored me, the standard seemed so easily obtained, and I was constantly in search of something new and different.

I was always inspired. I remember my elderly mother and the joy in her voice as she spoke of me as her "Golden Boy". We shared many wonderful memories. My parents always gave me love unequalled by any other, full love of security and without selfish motives.

From a young age, I enjoyed the sense by security of having two people to rely on with my troubles – and my troubles were many. I could fill pages and pages with stories of my challenges. In my study of life and quest for the difficult, I traveled the world over, and was unsettled for four decades. My mistakes were many, but I always looked to my heroes for answers. Heroes to me, are the ones who are willing to sacrifice their lives for their beliefs.

My heroes were many but the biggest were just two people, a man and a woman. The man was powerful and wise. The woman was strong, compassionate and disciplined. In their own way, the two – my parents – taught me that it is impossible to learn all you need to know at any school, or to be taught everything by any single tutor.

They guided their children through the difficult stages of childhood to maturity and self-discipline. More importantly, they infused in me a feeling of self-respect to keep my mind and body free of alcohol and drugs. Such clarity of mind enabled me to bounce back more easily from my mistakes and difficulties.

My parents will always be my motivation, and the influence that my life is based on. Their gifts of love and respect affected my lifestyle so much, that I only wish to be the same shining example to my children. I want my children to look back and remember that disappointments are necessary for shaping values.

Sometimes happiness means working 18 hours a day, putting aside material desires and remaining optimistic through the hard time. As time goes by, I am proud to see my children grow closer to me, and know that discipline has paid off for us all.

the
Dream & the Inspiration

for the Love of Cooking

Near my father's taverna in Kiaton, Greece stood a bakery, it's windows full of pastries. Passing over its hearth was every child's heaven. At a young age, I developed a passion for the aroma of melted chocolate and baked goods that draped every inch of the surrounding neighborhood.

On holidays, we would wake to honey and cinnamon adorning the air. My mother had stayed up all night to make Loukoumades, Galaktobouriko or other goodies for us.

Between my mother and father, they raised a child with a divine calling for toothsome desserts, and a love for memories to cherish.

Throughout the years, the glorious taste of sweets and the pride that my parents expressed in their cooking helped me tremendously in my work. I regretted not a minute of the years I spent secluded, sculpting recipes before and after opening my restaurant, the thousands of hours dreaming of recipes for this book. Conceived in mind and born in the kitchen, this cookbook was purely an act of passion and creativity.

My Private Collection was a long time coming. It has completed the cycle of 15 years of dessert creativity.

When I opened Golden Cuisine restaurant in 1984, I finally felt ready to create the joyous, unique flavors my mind had imagined. I am proud to say that most of my recipes are prepared in completion the first time, with little or no experimentation.

Imagination has proved to be a true partner. Since I do not drink alcohol, I blend its flavors in my mind to create desserts with uncooked alcohol. Friends tasting assures me a creation is ready for the showcase.

When I first created desserts at Golden Cuisine on McDowell Road, I had only a non-refrigerated case. I was limited to the things I could keep fresh on display. As my restaurant expanded, so did my imagination. The one display case multiplied to many. The endless array of desserts won my guests. They brought their friends to show them my unique collection and throughout that amazing display an eternal relationship was destine to develop.

I hope you'll enjoy these recipes as much as my thousands of loyal customers and friends have over the years.

"The Heroes of My Thoughts"

This extraordinary book is a tribute to my parents. It is a book about heroes that have changed our lives, and inspire us to be the best that we can be. This is an important book, it will help to construct and strengthen relationships within the family, as well as to understand the problematic behavior of the children who have been denied the true love of their parents. Now available from Inkwell Productions.

*I*n the beginning of the 4th Century AD, a group of people came down from Alaska to occupy the peninsula located between Guatemala and Mexico. Those people were the Mayas and the peninsula was Yucatan.

This remarkable civilization which existed in the 5th Century built pyramids, temples and paved roads. Suddenly for an unknown reason the Mayans went into the virgin forest and never came out, leaving behind abandoned cities they had built. Some were even left halfway built. In the forest the Mayans discovered a tree that had grown about 10 meters tall. This became the tree of the Mayan gods. The trees' seeds were an offering to their gods. This seed of the cocoa pod, which later was named "bean" was roasted and then crushed between two stones. It was then boiled in water and the Mayans drank it, thanking their gods for being good and allowing people to share their sacred food. This boiled liquid was named "tshacabouku."

The Mayans were a bloodthirsty civilization. Before they went to war, for additional calories and energy they mixed the boiled powder with maize or honey and musk and drank it. They attributed this energy to their gods. In the early 15th Century when the Spanish reached Central America, there was nothing left of the Mayan, but their forgotten cities and few primitive tribes who called themselves Mayans.

By this time the Aztecs occupied this territory replacing the Toctecs who came after the Mayas. The Aztecs came down to this territory from North America. In their need for provisions they went into the forest, and were forced to fight the Mayans for everything they brought out. The most precious possession was the bean of the tree so the Aztecs could make the liquid for the gods. They named this liquid "tchocoalt."

There is a myth that claims that the decision of the Mayas to enter the forest and never come out was caused by the departure of the bearded god Quetzalcoat who disappeared going east in the great ocean towards the rising sun. It was to him that this tree, "cacabuaquchtl" was dedicated.

Throughout the centuries, people would whisk the powder of this bean with boiling water into a froth and drink as much as possible awaiting the return of their god. Finally their god arrived. He was a strange bearded creature clad in iron that came from the East across the great sea. People were delirious with joy and hailed him as their god.

This "god" was none other than the conquistador Hernando Cortez who, on his quest for gold, took advantage of the unexpected welcome and asked for their treasure. They led him into plantations where he at first was greatly disappointed but eventually realized that the mountains of cocoa were as valuable as mountains of gold.

A few years earlier, Columbus, in his fourth voyage into what now is Nicaragua, sent cocoa beans to Spain, however nobody knew how to rid them of their forbidden bitterness. Hernando Cortez, who had tasted chocolate as liquid brought back the knowledge of how the Aztecs treated the bean.

how the Chocolate Addiction Began

By the time Cortez and his crew went back home a couple of years later, they were so addicted to the chocolate drink that they kept pots full at all times and some of them even lost the urge to drink alcoholic drinks.

The voyages were made to Central America for this chocolate to be brought back and convert Christianity to it. By now the flavoring had changed to sugar, vanilla and cream.

In the late 15th Century the first full cargo reached land in Europe and, despite the high price, was sold in just a few hours. The Spanish ladies developed a passion for cocoa and drank it flavored with cinnamon. It even became an issue of the church. The ladies had this liquid served in the communion table claiming that liquid does not break the fast. Pope Clement VIII who liked cocoa was given the task of resolving the question to whether or not drinking chocolate broke the fast. A few years later a group of priests in Madrid opposed this idea along with the idea of drinking chocolate before celebrating the mass.

In the early 16th Century this long time Spanish specialty was brought to Naples and its addictive taste spread all over Italy. It was then introduced to the Netherlands and France where it became a great success with high society. Later on, it was introduced to Germany and in the late 16th Century the English finally gave in to the chocolate temptation, which up until now they had turned up their noses to it because of anti-Spanish political reasons.

By now all of Europe was addicted to chocolate and in the middle of the 17th Century the addiction would spread to America.

Throughout the centuries the chocolate addiction would grow as the technique of forming the liquid chocolate into solid form and flavoring it with creative flavors continued to improve.

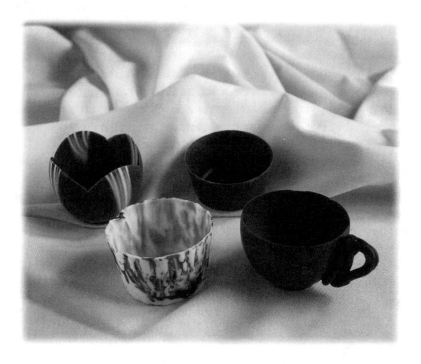

The proprietors awaited for opportunities to gain wealth from the public's demand of a product. This time the marketing of a product was so easy because people made chocolate drinking and eating a part of their life.

In Europe, the gathering in the coffee shops became a cultural event and the frequent visit to the pastry shop where its cakes were full of luscious chocolate creations became part of family life.

Public chocolate, coffee and tea drinking started in Vienna in the late 16th Century where many coffeehouses started to appear. It is claimed that the first establishment was "The House at the Sign of the Blue Bottle," where the coffee was strained, then milk and sweeteners were added and eventually was served with milk, sugar and cinnamon (today's cappuccino). It was back then that the coffeehouses were serving "kiftel," a crescent-shaped roll created by a Viennese baker to celebrate the defeat of the Turks and the lift of the city's siege. This would become the French croissant. Some historians date the croissant back to 1217 when Vienna bakers made crescent shaped rolls to offer to the fifth crusade against the Moors in Egypt and the Holy Land.

The kiftel rolls arrived in Paris around 1686, shortly after the Viennese bakers created the crescent shaped roll. There French bakers added yeast to the puff pastry and by rolling it into butter made it flaky and soft. This dough was rolled into triangles then rolled into a crescent shape to become our beloved croissant.

The coffee houses in Vienna also served jelly doughnuts, which were brought from the local street vendors. By the end of the 16th century, Vienna had ten coffeehouses, each one with its own patronage of men who made those coffeehouses a home away from home.

In 1957 at about the same time, a shop opened in London called "The Coffee Mill." That shop sold chocolate melted to drink or to eat.

The first manufacturing chocolate plant opened at the end of the 17th Century. But even before this, several shops were processing their own chocolate, using it to make cakes and other pastries. Even though chocolate was very expensive, customers frequented the little shops and the demand of chocolate was spreading rapidly and prices were driven even higher.

By the beginning of the 18th Century, several plants were opened all over Europe, especially in the Netherlands and Switzerland, and the chocolate making became a great family business in Europe.

The first chocolate factory was opened in North America in 1764 in Dorchester, Massachusetts. An Irish-American baker named John Hannon set it up with the investment of Doctor James Baker. Baker's chocolate had its beginning in 1779. John Hannon disappeared at sea after sailing in the West Indies to buy cocoa beans. However, the first true chocolate factory with modern equipment and production to keep up the demand for chocolate opened in Paris in 1824. In the same year, Cadbury's

the
Beginning
of the *Shops*

Chocolate began in a coffee-tea shop in England. John Cadbury, 23 years old, installed London's first glass window. He employed a Chinese man to work at the tea counter and experimented grinding cocoa beans with a mortar and pestle, mixing them with different flavors.

Several years later, his product list would include 15 different kinds of drinking and eating chocolate and ten forms of cocoa.

The beginning of the 18th Century is where all the family business started to merge in what would become the great manufacturers of chocolate: Ban Houten in the Netherlands, who discovered the method of solubilization (now known as Dutch chocolate); Menien in France; Cadbury and Rowtree in England; Suchard, Kohler, Lindt and Nestle in Switzerland.

In 1875, a Swiss Doctor Daniel Peters was responsible for inventing milk chocolate. He entered into partnership with his two biggest competitors and they merged with Nestle in 1929 and Switzerland would thereafter become the mecca of the world's chocolate. By now the chocolate taste had spread thoughout the world. Much faster than any other food. The chocolate taste was craved from children to adults alike.

The addiction of chocolate did not escape America either. As far back as the 17th Century, ads were in newspapers advertising the trade of chocolate. In 1927 Hershey's chocolate was incorporated.

Spanish conquistador Cortez was disappointed to find mountains of cocoa beans instead of chests full of gold, but he decided to bring back the method of preparing the "beans" into addicting forms of drinking and eating them. He knew very little of how this single "bean" would affect the world and how it would make trade giants very wealthy.

*I*n the beginning of the 18th Century, the medical profession considered chocolate to be a remedy for fever, chest pain and stomach illness. The confectioners of the 18th and 19th centuries gladly became druggists to profit from this belief of the doctors.

Chocolate was believed to have medicinal properties and various medication made from chocolate was sold by many doctors. The products included purgatives, cough mixture, aids for digestion, aids to put on weight, antispasmodics (mixed with orange blossom), anti-inflammatories (with milk of almonds), tonics, and much more. The expression "health chocolate" remained common until the beginning of the 20th Century.

Chocolate is a concentrated food with a high-energy value, 4 oz. of chocolate contains 500 calories. It also contains 55-60% glucose, 30% lipids, 49% protein and potassium, magnesium, iron and vitamin D. Contrary to popular belief, chocolate by itself does not have any harmful effect upon the liver.

Chocolate Definitions

COCOA BEANS
The cocoa tree grows only in tropical regions, approximately 20° of the Equator. This wide branching tropical evergreen tree is found mainly in the great cocoa plantations in South and Central America, and in Africa. It produces fruits, which contain between 30 to 50 seeds. These are the cocoa beans. Once they are picked, they are left for about one week to ferment and develop the cocoa aroma, then they are dried and sent to chocolate manufacturing companies.

COCOA PASTE
The beans are roasted and crushed to extract the kernels, these are then ground to produce this bitter-tasting paste which is the basic material for chocolate products.

CHOCOLATE POWDER
After the paste has been pressed and the cocoa butter has been extracted, the residue of the cocoa beans is ground to produce the cocoa powders. To make the chocolate powder, the cocoa is mixed with sugar. Some powders of chocolate or cocoa contain starch, flour or dry milk and are suitable only to make drinks.

CHOCOLATE COVERTURE
This semisweet chocolate contains a higher proportion of cocoa butter, or other fat, which lowers its melting point and is used for covering, molding, dipping or coating.

CHOCOLATE BARS
In this mixture of cocoa paste, cocoa butter and sugar are added with various other optional additions such as milk, nuts, liqueurs, fruits and coffee. All ingredients are ground and mixed. Chocolate bars may be filled with various other products such as caramel, pralines and liqueurs.

UNSWEETENED CHOCOLATE

True unsweetened chocolate is 100% chocolate. It is good for brownies, fudges and frostings. It's taste is too strong without sugar.

SEMISWEET OR BITTERSWEET CHOCOLATE

Semisweet or bittersweet chocolate contain 30 to 60% cocoa butter. The higher the percentage the better the quality. Both are very similar, the bittersweet has a stronger taste. They contain sugar, vanilla and additional cocoa butter and sometimes lecithin. They are great for mousses, butter creams and fillings.

MILK CHOCOLATE

Milk chocolate contains 10% cocoa butter, 50% sugar, 25% dry cocoa and 15% milk. It should not be used for cooking unless specified. It is milder and sweeter than any other chocolate. It is mostly eaten plain but it is also great for making icing. Be careful with this when melting it.

WHITE CHOCOLATE

This is not a true chocolate because it does not contain cocoa. It is made with cocoa butter, milk, sugar and oil. The more cocoa butter that is used, the more addictive this white wonder becomes. It is very difficult to find quality white chocolate. The best is that of ivory color, not white. It does not tolerate high heat. It is great in mousses, sauces and icings.

QUALITY CHOCOLATE

The quality of the chocolate depends on the raw material and the handling of the different stages of preparation by the manufacturer. It is important to roast and crush the cocoa beans and mix them with sugar or other ingredients. Good chocolate should be shiny brown, free of bubbles, white specs and should break cleanly. It should melt like butter, have the true aroma of chocolate rather than cocoa powder and is neither sticky nor greasy. The more cocoa butter it contains the creamier it becomes. Chocolate should be stored at 65°F.

In 1828, Dutch chocolate maker Conrad Van Houten patterned an inexpensive method for pressing the fat from roasted cocoa beans and produced the world's first chocolate candy. The defeated "mass" can be used to make a powder. Van Houten discovered by adding the extra cocoa butter (as it will be called) to an experimental mixtue of cocoa powder and sugar, will result in a sticky substance, which cools into a solid moldable form.

*M*ost of my recipes are surprisingly easy to prepare. The recipes require organization and also paying attention to the basics. The imagination to create will follow naturally once you have mastered the basic recipes. Like all professional chefs, I am used to working with larger quantities of cakes, creams and doughs that are prepared to be used for several desserts. Do not be afraid to make a larger quantity of the basic cakes, doughs or fillings. It takes no longer to make a larger amount and the left over cake or dough can be transformed to make a variety of easy desserts. The leftovers usually become an inspiration for creating new tastes.

Thoughts

In every walk of life to be successful we must have respect for tradition. Our familiarity with history provides the respect for our ancestors who made the necessary steps to improve our lives. Before us, they had imagined and created new tastes to set the basics needed so we are able to imagine further. Our ancestor chefs were geniuses in their own time and we must respect them and learn that we are useless without the history and the tradition, which molds us to what we are today. Dessert making is the most beautiful of the culinary arts. A wonderful dessert will make any dinner festive and will place a smile on everyone's face. Successful dessert making can only be accomplished with love for the art and pride for ourselves. That will allow us not to use mediocre ingredients, substitutions or artificial flavors. Skimping on ingredients and lacking love for the art will result in a disastrous tasting creation.

Use the finest ingredients and put love into the cake. Then watch the faces of your guests after one bite of your creation. There is no better reward than to bring a little pleasure to another's life, whichever way possible, especially if you can accomplish it by doing something that you really love.

Taste: A Sensual Experience

*T*he detection of tastes has undoubtedly been essential to survival. The human desire for salt or sugar appears to be inborn, but it is also influenced by individual physiology. The "salt craving" may be due to an unusual amount of salt excreted by adrenal glands.

The "sweet tooth" may be inborn from the sweetness of mother's milk or the sweets that we treat young children to satisfy their need of a pleasant experience of food.

Beginning from the sight to the touching of the food, and until the last swallow of the feast, the sight of certain food will stimulate the glands to produce saliva, which of course "mouth-watering" results.

Touch, smell, sight and taste: senses that stimulate long before we ever place a bite in our mouth.

Whether or not the food is actually accepted depends on whether it is considered to be edible by the society and upon sensory perceptions; appearance, aroma, taste, texture and sometimes even sound.

Touching is the most provocative of the senses. It arouses the imagination of the artist, when he works the fingers into the silky dough, touching each part separately the flour, the oil, the eggs. The texture and the temperature of the body of the dough excite the fingertips. The excitement signals to the rest of the senses to be prepared for a continuing stimulation. Touching allows perceiving the essence of the final results. Finally when the tongue samples the taste, texture and temperature will signal the body either to accept it or reject it.

When chocolate melts in the double boiler, its seductive aroma drapes the air and overwhelms the sense of smell. "Come. . . come . . ." the voice is calling from the silky dark body of the sorceress. I do not know many who are able to resist the calling of the siren "taste me . . . eat me . . ." voices that drive fingers to be dipping into that sinful desire.

The most memorable foods are the ones you touch during preparation or while you eat them.

Squeezing the lemon you feel the tartness on your fingers. Washing the vegetables, you will sense their crispness. To determine the thickness of the body of the sauce you feel it with your fingertips before you taste it.

The direct contact with foods brings you closer to the reality of the taste.

When Aristotle divided the sensation of the taste into four categories: sweet, salty, bitter and sour; he determined it by using touch and taste more than any other sense.

Homegrown products bond us with the taste of various foods: the vegetables from our garden taste real; the eggs from our chicken have a more potent flavor; the milk from the cow or the goat warms the senses with its thickness and flavor; the fruit from our tree has its natural flavor. Homegrown products may not be better than some of the products bought from the market but the association with the ingredients, through the touching and caring bring us closer to its natural taste. Most of humanity has been eating with their fingers for a long time.

The sight of the actual food can also be important. Usually people will not believe that something will taste right unless it has the familiar color. In commercial orange juice for example, an orange coloring has been added to stimulate the color of the orange. Similarly, yellow coloring is added to lemonade, the natural lemon juice is colorless.

Sound and texture also play a role in the acceptability of the food. The carrot and the apple are expected to crunch in the mouth. In fact, more often than not, the sensory properties of food play a greater role in the choice of food than does nutritional value.

The odor of the food prepares the mind for the final result of the taste.

Like eroticism, in foods also, the final contact begins hours and even days before the final taste is achieved.

Patience is a virtue, especially when it comes to the anticipation of savoring the final result with utmost satisfaction. How can anyone enjoy a hamburger from the drive-thru window and swallow within half a mile of driving? This act has lust written all over it.

The experience of cooking, baking and eating does not differ from any other ceremonial experience that is meant to satisfy the senses and not the flesh.

Smell is the most sensual of the senses. The aroma haunts the mind like an irresistible beast, which opens its tentacles to all directions, enslaving the mind and manipulating the senses. The nose is capable of detecting thousands of smells and sends them to the brain where the mind distinguishes among them with our eyes shut and nostrils wide open. We can distinguish most of the aromas in the beginning of the experience. The most obvious: coffee, chocolate, cinnamon or baked bread. When these aromas register in the pages of our brain, they are unforgettable. Then we must try to identify the other aromas less potent: vanilla, basil, butter, eggs, adding to the collection of flavor.

Eventually one will be able to identify the smell register among the plethora of the other ingredients in the mind.

You will be able to single out the tomato smell from the stew, distinguish the vanilla in the pudding, the pistachio in the ice cream, the anise in the biscotti, and the nutmeg in the pie.

Before you know it, you will be able to strip every ingredient from the dish or cake and savor each taste individually in your palette.

A symphonic taste of every ingredient used.

The surface of the tongue is covered with about ten thousand taste buds, which are clusters of sensitive nerve endings.

The olfactory sense becomes precise, swift, and powerful, it bores in our memory with persistent tenacity.

How can we forget the aroma of a sensuous perfume, the salty breeze of the seashore, the smell of grandmother's kitchen, the odor of the rain streaming out on the thirsty land?

For centuries humanity has stretched its ingenuity in search for delicious fragrances, always with the hope of creating the scent capable granting the user the power of obsolete seduction.

The art of fabricating heart stopping aromas is complex and difficult in culinary art, in perfumery and in wine making.

The chemistry of mixing ingredients that produce results requires imagination and experience.

Creativity is more difficult in culinary art than any other, because it involves the satisfaction of all the senses, and the involvement of thousands of ingredients.

You can create aromatic temptations with a pinch of spice, a dash of liquor, a dab of vanilla, a squeeze of lemon, a drop of honey, a handful of herbs, you can measure your own strength of perfumed desires.

The sight of the food works wonders.

We should not confuse the sight of the food with the calligraphy of the table setting and the mechanical images of the flesh that have gathered around the table.

The concept of table setting and table manners is new.

Both correspond to a culture that relates to the world through sight with lack of confidence in the other senses, especially touch. I am not saying that one must act like a barbarian at the table, sinking his teeth into the meat of a huge bone, then throwing the bone on the floor and wiping his hand with his jacket, gulp down the wine, spilling most of it out of his mouth and onto his chest.

Norms of conduct at the table are basically a series of prohibitions that for the impatient lover may not be erotic; on the contrary it can produce opposite effects because of its strictness.

Frequently, my guest will describe their experience in other places more stuffy than mine, "at dinner I had the best of everything - great service, food, excellent wine, mouth watering desserts, but I did not enjoy the meal."

The mystique of a successful meal relies on the art of relaxing the senses, to let every sense arouse to the level of utmost pleasure. It is disappointing if something that looks good tastes awful. If something that smells, looks and tastes good is not enjoyable, it is because of the uncomfortable strictness imposed at the table where diners are more concerned to follow the directions of mannerism which can produce disastrous results; a suffocating atmosphere that will drown all other pleasant experiences of the meal.

There is no fundamental principle of table setting or table manners, simply because every setting is different and must act and react accordingly. It is the surroundings that set the mood. The sunset, the candlelight, the fireplace, the moonlight, the people participating.

Different romanticism on a different scene. Different mannerism on a different table.

It is different with your family, your mate, your friends, or with strangers.

The myth of impeccable table setting and hypocritical mannerism is a subject of an imperial class of people that have turned social conviction into this philosophy of honor.

Nothing that will violate the normal behavior is allowed.

The table must be set in a certain way, you must hold the cup with the correct fingers, keep your body in the right posture, your hands away from forbidden spots.

It is the maniacs of precise mannerism that overshadow the senses for the enjoyment.

It turns the person into a mechanical creature of habitual ceremonies.

I love to touch the hot bread and feel its texture and temperature.

I like to touch the meat of the shellfish to feel its softness; to roll the strawberry in my fingers; to touch the butter creams of the cake and lick my fingers afterwards; to hold the pizza in my hands.

Why deprive yourself of added pleasures by hiding behind the hypocritical shame of vain mannerism.

It seems to me that those who originally cultivated the language of flowery mannerism at the table have grown in a world of parallel proliferation of misbehavior away from the table.

There is no eroticism in formality.

To understand and enjoy the flavor in its fullest you must touch, look, smell and sometimes even listen.

There are several flavors that have entered into my senses for eternity, especially those of my childhood. One is the smell of fresh roasted peanuts. The peddler walked the streets of my hometown selling the precious nuggets. With a few drachmas I bought a small white bag full of that warm aromatic treat. It took me a long while to finish eating those peanuts. Their temperature warmed my hands, their aroma broke through my nostrils, I held them in my hand a few at a time, then in my mouth for a while longer chewing, pretending to eat them over and over.

A taste to last forever. That taste is still on my mind today, as is the soft buttery taste of roasted chestnuts found in the corners of Athens during the winter months, tastes that I had explored to the fullest. I remember vividly the texture, the temperature, the smell and the taste.

The senses react to an unlimited number of chemical compounds that have odor, flavor or taste.

Odors do not spur us to eat until the brain has evaluated them.

Scientific interest in the regulation of eating has shifted in recent years from the stomach to the brain, which now is considered to be in effect the first part of the digestive system. But the internal regulators in the brain that tells humans what or when to eat can be overridden by cultural attitudes. Consequently, people may be in the habit of eating several times a day or none at all due to religious diets or fasting.

Feelings of revulsion about certain foods may also cause people to starve themselves rather than eat a food their culture has labeled inedible. People also may not eat due to social attitude concerning the shape of the body.

The reason humans eat or do not eat is explicable neither in terms of a full or empty stomach nor as a result of any mechanism operating in isolation. Not even a combination of mechanisms sends humans in search of food. No single part of the brain dictates that they will eat the food once it has been found, since it might turn out to have been labeled as inedible by that particular society. Whether or not humans eat depends upon the interactions among numerous physiological and environmental variables, which has led up to the belief that our senses join hands to signal the mind about the sensual attraction of a certain food.

Baking is the most poetic of the culinary arts.

Baking requires patience and daring instincts to express the mind on its fullest dimensions. The primary requirement for dessert making is imagination and the benefit is a free time for the soul.

To be exact, baking is not like poetry - it is poetry.

The pastry maker and the poet, both committed to the task of nourishing the world with imaginary food for the soul.

Anyone on this artistic level is capable of giving you a vision of paradise.

Some of us find reading Nick's dessert menu better than erotic poetry.

Arizona Republic, 1996

The element of surprise depends on the simplicity of the approach. With this in mind I wanted to create an art that scales away from the overdressed and the over decorated approach.

I envisioned simple lines and dramatic use of colors and forms.

A classical simplicity to drape the real treasure: the taste of the creation.

A sense of design that is incredibly eye-catching and also appetizing.

I want my displayed dessert to appear as exquisite jewels, as rare pieces of art.

The elegant simplicity and the dramatic scupltural shapes that I envisioned were to bring forth the image of a culinary artist with creative eyes and clever hands.

My idea of dessert designing was really to please the mind and provoke the palette. I had no form in mind. It did not matter if it was classical or contemporary.

I want each of my creations to make a statement of visual simpicity.

The element of surprise is hidden in the taste, at that very first bite, when the discovery is made that the substance is greater than looks.

My concept of designing desserts is about quality and simplicity.

The same concept that has profoundly influenced my lifestyle.

The Art of Design

The selection of foods from the environment, the manner of preparation, the flavoring of the foods, the ceremony of eating; these four things make up the cuisine.

In many cultures, the cuisine is as important as is religion, politics, and history. The flavor principle of each society tends to be identified with what is edible, mainly because foods previously eaten without difficulty are safe, as new foods are a possible danger. Hence the rapid expansion of the fast food restaurant with extremely limited menus to which people return with the assurance of familiarity, although in all cuisines some new foods are constantly being added. This is due to few innovative chefs who open new avenues of tastes and also to the preferences of immigrant ethnic groups that have been added in to the original society.

The origin of most cuisines is lost in the unrecorded past. Every cuisine is based to some extent on staple foods that were available in abundance.

Chinese cuisine would be unimaginable without rice, the Americans without food derived from maize, the Europeans without bread, and the Mexicans without beans.

The Eating Ceremony

Weights &
Measurements

FLOUR WEIGHT

1/2 oz.	2 grams	1 tsp.
1/4 oz.	6 grams	1 tbs.
1 oz.	33 grams	1/3 cup
3-1/2 oz.	100 grams	1 cup
16 oz. (1 pound)	454 grams	4-1/2 cups
2.2 pounds	1000 grams (1 kilo)	10 cups

BUTTER

1 pound = 2 cups or 32 tbs. or 424 grams

SUGAR

1 cup = 8 oz. or 454 grams

EGGS

1 large egg = 2 oz.
1 large egg white = 1-1/4 oz.
1 large egg yolk = 3/4 oz.

LIQUID MEASURE

1 tsp.	1/6 oz.	5 grams
1 Tbs.	1/2 oz.	15 grams
1 cup	8 oz.	227 grams
2 cups (1 pint)	16 oz.	454 grams
4 cups (1 quart)	32 oz.	907 grams
2/3 tbs.	3-1/2 oz.	100 grams
1 cup plus 1 tbs.	8-1/2 oz.	250 grams
4-1/3 cups	2.2 pounds	1000 grams (1 kilo)

To convert:
Ounces to grams - multiply the ounces by 28.35
Grams to ounces - multiply the grams by 0.035
Inches to centimeters - multiply the inches by 2.54
Centimeters to inches - multiply the centimeters by 0.39

1 Tbs - 1 tablespoon
1 Tsp - 1 teaspoon
1 Tbs. - 3 tsp.

Fahrenheit	Centigrade
160	71
200	93
212	100
107	very slow
250	121
275	135
140	slow
300	149
325	163
177	moderate
375	190
400	205
218	hot
450	232
246	very hot
500	260
525	274
550	288

Temperatures

To convert Fahrenheit to Centigrade:
First subtract 32 from the number you want to convert, then multiply that by 5 and finally divide the total by 9.

To convert Centigrade to Fahrenheit:
First multiply the number you want to convert by 9, then divide that number by 5 and finally add 32 to that.

Ingredients

*M*ost of the ingredients used for my baking are straight forward, good quality products. You can find them in a good supermarket. Shop for the best of quality. Make a trip to a local specialty shop. There you will find what is not available at the supermarket, like quality chocolates, chestnuts, bulk nuts, organic products, etc. You will enjoy the experience of trying different brands of various products until you discover the one that works best for you.

UNSALTED BUTTER
Unsalted (sweet) butter works best for pastry (lightly salted can also be used). Regular butter contains too much salt for the delicate taste of the dessert. Unsalted butter has a lower water content and a fresher flavor. It is best to use for clarifying butter.

CREAM OF TARTAR
Cream of tartar is one of the ingredients in baking powder. It stabilizes beaten egg whites for meringue and keeps them from becoming grainy and dry.

CHESTNUT PUREE AND CREAM
You can avoid the process of making your own puree by buying it from the specialty markets. There are only a few brands of chestnuts or chestnut puree that are of excellent quality. Directions on how to make your own puree is on page 64.

FLOUR
Cake or pastry flour makes superior cakes. It is made from softer wheat and finer millet. All-purpose flour is used for the majority of my recipes. Do not substitute the all-purpose flour unless otherwise stated.

COFFEE
Use an instant quality brand, dissolved in a few drops of water. This way you will get the maximum of flavor with minimum liquid.

FRUIT JUICE AND PEEL
Several fruit juices are used throughout this book. If used for flavoring, run the juice through a sieve; if used for syrup, squeeze in the juices and drop in the fruit to boil with the syrup. For fruit peel, simply grind the surface of the skin.

CREAM
Cream varies in richness and purity. Heavy cream, whipping cream, manufacturing cream - they all vary in the content of butterfat. Some creams contain a stabilizer, which makes them seem thicker but they taste like foam. Manufacturing cream is the best but very difficult to find in retail shops. If you read the ingredients on the carton of the cream, the less ingredients listed the better the cream is. The best way to try different brands of cream is to conduct your own taste tests. Do not use "sterilized" or "ultra pasteurized" creams. Techniques on how to work with cream is given throughout the book.

EGGS

Eggs used in the recipes are AA large eggs. Always bring the egg to room temperature before using it, especially for meringues.

BERRIES

For sauce use frozen berries, the juice is extracted easier along with the water that the frozen fruit contains. For cake layers, purees, fillings, use fresh fruit. The frozen fruit does not have the superior taste of the fresh one, and besides, your results will be a watery disaster.

NUTS

Shelled nuts can be purchased natural (raw with skin on) or blanched (raw with the skin removed). The best way to buy nuts is whole, then grind or chop your own. Once the nut is broken up it stales easily. Nuts keep well in the freezer. Toast your own nuts by spreading them on a single layer on an ungreased baking sheet and bake until roasted 15-20 minutes in a medium temperature oven. If you buy already roasted nuts, they may be rancid. Roasting brings out the rich flavor of nuts, the flavor is completely different between a raw and a toasted nut. To blanch almonds or hazelnuts, drop them raw into a pot of boiling water for about one minute, discard some of the hot water, run cold water in the pot until nuts are cooled. The skin will slip between your fingers. Dry the nuts before using.

SUGAR

Ordinary granulated sugar is the best for baking. Superfine granulated sugar is good to use also. Use confectioners or powdered sugar only when specified, those two are granulated sugars milled to a powder with cornstarch added. Brown sugar, light or dark, is granulated sugar with molasses added. I use light brown sugar for the majority of my desserts when the recipe calls for brown sugar. Use dark only when specified.

Ligidakis stresses quality.
Because of this, he refuses to compromise
when it comes to ingredients he uses.
Arizona Republic, 1991

Tips of Experience

*O*kay, I know many baking and cooking methods have been done in a certain way for a long time. It is natural to assume that this is the only way. Finding a simpler way is the challenge for this art. Complex recipes are the norm of my work, yet I try to simplify things without compromising the taste. Why take unnecessary steps and use complicated methods if you can avoid it? In my baking I have broken many rules. The only rule I have not broken is the final result of my work. I found that breaking up some of the old tired techniques sometimes improves the final taste. The simple truth about baking as well as cooking is this: take pride in your work and use the best ingredients available. Use your own judgment about changing or substituting ingredients. You can only fail once, but the lesson learned from the experience is invaluable. Never be intimidated. Develop your own style and techniques of this great art. If you develop true love for baking your work in the kitchen, it will show in every morsel of your creation. Do read carefully through all the recipe ingredients and instructions before beginning. Follow directions carefully. Most of my desserts rely on the marriage of many complicated tastes and textures. Be sure to read the recipe before beginning to understand the method used. Directions follow after each list of ingredients. It will be very helpful to read throughout the book about facts, information, history and other tips. Above all - enjoy yourself!

* To clarify butter, melt gently without stirring, skim the foam. Use the clear yellow butterfat, discarding the thin milk-looking liquid in the bottom.

* Sifting sugar and flour allows the grain of the flour to separate and reduces the risk of having hard flour balls in your cake. Sifting the cocoa and the flour together accomplishes the same goal.

* Combining the hot butter with some of the batter before folding is critical because melted butter has the tendency to sink in the bottom of the saucepan while baking if not mixed thoroughly with the rest of the batter.

* If you have left over cake from your recipe, simply wrap it well and refrigerate or freeze for future use.

* To make a great icing using milk chocolate, boil the cream gently then add the milk chocolate pieces in to the hot cream and stir with a plastic spatula until it is mixed thoroughly.

* Endless helpful tips are scattered throughout this book.

In my cooking, the purity and integrity of ingredients is essential. In my baking, I have adopted the same philosophy. Real chocolate, fresh fruit juices, quality liquors, freshly ground nuts, and sweet butter. The purity of ingredients and technique used is almost unprecedented today, in an epoch of convenience and ready to use fillings and creams. It means no artificial flavoring no ready to use mixes, absolutely no compromise. Yet

26

the simplicity and the substance carry on from the designing of the cake into the dessert making. With little practice you can go a long way. If you are comfortable to use a knife to slice a cake, handle a spatula with a firm hand, release the cream from the pastry bag, then you can also be celebrated as a true craftsman who has mastered basic techniques. A true pastry chef.

PANS, BUTTER, FLOUR AND PARCHMENT PAPER

Lining the baking pan with parchment paper eliminates the problem of the cake sticking to the pan. Buttering and flouring pans is unnecessary most of the time. The parchment paper will also eliminate the mess of smearing pans with butter and shaking flour around the kitchen. You can butter the sides lightly and line the bottom of the pan with parchment paper. Use the butter sparingly. The sides of the cake release easily with a metal spatula. Parchment paper is available in all baking decorating shops. It is easy to cut the paper into the size desirable for your use. Use parchment paper under meringues, cookies, macaroons and everything else you want to release after baking or use it to make cones for fine writing on a cake. Parchment paper is my best friend in the kitchen.

CAKES IN A PAN

I cool most of my cakes in the pan. This is against the belief of many that the cake will be damaged if it is cooled in the pan. I found that many of the cakes turn out more moist if cooled in the pan. I believe that the moisture remains in the cake as it cools. The same thought applies to recipes like a carrot cake, I like to "ice" the cake while still warm. This way the moistness will be trapped in the cake and at the same time will allow the icing to spread better. Allowing cakes to cool in the pan helps to avoid the handling of hot pans, and also allows the cake to "set" and form into a nice even shape like the one of the pan. Don't worry, the taste and the texture of the cake will not be compromised if cooled in the pan.

SIFTING

Sifting has a few advantages; one is the measuring accuracy. Sifted flour fits easier in the measuring cup, recipe measuring is essential in baking. The other advantage is to aerate the flour and make it easier to fold into a delicate batter. Sift your flour especially when used for cakes. I use a strainer for sifting. I find it easier to use than a sifter. Also one less tool I have to store in my small kitchen.

MEASURING

I love to use the scale. It saves time and by using the scale I have less cups and bowls to wash.

DOUBLE BOILERS

I don't like them. One less tool to keep around. For melting chocolate use the water bath method. Fill a container and set it directly in simmering water of a wide skillet. The advantage is that you can place many bowls or containers at the same time: melting chocolate, butter and soften the icing or the butter cream. Also you can control the temperature of the water easily.

EGGS

Must be room temperature before used. If you forget to take them out of the refrigerator, dip them in a bowl of warm water for a few seconds. To beat egg whites you also must bring them to room temperature, heat water in a pot, place eggs in a mixing bowl, and hold the bowl over hot water. Beat egg whites gently until warm. Warm egg whites are essential for the successful making of meringues.

EGG WHITES

The lightness of a cake or dessert mainly depends upon the air beaten into the egg whites. For best results of "stiff" beaten egg whites, here is what you do:

A. Make sure the bowl is clean, free of oils, soaps and also that the bowl is at room temperature.

B. Add 1/4 tsp. of cream of tartar to six or seven egg whites. The general belief that the salt "stiffens" the egg whites does not work half of the time.

C. Sugar must be added slowly until soft peaks are formed. Adding sugar early prevents the whites from achieving maximum volume.

D. If you have overbeaten the egg whites and they seem dry, you can rescue them by adding an additional egg white to the batch.

NO SALT

I hardly use any salt in my baking or cooking. To activate the baking soda with the salt for a moister cake is a myth to me. I discovered that the egg white will also activate the baking soda and make the cake as moist. In a cake recipe that calls for salt, simply eliminate it, separate the eggs and beat the egg whites gently with a little baking soda (the amount of the eliminated salt).

FOR BETTER BREAD

For bread making I have discovered the perfect way to raise the dough and achieve the moistness necessary if you live in a dry climate, let your dough rise in the refrigerator overnight (see dough rising techniques on page 190).

PERFECT MERINGUE

For a few of my recipes you will need to prepare baked meringues. Make sure to run the mixing bowl through hot water and all the eggs to cool to room temperature. Make sure there is no trace of an egg yolk in the egg whites. Beat the eggs on high speed until stiff.

I like my kitchen to be simple and not cluttered with items that I may use only once a year. I approach my dessert making with a straightforward simplicity. The equipment here is all you need to have to be a pastry chef.

MIXER
I like a strong mixer to mix and whip things with authority. KitchenAid is the one that I've been using since the beginning of time. It comes with a paddle, which is a flat beater used for creaming butter, mixing icings, mousses, or beating stiff batters. It also comes with a wire whisk for beating egg whites, whipping cream or mixing soft mixtures. There is a dough hook for kneading dough. Buy some extra bowls for this mixer, they come in handy.

CAKE PANS
I use a heavy-duty aluminum pan 12"x17" or 9"x13". I like the deeper pans about 3". Also 9" round pans are standard in my kitchen. To have on hand several sizes of pans serves no purpose. Just keep on hand a few of the standard sizes that you always use.

SPRINGFORM PANS
Along with the mixer this is always used in my kitchen. It is used constantly for cheesecakes and no set cakes after they have been assembled. I use a 9-1/2" or a 10" springform pan, but they come in different sizes.

BAKING SHEETS
I use heavy aluminum baking sheets. The advantage is they do not bend or warp. The best size to have on hand is the 12" by 16" by 1" deep. This is called "half-sheet" and is available in restaurant supply stores.

RUBBER SPATULAS
I use them all the time.

ICING SPATULAS
Pastry chef's right hand tool.

STRAINERS
I use fine strainers for extracting fruit juices and sifting.

SERRATED KNIFE
The best for slicing cake.

MEASURING CUPS
A must.

PASTRY BAGS
Use a 12" or 18" pastry bag depending on the work. You can collect an assortment of pastry tips. The size that will be used the most is #7, #9, #26 star tips and #9 plain round tip.

SCALE
Important to have, don't forget baking is an art of precise measurements.

EQUIPMENT I USE VERY LITTLE OR NOT AT ALL:

FOOD PROCESSOR
Has very little use in my kitchen. There is not much this thing can do that my mixer cannot.

MICROWAVE OVEN
is not allowed.

THERMOMETERS
Never use them.

PASTRY BRUSHES
Very little use.

CAKE DECORATING TURNTABLE
Don't use it.

In many recipes throughout this book, you will find that the recipe calls for a certain kind of cake, or a syrup, or a sauce. Simply check the recipe index in the end of the book for reference.

*I*t's exquisite aroma paralyzes the senses, it is like no other aroma that ever has fragranced the walls of the kitchen. But behind that aroma there is a beast: untamed, unpredictable, and difficult.

Cocoa butter, the natural fat of the cocoa bean, contributes to the aroma and also makes it unpredictable to work with. If it is overheated it sometimes turns to lumps, sometimes is dull, sometimes shiny. If added to another mixture with a different temperature, it may become gritty.

White chocolate is even more delicate to work with because of its high milk content.

The cocoa butter contents of the chocolate makes the difference in the taste and in the difficulty of working with chocolate.

Always handle chocolate gently when you work with it, especially the melting process.

Tempering the chocolate is a process that everyone wants to follow but very few understand and even fewer know that it makes no difference in the process.

People like me don't even care.

In short, tempering is a process of slowly raising and lowering the temperature of chocolate as it melts, stirring constantly until the fat crystals in the cocoa butter stabilizes and blends smoothly together. Tempering is more important to candy makers than to pastry chefs. Every chocolate bar has been tempered, a temperate chocolate keeps at room temperature for a long time without losing its consistency.

Dessert chefs care very little about tempering.

There is no reason to temper chocolate when using it with butter creams, fillings, batters, cakes, pies, mousses, custards, or creams.

Each brand of chocolate behaves differently and melts at different temperatures.

The best way is to melt chocolate in a water bath, in a very low heat, uncovered.

You do not want to cook the chocolate but melt it.

The low heat will melt, eventually, every type of chocolate, some in more time than others, you just have to pay attention to the process. I found that chocolate melts faster and smoothly if done in low heat. It helps if the chocolate is cut into small pieces. If chocolate is transformed from smooth and shiny to a mass of dull paste, there are explanations for this. One is that the chocolate is burned from too much heat. Another reason is that it is mixed with a cold liquid, the cold substances immediately hardens the chocolate and causes it to form gritty particles. Do not mix warm chocolate with cold creams.

Whatever you do - handle chocolate with care.

Chocolate - The Untamed Beast

Chocolate:
When you first taste chocolate
it warms up your palette for an instant,
and it persuades your mind for a while.
Then suddenly it awakens a mortal fever for its taste.

Tastes & Smells

When does the temptation begin? Is it born with the smell or the taste? A sensuous perfume will isolate every other sense of human existence except for the smell which rises to levels of weakness, that surround the mind with irresistible calling of the aroma of fresh brewed coffee, the fragrance of melted chocolate, fresh baked bread, blossoms of violets, rubbed basil, cinnamon, vanilla, fresh rosemary ... smells that make one close their eyes into a deep swallow of the fragrant air, as if nothing else exists around us. Suddenly we are found on a remote island of pleasure, on a mountaintop of freedom where the soft breeze claims that virtuous power of the smell. These aromas prepare the senses for the taste.

Love or lust. How is it possible to distinguish the difference between the two? Is the smell love? Is the taste lust? Both of these senses arouse the imagination with powerful tenacity. Humanity always has welcomed countless possibilities in an incessant search for new stimulated tastes of the flesh. The search of the imagination leads to creativity. New tastes arrive, filtering through the mind and into the flesh.

Searching, you will discover many sinful tastes, so many that the mind becomes imaginative and the senses lustful.

Foods sensuous to the smell, foods attractive to the eyes, become mouthwatering and tempting. Stimulating the senses is an ancient practice and it is a big part of our lives today. Unfortunately, the process of stimulation is different than it used to be.

In an era that the social lifestyle is so fast, where we are racing though life to see who is going to die first, running through the desert of loneliness without an oasis in site, we have come to the point that nothing is enough for the pleasure of the skin. The pleasures have become lust. We demand a cosmic euphoria that nothing can provide anymore. The pleasure of the visual and smelling process has been eliminated and lust sinks directly into the flesh. Alcohol, drugs, violence, pornography, searching for relief from boredom we raise cruely to the level of unrealistic art. It is not accidental that people who write about passionate subjects come from a long tradition of social refinement. The people who imagine passionate, stimulating cuisine are the ones who have witnessed the beauty of the tabletop and the aroma of the foods that has become a part of the soul in evocative places where their mothers and grandmothers cultivated the art of cooking and raised it to a delicate, succulent level.

There were the fine foods set at the table. Robust flavors, mountains of steaming platters, mouthwatering soups and delicate appetizers, succulent roasts, quintessence stews, crispy salads, mounds of beautiful fruits, boards of cheese, memorable breads, heart stopping sweets. There were glorious feasts that daily united the family in the ceremony of the meal. At the table, young and old felt the love and experienced the lust of the food, which, like eroticism, began with the eyes feasting on the beautiful art, the seductive aroma provoking the senses, flowing into the imagination that overtakes the sensitive part of the mind, ready to truly enjoy the masterpiece of all the senses - bonded together.

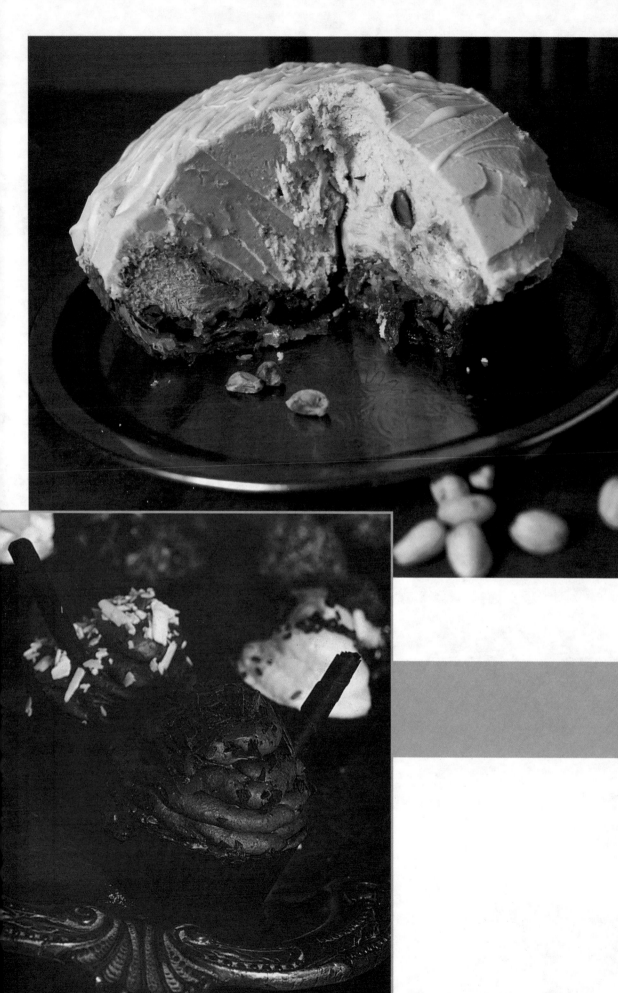

2

3

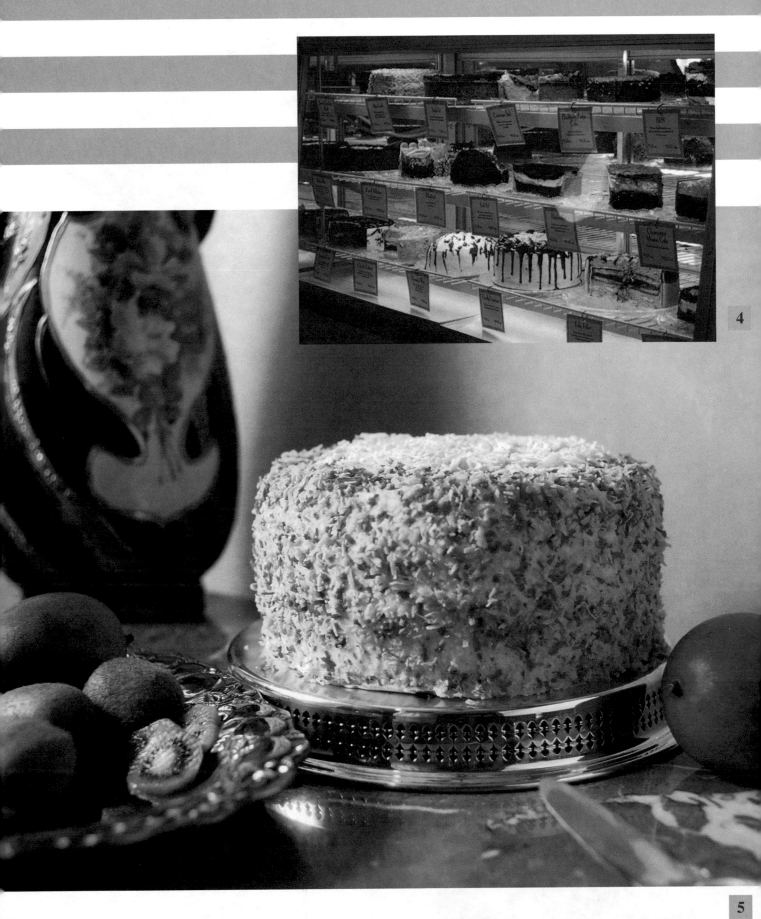

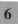

6

7

8

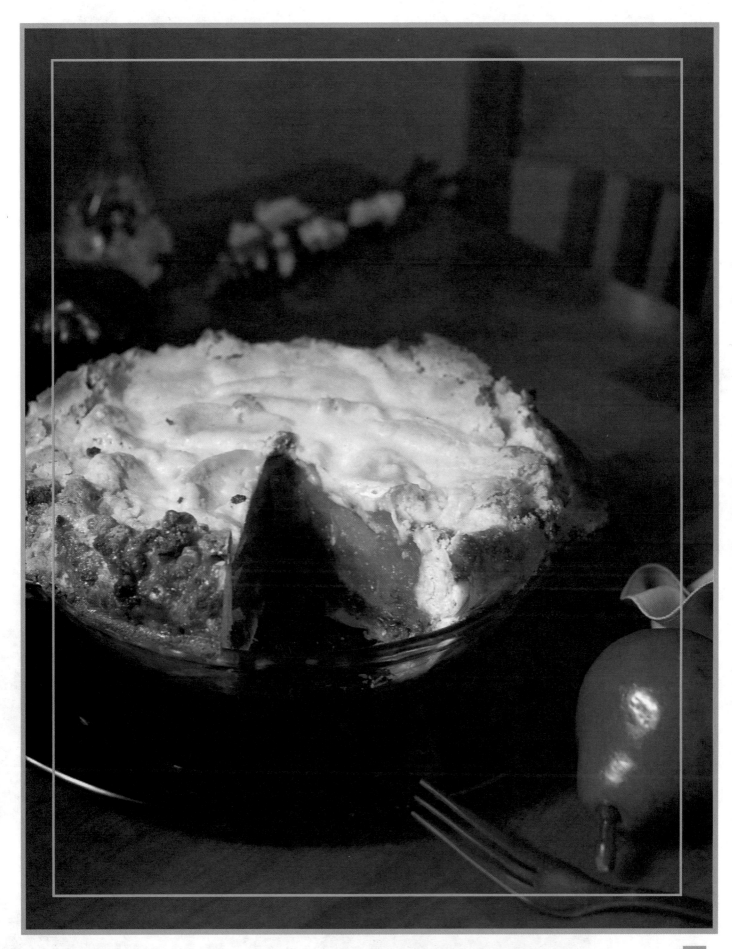

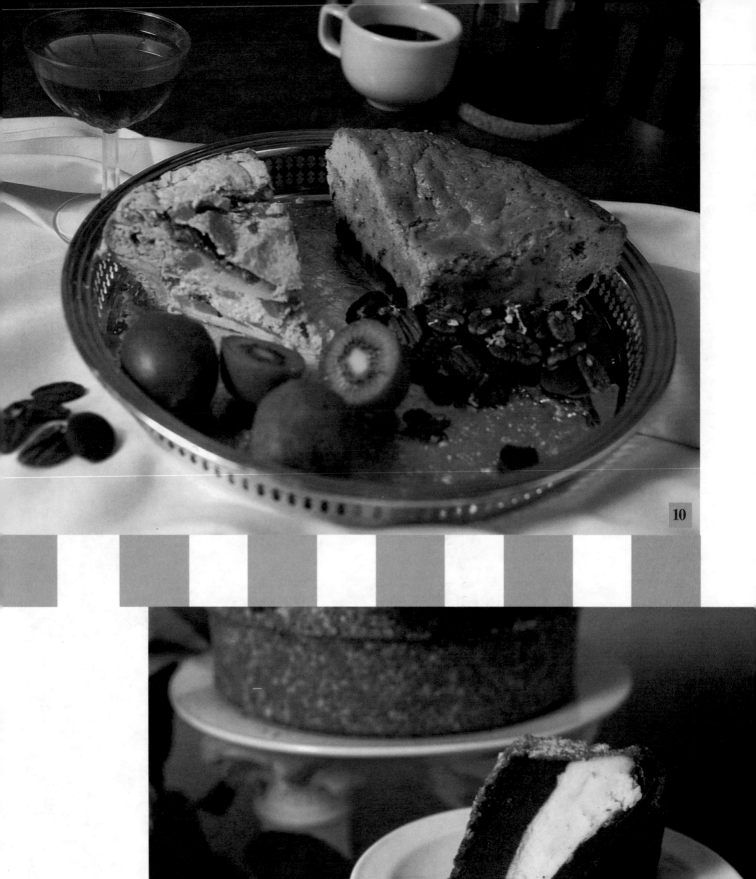

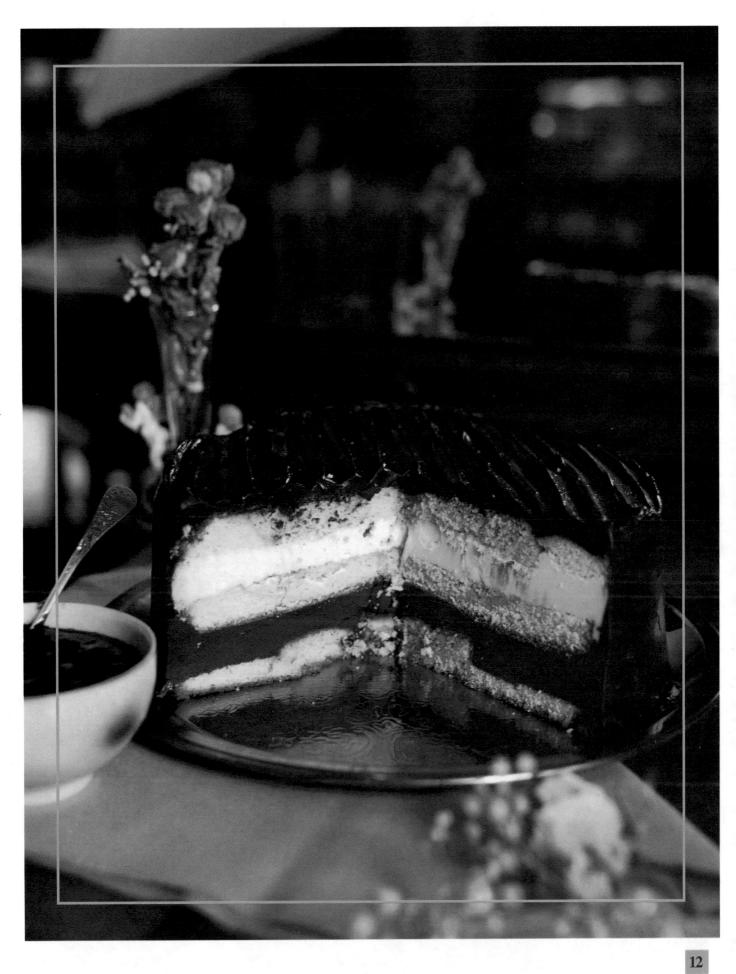

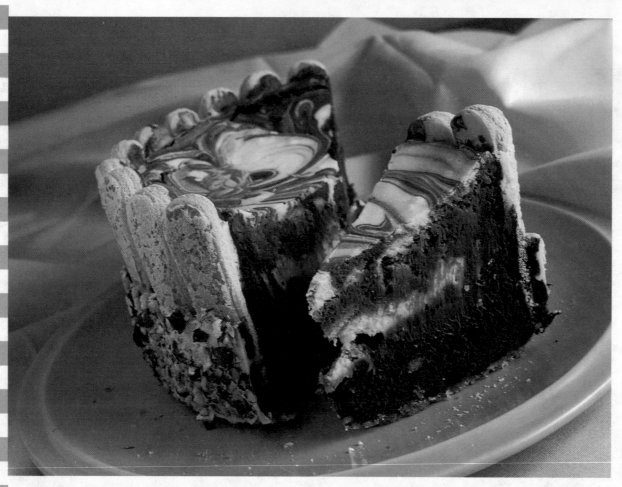

13

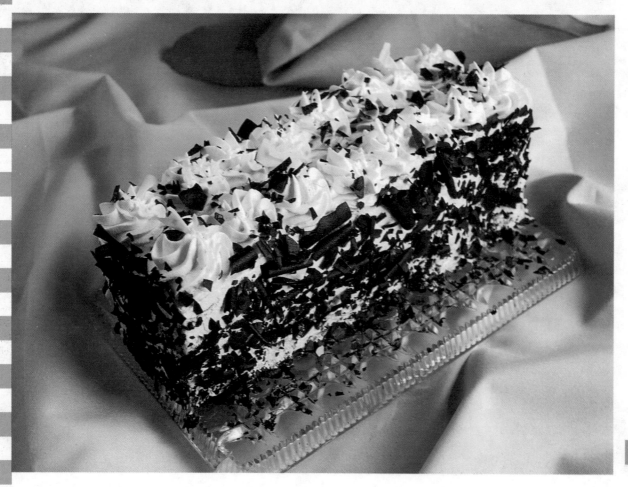

14

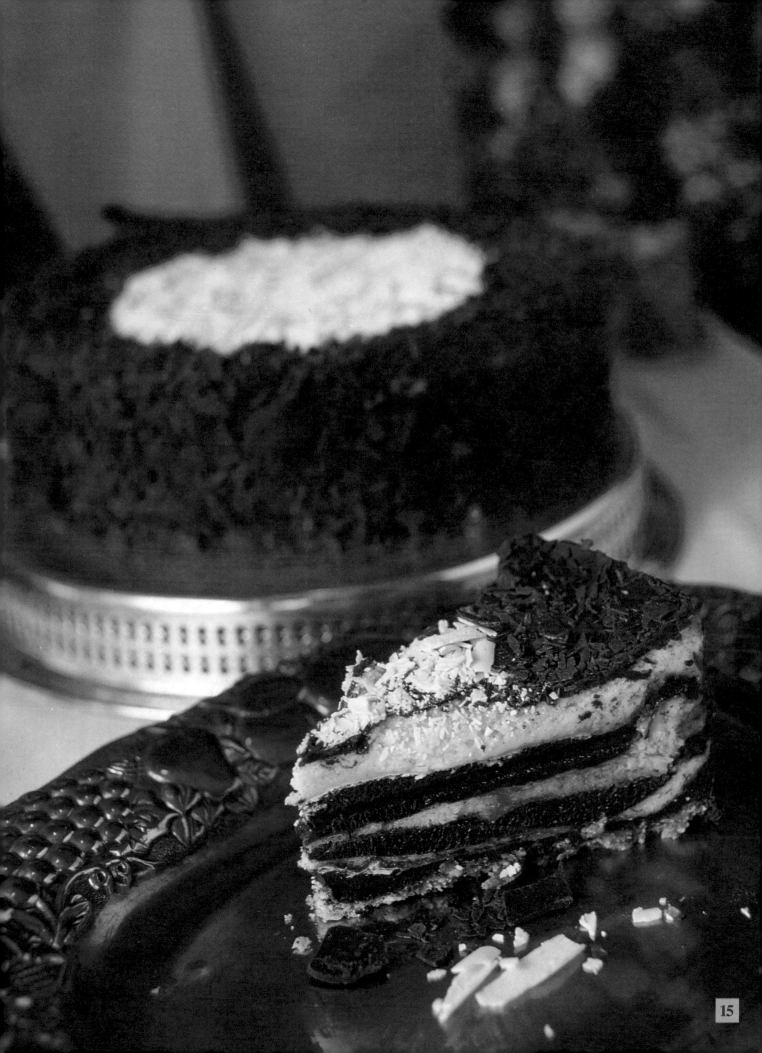

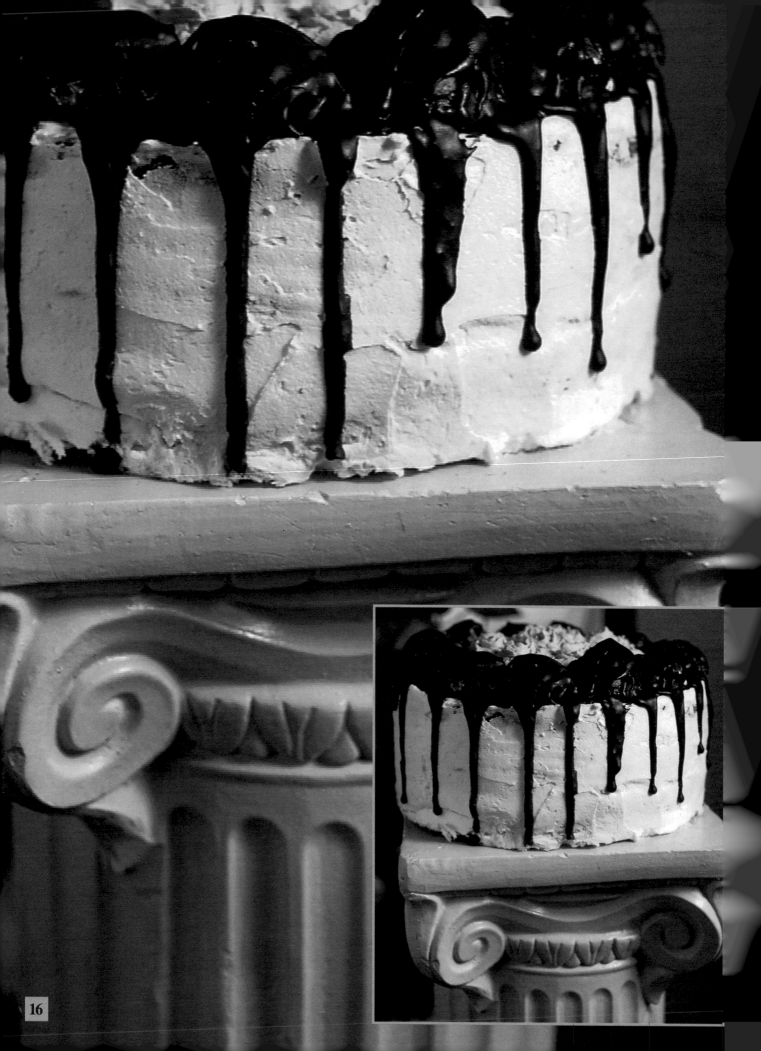

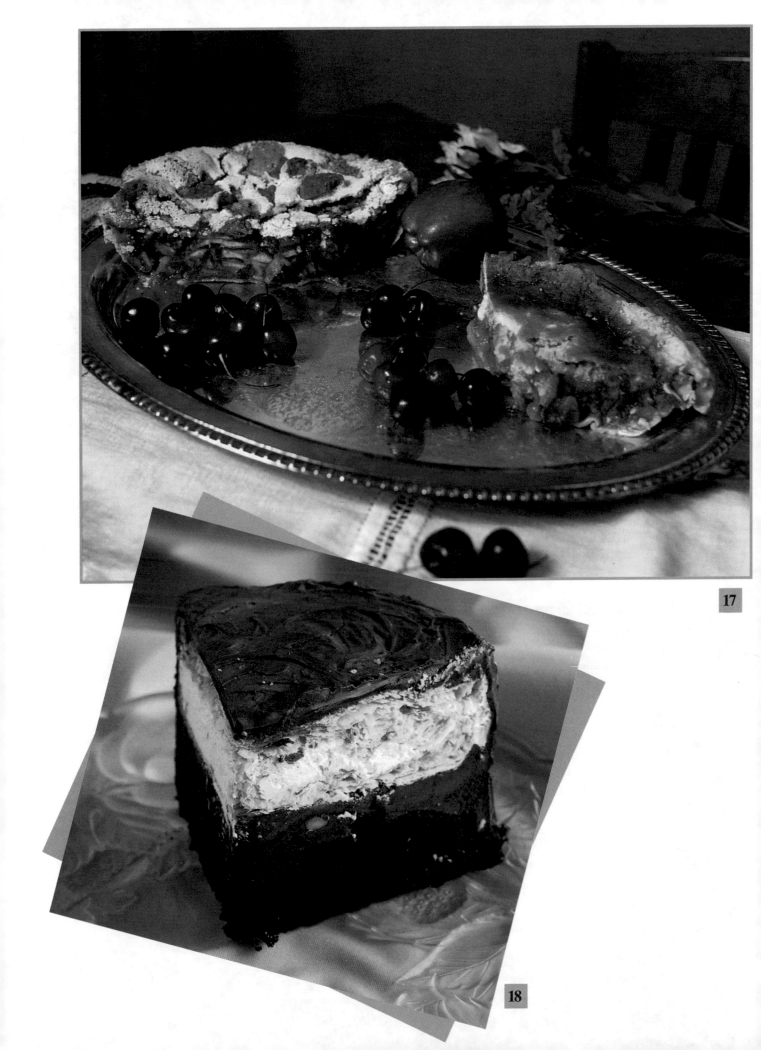

17

18

19

20

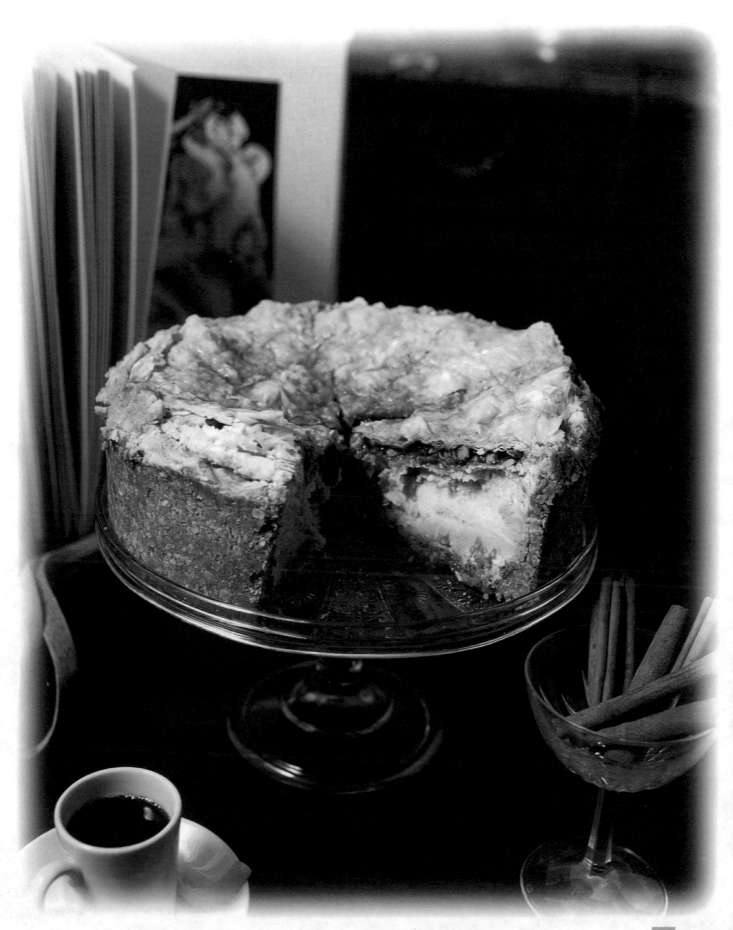

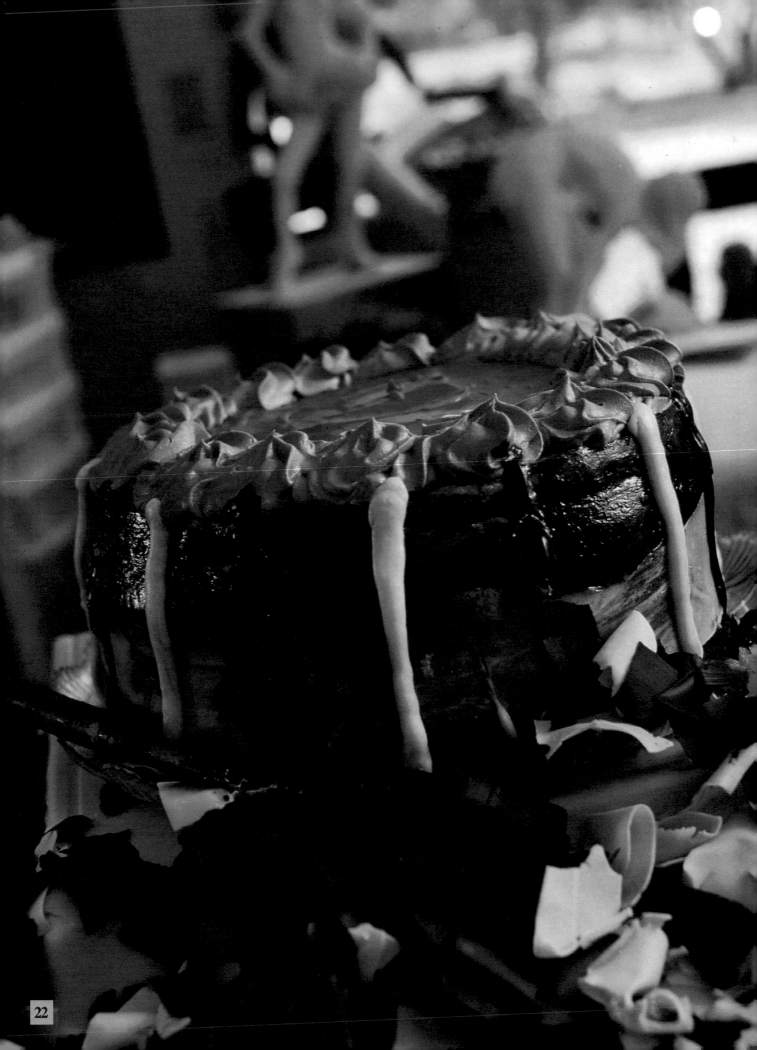

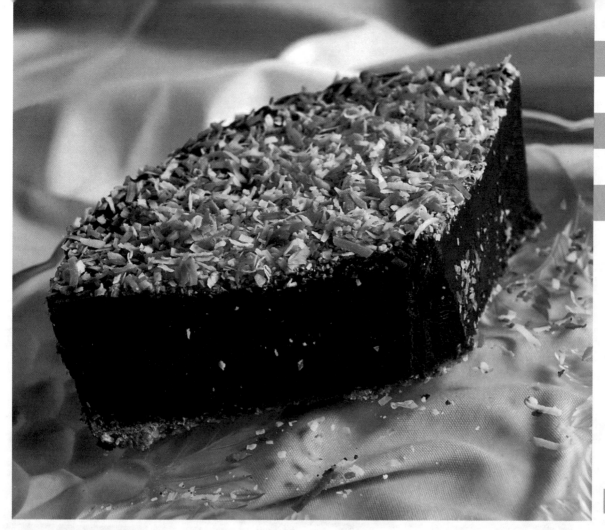

23

24

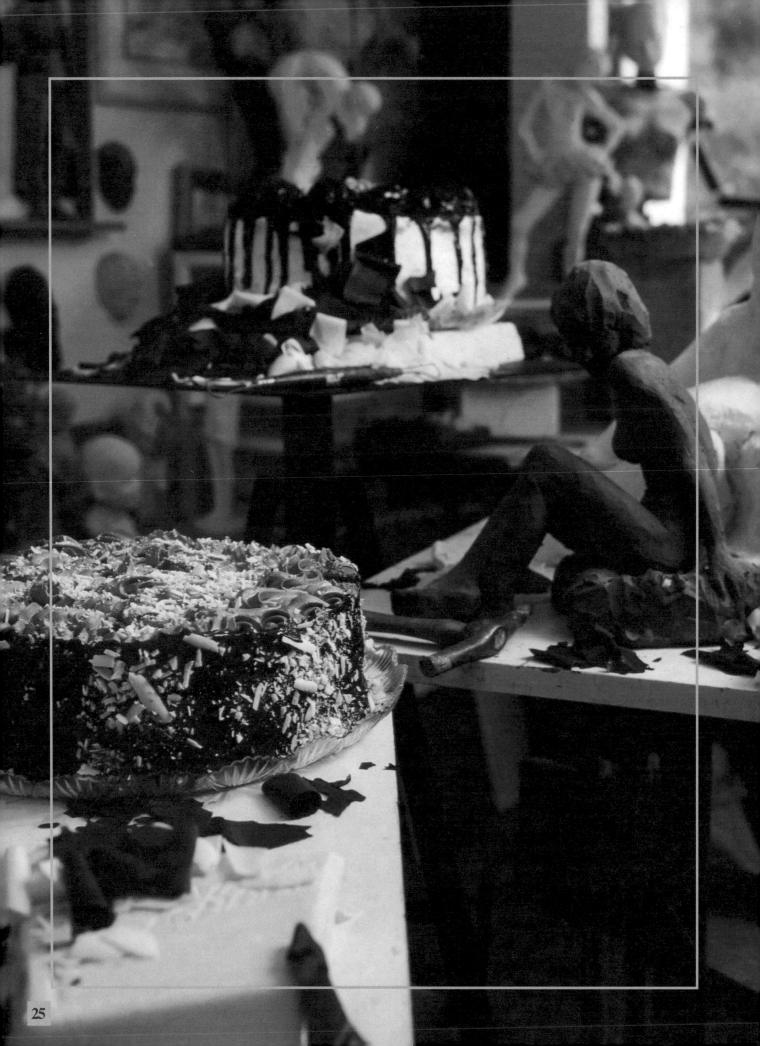

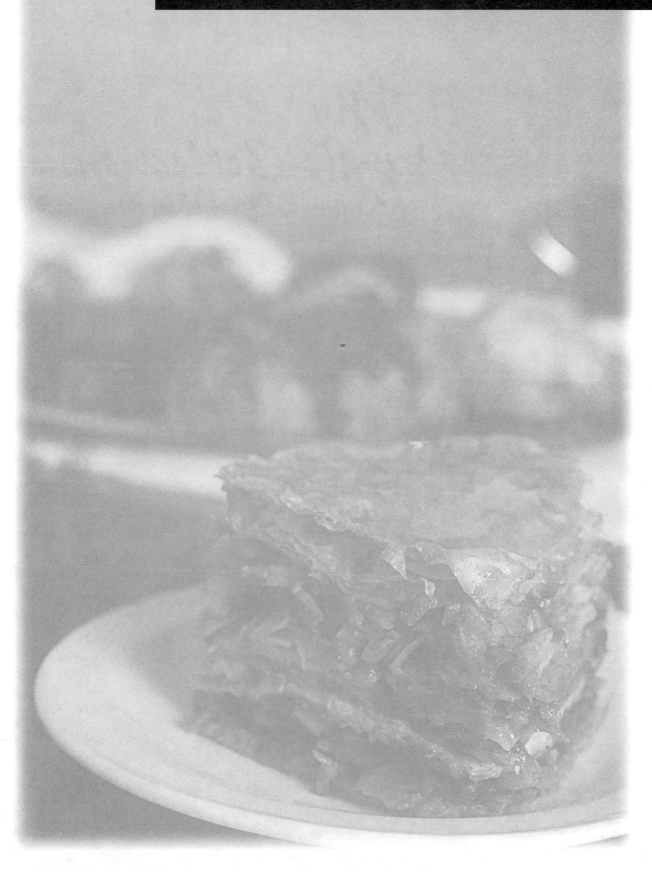

My Private Collection
of Original Pieces of Art

Baklava

Filling
Prepare before opening the fillo
2 cups sugar
4 tbs. cinnamon
1/2 lb. sliced almonds
1 lb. grated walnuts
1/2 lb. pinenuts
1/2 lb. pecan pieces
> *Mix well.*

Cinnamon Syrup
Prepare while the baklava is baking
8 cups water
4 cinnamon sticks
6 whole cloves
1 tsp. grated lemon peel
1 tsp. grated orange peel
2 cups sugar
3 cups honey
2 tbs. cinnamon
1 tsp. vanilla extract
Juice of 1 lemon
> *Bring to a boil. Simmer 30 minutes.*

2 lbs. of fillo dough
1/2 lb. lightly salted butter, melted
> *Lay on working surface. Brush a 9" x 13" pan with butter. Butter fillos one at a time as fillos are used.*
> *Lay one third of the fillos on bottom of pan, overlapping edges slightly. Work fast, keeping the extra fillos covered with a moist towel.*
> *Place half of filling in pan, layer with the second third of buttered fillos. Fold overlapping fillo edges into pan. Spread remaining filling in pan and top with remaining fillos. Tuck in fillo edges.*
> *With a sharp knife, slice the top row of fillos diagonally, creating diamond shapes. Sprinkle a little water on fillos to keep pastry moist while baking.*
> *Bake for an hour to an hour and fifteen minutes in a preheated 350° oven. Saturate the Baklava with syrup and let stand for two hours.*

❧

This filling is not the traditional baklava, but my own recipe that I have found blends nicely with the syrup (also original). The syrup is lighter to compensate for the heavier nut filling. There are several baklava recipes. The diversions are according to the filling (use any nuts you would like) and the syrup. I use more honey and less sugar in my syrup for a lighter fuller taste.

❧

Fillo Rolls

Filling
2 lb. walnut crumbs
1 tbs. cinnamon
1 tbs. ground cloves
2 cup toast crumbs
2 cups sugar
1/2 cup rose water
6 fillo dough
1/2 lb. butter, melted
Mix together all ingredients, except for the fillo and the butter.

Honey Syrup
Prepare while the fillo rolls are in the oven
3 cups sugar
1 cup honey
2-1/2 cups water
Juice of 1/2 lemon
Bring to a boil. Simmer 15 minutes.

Melt butter. Using three fillos at a time (butter each sheet) lay on working surface and place half of the filling lengthwise. Roll tightly to form a long roll. Place on a baking sheet and repeat the process with the remaining three fillo sheets. Pour remaining melted butter over rolls. Bake at 350° for about 45 minutes or until golden brown. Let cool and cut rolls into small sizes (approx. 4" long) and drizzle wth syrup.

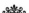

Diples

4 eggs
8 egg yolks
1 cup orange juice
1 cup sugar
1/4 cup olive oil
1 tbs. lemon peel
Mix together gently.

8 cups flour
1 tsp. baking soda
Add in and mix well.

Heat shortening or canola oil to 350°. Dust dough with a little flour and roll into very thin sheets. Cut into approximately 8" x 4" pieces and fold lengthwise. Dip dough into hot oil holding them closed with tongs until diples curl into a round shape, continue frying until golden brown. Dip diples in cinnamon honey syrup (pg. 51) one at a time. Then sprinkle with a mixture of 1 cup grated walnuts and 1 tsp. cinnamon.

Kataifi

2 lbs. lightly salted butter, melted
2 lbs. shredded Kataifi dough

Filling
1 lb. grated almonds
1 lb. grated walnuts
1/2 cup toast crumbs
2 tbs. cinnamon
1 tbs. cinnamon
1 tbs. lemon peel
2 tbs. cognac
2 tbs. orange juice
1/4 cup rose water
2 cups sugar
 Mix ingredients well.

Syrup
3 cups sugar
1 cup honey
2-1/2 cups water
Juice of 1 lemon
 Bring to a boil. Simmer for 15 minutes.

 Place approximately one ounce of lightly buttered dough flat on a working surface. Place one tablespoon of filling on the dough and roll loosely. Place roll on a buttered baking sheet and repeat the process until dough is all used. Pour remaining butter on top of Kataifi and cover with foil.

 Bake in a 350° oven for 20 minutes. Remove foil and continue baking for 45 to 50 minutes longer until golden brown. Soak pastry well with syrup.

Rose-flower water is fragrant water produced by distilling the blossoms of the flower. Use it in small doses. Orange-flower water is also made by distilling the orange blossoms. These liquids are found in specialty shops, mostly in Middle Eastern shops.

This idiosyncratic chef is a kitchen magician, a candidate for culinary sainthood.
New Times, 1997

Karidopita

12 eggs
2-1/2 cups sugar
 Beat at high speed, 15 minutes until stiff.

2 cups milk
2 tbs. Grand Marnier
 Add in at slow speed.

4-1/2 cups grated walnuts
3 tsp. cinnamon
3 tsp. cloves
2 tsp. baking powder
3 tsp. orange peel
5 cups flour
2 tsp. baking soda
 Add in and mix very lightly.

 Place batter in a buttered 12" x 18" pan. Bake at 350° for 45-50 minutes. Remove from pan and let cool slightly. Cut into desired size pieces.

Syrup

3 cups sugar
4 cups water
1 cup honey
1 tbs. lemon peel
 Boil for 5 minutes slowly. Pour 2/3 of the syrup on top of the cake. Mix the remaining syrup with 1 cup melted milk chocolate. Sprinkle pastry with 2 cups of chopped walnut pieces. Pour chocolate mixture on top of walnuts.

During my stay in Greece, I was reminded of a simple dessert that became one of my favorites after I enjoyed it in Milos again in 1990. Since that moment I worked to master its' compelling taste. I believe I have succeeded.

**It is a must to try Nick's dazzlng desserts.
I'll wager that no one will be able to resist his
Symphony of Chocolate cake. It is dark, white and chestnut
chocolate veiled with an orange cinnamon, white chocolate icing.**

Phoenix Downtown, 1995

Galaktobouriko

12 cups milk
> *Bring to a gentle boil.*

1/4 lb. butter
> *Add in, stir until the butter melts, remove pot from heat.*

12 eggs
2 cups sugar
> *Beat in a mixer until stiff, add them slowly into hot milk, stirring well.*

1 tbs. vanilla extract
> *Add in, stir.*

2 cups semolina
12 tbs. pastry flour
> *Mix together, add to milk mixture stirring with a wire whip. Let mixture cool.*

24 fillo dough sheets
1 cup melted butter
> *Lay 12 fillo sheets, buttering each one of them, in the bottom of a 12" x 18" baking pan. Make sure the fillo sheets overlapp the edges of the pan. Pour in the mixture. Fold the overlapped fillo dough on top of the mixture. Lay remaining fillo on top, buttering each one of them, tucking the edges of the fillo into the side of the filling. With a sharp knife slit the top of fillo into diamond shapes. Preheat oven to 375°. Bake 45 to 50 minutes. Remove and let cool.*

1-1/2 cups sugar
1-1/2 cups water
> *Boil for 5 minutes. Pour over Galaktobouriko.*

Greece:
a land of blue skies,
blue seas,
white washed islands,
retsina,
souvlaki
and
galaktobouriko.

Orange Ravani

12 eggs
2-1/2 cups sugar
>*Beat at high speed, ten minutes, until eggs thicken. Remove from mixer.*

3-1/4 cups semolina
3-1/4 cups cake flour
3 tsp. baking powder
2 tbs. orange peel
1 cup grated almonds
>*Add to eggs and mix by hand.*

1 cup milk at room temperature
1-1/2 cups orange juice
2 tsp. vanilla extract
>*Add in, mix lightly. Place mixture in a buttered 12" x 18" pan. Bake at 350° for 40-45 minutes.*

Syrup
6 cups sugar
5 cups water
>*Boil for 5 minutes.*

1/2 cup butter
4 tbs. lemon juice
3 tsp. lemon peel
>*Add to sugar water, stir until butter melts. Cool syrup to room temperature. Cut Ravani into desired sizes, pour 3/4 of the syrup over pastry, slowly and carefully.*

2 cups of toasted almonds
>*Sprinkle on top of Ravani.*

1/4 of the remaining syrup
1/4 cup of orange juice
2 cups apricot marmalade
>*Blend together and spread over Ravani.*

***Baking powder** was introduced commercially in the United States in 1856. In Brooklyn, New York spice dealer James A. Church closed his factory to enter the baking soda business but retains his symbol sign of the roman god Vulcan to identify his vulcan spice mill. Church adopted the name Arm and Hammer under which he dominates the market, even today.*

Pistachio Saragli

1 lb, pistachios, thickly chopped
1/2 tbs. cinnamon
1/4 tbs. ground cloves
3/4 cup sugar
1/2 tbs. melted butter
 Mix together.

12 fillo dough
1/2 lb. melted butter
 Use three fillo sheets in each pile. Make 4 piles of fillo, buttering each fillo, divide filling into 4 parts. Place the filling on the bottom center of each fillo pile. Fold in the sides of fillo to cover the filling, then roll up the fillo to make a roll. Place rolls into baking pan.

1/4 lb. butter, melted
 Pour over the rolls. Bake at 350° for 25 to 30 minutes, until rolls are golden brown.

Syrup
1/4 cup honey
3/4 cup sugar
1 cup water
Juice of 1/4 lemon
 Bring to a boil. Simmer for 15 minutes. Pour over rolls. Let cool.

Icing
2 tbs. milk chocolate
1 tbs. heavy cream, warmed
 Mix together. Use a serving spoon with holes to drizzle lines on top of the rolls.

CLOVES

No kitchen should be without cloves. This nail-like spice gets its name from the Latin davus (nail) and its history goes back to the islands of Southeast Asia. It was used in the Chinese kitchen hundreds of years before it was introduced to the Europeans.

Cloves are bitter and strong flavored. But when cooked they bring out a strong perfume, yet a warm flavor. Now they are widely used throughout Europe in breads, puddings, cakes, cookies, meat stews, soups and marinades. Cloves are essential to foods with festive tastes.

Cloves were also used throughout the centuries to ease the pain of toothaches.

❧

About Cookies

The hundreds of cookie recipes are a testimony to the popularity of these little cakes. There is a wide array of flavors and textures. I believe that their popularity accounts for the easy and quick way of making them.

Drop cookies are the easiest to make. The dough should be soft and since they spread during baking, keep them about 2" apart.

Bar cookies are also made from soft dough and baked in a shallow pan. These may be layered in different flavors and textures.

Rolled cookies are made from stiffer dough and cut with a cookie cutter after they are rolled out.

The main ingredients for cookies are flour, eggs, sugar and shortening. All these ingredients should be used at room temperature. Be careful, especially with the quality and the quantity of flour. Too much flour will result in a dry, hard cookie.

Butter is used for a more flavorful cookie. If you have to separate the eggs it is easier to do so while they are cold. The egg whites must be at room temperature if they are used to make a meringue. Baking sheets should have almost no sides so the cookie can be baked evenly. Preheat your oven to the correct temperature before baking.

My "puffs" recipe is simply a cookie made without the eggs and it is a must to try.

The time range for baking cookies will vary depending on the type of the oven and the size of the cookie. Please note cookies continue to bake for a few minutes after they come out of the oven.

❧

Cookies

Almond Butter Cookies

1/2 lb. butter
1/2 cup sugar
>*Cream in a mixer.*

6 egg yolks
1-1/2 cups grated almonds
>*Add in, mix well.*

1 cup orange juice
1 tsp. vanilla extract
1 tsp. ground cloves
5 cups flour
1 tsp. baking soda
>*Add in, mix gently. Form cookie into half moon shape. Place on a lightly buttered baking sheet. Bake at 350° for 12-14 minutes. Remove from oven. Cool slightly. Place cookies on a serving tray. Sprinkle loosely with powdered sugar.*

To caramelize almonds or hazelnuts, first chop nuts into average pieces then toast them in a 350° oven for about 12 minutes or until light brown.

Caramelize 1 cup of sugar with 4 tbs. of water (pg. 76). Stir in the nuts immediately and pour the mixture into a baking pan. Let cool. Break into pieces. In this stage you have nut brittle. Pulverize the pieces in a blender or a mortar and now store in an airtight contaner. Use on ice cream, yogurt, cheesecakes, fillings or icings.

Hazelnut Butter Cookies

1/2 lb. butter
1/2 cup sugar
>*Cream in a mixer.*

6 egg yolks
1-1/2 cups grated hazelnuts
>*Add in and mix well.*

1 cup orange juice
1 tsp. vanilla extract
1 tsp. ground cloves
5 cups flour
1 tsp. baking soda
>*Add in and mix gently. Form cookies into an oblong shape. Place on a lightly buttered pan. Bake at 350° for 12-14 minutes. Cool slightly. Place cookies on a serving tray and sprinkle loosely with powdered sugar.*

Sugar Cinnamon Cookies

1/2 cup margarine
1/2 cup butter
1 cup sugar
4 eggs
>*Mix well together.*

1 tsp. vanilla extract
2 tbs. whipping cream
1 tbs. cinnamon
>*Add in and mix lightly.*

3 cups flour
1 tsp. baking soda
1 tsp. baking powder
>*Add in and mix lightly. Form cookies. Place on a lightly buttered pan. Bake at 350° for 15-18 minutes.*

Honey Beer Cookies

1-1/2 cups butter
1-1/2 cups vegetable oil
1 cup sugar
>*Mix well.*

1-1/2 cups beer
1/2 cup orange juice
2 tbs. baking soda
2 tbs. cognac
1 tbs. orange peel
12 cups flour
2 tbs. baking powder
1 tsp. baking soda
>*Add in and mix gently. Form cookies into walnut-sized rounds. Place on a lightly buttered baking sheet. Bake at 350° for approximately 16-18 minutes. Let cookies cool,*

Honey Syrup
3 cups sugar
1 cup honey
2-1/2 cups water
>*Bring to a boil, simmer for 10 minutes. Dip in cookies.*

Topping
1 lb. grated walnuts
2 tbs. ground cinnamon
>*Sprinkle on top of cookies.*

Peanut Coffee Cookies

1/2 lb. butter
1/2 lb. margarine
1-1/2 cups sugar
 Mix well.

4 eggs
 Add in and mix well.

1/2 cup yogurt
1/4 cup instant coffee
 Add in and mix well.

1 tsp. cocoa
4-1/2 cups flour
1 tsp. baking soda
1-1/2 tsp. baking powder
1/4 cup chopped peanuts
1/4 cup creamy peanut butter
 Add in and mix well. Form cookies and place them on a lightly buttered pan. Bake in 350° for about 16-18 minutes.

*I use **corn syrup** in most of my cookie recipes because the butter involved tends to dry out the cookie in a day or two. The corn syrup is a natural preservative that keeps the treats moist. It also helps soften any excessive sugary taste.*

I like to bake most of my cookies at 325° for 16-18 minutes. Refrigerating the dough before cooking, makes it easier to handle and imparts a richer flavor.

The best and easiest way to form a cookie is with an ice cream scoop.

Coconut Chocolate Chip Cookies

1 cup butter
1 cup brown sugar
 Mix together.

1/3 cup corn syrup
3 eggs
2-1/3 cups flour
1-1/2 tsp. baking soda
1-1/2 tsp. baking powder
2 cups toasted coconut
2 cups chocolate chips
 Mix together. Place on a lightly buttered baking sheet. Bake at 325° for 16-18 minutes.

Peanut Butter Cookies

1/2 cup peanut butter
1/4 cup margarine
1/4 cup butter
1/2 cup sugar
3/4 cup brown sugar
1/4 cup corn syrup
Mix together.

3 eggs
1 cup peanut butter
3-1/2 cups flour
1 tsp. baking soda
1 tsp. baking powder
Blend well. Form cookies into walnut sized rounds. Place on a lightly buttered baking sheet. Bake at 325° for 16-18 minutes.

Variations for a richer flavored Peanut Butter Cookie:
Add 2 cups hazelnuts and 2 cups white chocolate chips; or 2 cups whole peanuts; or 5 tbs. plain yogurt, 2 cups whole peanuts and 4 tbs. instant coffee.

Orange Oatmeal Cookies

1/2 cup butter
1/2 cup margarine
1 cup brown sugar
3/4 cup sugar
1/4 cup corn syrup
Blend together.

5 eggs
3 cups flour
1 tsp. cinnamon
1 tbs. vanilla extract
3 tbs. orange peel
3 cups oats
1 tsp. baking soda
1 tsp. baking powder
Mix together. Place walnut-sized rounds on a lightly buttered baking sheet. Bake at 325° for 16-18 minutes.

Oatmeal Raisin Cookies

Chestnut puree
is made with fresh chest-
nuts, peeled, boiled and
then pureed. *Chestnut
cream* is made with
chestnut puree mixed
with milk, sugar, and a
little vanilla. To easily
peel the chestnut, boil in
water for about 1 minute.
Use 2-1/2 cups
of chestnuts (about 1
pound) in 5 cups of milk,
1 tbs. sugar, 1/4 tsp.
vanilla extract.
Chestnut puree
and cream are sold
canned in specialty
shops.

Parchment paper
is a special non-stick
paper. It is best used to
line baking sheets
instead of butter or oil.

1/2 lb. butter
1/2 lb. margarine
1 cup brown sugar
3/4 cup sugar
1/2 cup corn syrup
Blend together.

5 eggs
3 cups flour
1 tsp. baking powder
1 tsp. cinnamon
1-1/2 cups raisins
1-1/2 cups walnuts
2-1/2 cups oats
1/2 tsp. mace spice
1 tsp. baking soda
Mix well. Place walnut-sized rounds on a lightly buttered baking sheet. Bake at 325° for approximately 16-18 minutes.

Chocolate Chip Cookies

1/2 lb. butter
1 lb. margarine
1 cup brown sugar
1/4 cup sugar
1/4 cup corn syrup
Blend well.

5 eggs
1 tbs. vanilla extract
4 cup flour
1 tsp. baking soda
1 tsp. baking powder
3 cups walnuts
3 cups chocolate chips
Mix together. Place walnut-sized rounds on a lightly buttered baking sheet. Bake at 325° for approximately 16-18 minutes.

White Chocolate Hazelnut Cookies

1/2 lb. butter
1 lb. margarine
1 cup brown sugar
1/4 cup sugar
1/4 cup corn syrup
 Blend well.

5 eggs
1 tbs. vanilla extract
4 cups flour
1 tsp. baking soda
1 tsp. baking powder
3 cups hazelnuts
3 cups white chocolate chips
1 tbs. Frangelico liqueur
 Mix together. Place walnut-sized rounds on a lightly buttered baking sheet. Bake at 325° for approximately 16-18 minutes.

Pecan Puffs

1 lb. butter
1-1/2 cups sugar
2 tsp. baking soda
 Cream in a mixer, on medium speed for 15 minutes.

4 cups flour
1 tsp. vanilla extract
3 cups pecans
 Add in and mix well. Form cookies. Place on a lightly buttered pan. Bake at 300° for 20 minutes.

The Girl Scout Cookies of America was founded in 1912. In 1938, Girl Scout Cookies signed a contract with Interbake foods of Richmond, Virginia to supply all its cookies.

This program started in the early 1920's for fund raising purpose. Interbake made Girl Scout Cookies until 1974 when they lost the contract to Little Brownie Bakers of Louisville, Kentucky.

In 1933, the Chocolate Chip Toll House cookies were created in Whitman, MA. by Ruth Wekefield, who figured that bits of semi-sweet chocolate dropped into cookie batter would melt in the oven and stay firm after cooling.

Double Chocolate Puffs

1 lb. butter
1-1/2 cups sugar
2 tsp. baking soda
 Cream in a mixer on medium speed for 15 minutes.

4 cups flour
1 tsp. vanilla extract
1 cup chocolate chips
1 cup white chocolate chips
 Add in and mix well. Form cookies. Place them on a lightly buttered bakng pan. Bake in 300° for 20 minutes.

To toast the coconut flakes, *place coconut on a baking pan and toast in a 300° oven. Be careful, coconut burns easily.*

To use a pastry bag, it is best to fill the bag three quarters full, twist the bag on top to squeeze the filling out. While you are doing this, with your other hand hold the bag close to the tip to have better control of your design.

Toasted Coconut Puffs

1 lb. butter
1-1/2 cups sugar
2 tsp. baking soda
 Cream in a mixer on medium speed for 15 minutes.

3-1/2 cups flour
3 cups toasted coconut
1 tsp. vanilla extract
 Add in and mix well. Form cookies. Place on a lightly buttered pan. Bake at 300° for 20 minutes.

Macaroons

5 egg yolks
1 cup sugar
 Beat for 3-4 minutes.

4-1/2 cups coconut macaroons (available in specialty mkts)
1/2 tsp. vanilla extract
1 tbs. butter, melted
1 tsp. lemon peel, finely ground
2 tbs. flour
5 egg whites
 Add in and mix well. With a star tip in a pastry bag, pipe mixture into a lightly buttered pan forming approximately 2-1/2" round and tall cookies.
 Bake in 325° oven for 18-20 minutes until golden brown.
 The macaroon mixture should be a thick liquidy consistency. If it is too thin add more coconut. If it is too thick, add a little warm water.

Almond Macaroons

Follow the macaroon recipe except reduce the coconut macaroon to 4 cups and the flour to 1 tbs. Add 1 cup of finely ground almonds.

Hazelnut Macaroons

Follow the macaroon recipe except reduce the coconut macaroon to 4 cups and the flour to 1 tbs. Add 1 cup of finely ground hazelnuts.

Chocolate-Dipped Macaroons

Dip macaroons into chocolate icing; dark or white.

❧

Do not throw away stale macaroons. Break them into small pieces and roast them in a 225° oven for about 30 minutes. Remove them and let them dry. They will become crispy. Pulverize them in an electric blender or beat them in a mortar. Store in an airtight container. Use it to flavor icings or fillings for cakes or sprinkle on top of ice cream or yogurt.

❧

Mac Mousse

1 tbs. cherry pie filling
 Place in the middle of the macaroon shell.

1/2 recipe of chocolate mousse
 With a star tip pipe the mousse into the shell. Repeat process to make as many Mac Mousse as needed.

*For the following three recipes you must make a **macaroon shell.** After making the macaroon recipe, pipe macaroon mixture into an oblong shape of approximately 5" x 2". On the edges pipe a line of mixture all around it as if you are building a wall. Bake at 325° for 18-20 minutes.*

White Peanut Macaroons

1/2 recipe of white chocolate icing
1 tbs. creamy peanut butter
 Mix well. With a star tip in a pastry bag, pipe the mixture into the macaroon shell. Repeat to make as many White Peanut Macaroons as desired.

Passion Bars

1/2 recipe of white chocolate icing
1/2 mango, chopped finely
1/2 kiwi, chopped finely
 Mix well. With a star tip in a pastry bap, pipe the mixture into the macaroon shell. Repeat to make as many Passion Bars as desired.

In his legendary restaurant, Nick makes a dessert named Sinful Act. It is a diabolical, multi-layered chocolate creation.

Best of Phoenix, 1994

Biscotti

When I started making biscottis a few years ago, the majority of my customers did not even know what a biscotti was. Today I can hardly keep up with the demand. Most of the following recipes yield 55-60 biscotti.

Anise grows to about 2 feet. It has delicate light green leaves and yellow and white flowers. It grows in many parts of Europe, the Middle East and Russia and India. It is used to flavor alcoholic drinks throughout Europe (Ouzo, Anisette, Sambuco, Pernod, Ricard etc.) The anise seeds are brown and fuzzy and are the most flavorful part of the plant. When anise is ground, it looses some of its flavor. For best results, grind the seeds as you need them in a mortar.

About Biscottis

Biscotti is an old-time European treat, practically unknown to the American general public until a few years ago when the coffeehouses became a trend in America. Biscotti is a natural marriage with coffee. It is usually hard and dipping it in coffee softens it and enriches its flavor. They keep well in an airtight container. Biscottis keep well for a long time but I doubt they will stay on your shelf for more than a few days because they are addictive.

Baking times vary due to the size and the oven used. When baking the strips, first make sure the dough is baked enough to be sliced easily. When you "dry" the biscotti in the second phase of baking, make sure they are lightly brown. You can turn them midway through baking so they will be brown on both sides.

If they seem soft after they are baked, do not be concerned. Biscottis will harden up. They taste better the second day and much better the third day.

Anise Ouzo Biscotti

1/2 cup butter
1/2 cup vegetable oil
1 cup sugar
> *Mix together.*

3 eggs
5 cups flour
3 tsp. baking soda
2 tsp. anise, ground
3 tbs. ouzo (Greek liquor)

Add in and mix well. Divide dough into 1 lb. parts. Shape into strips 12" long and 4" wide. Place strips in buttered pan.

Bake 12-13 minutes at 350°. Cool and cut into 1" long strips. Return biscotti to pan.

Bake at 350° for 13-14 minutes. Let cool and dry before serving.

Chocolate Espresso Biscotti

12 oz. butter
3 cups sugar
 Cream together.

8 eggs
10 cups flour
1 tsp. nutmeg
1 tsp. vanilla extract
3 tsp. baking soda
2 tsp. baking powder
3 tbs. melted milk chocolate
1/2 cup strong coffee
1 tsp. cinnamon
2 tsp. cocoa
 Add in and mix well. Divide dough into 1 lb. parts. Shape into strips 12" long and 4" wide. Place strips in buttered pan. Bake at 350° for 12-13 minutes. Cool and cut into 1" long strips. Return bicotti to pan.
 Bake at 350° for 13-14 minutes. Let cool and dry before serving.

❧

Almond Biscotti

12 oz. butter
3 cups sugar
 Blend well.

8 eggs
9 cups flour
1 tsp. nutmeg
1 tsp. vanilla extract
3 tsp. baking powder
5 cups sliced almonds
1 tsp. almond extract
 Add in and mix well. Divide dough into 1 lb. parts. Shape into strips 12" long and 4" wide. Place strips in buttered pan.
 Bake 12-13 minutes at 350°. Cool and cut into 1" long strips. Return biscotti to pan.
 Bake at 350° for 13-14 minutes. Let cool and dry before serving.

❧

I use butter in my biscotti recipes but if you do not like the rich taste you can use 1/2 butter and 1/2 margarine. Butter will make the biscottis harder. Margarine will soften them a little. Using vegetable oil in your biscotti recipe will make it crumbly.

❧

*To **cream butter** and sugar, use the regular beater of your mixer. Cut the butter into small pieces. Make sure your mixing bowl is warm. Beat at medium speed. The mixture is ready when butter mixture is light and fluffy.*

❧

Hazelnut Biscotti

12 oz. butter
3 cups sugar
> *Blend well.*

8 eggs
9 cups flour
1 tsp. nutmeg
1 tsp. vanilla extract
3 tsp. baking powder
5 cups sliced hazelnuts
5 tsp. Frangelico liquer

Add in and mix well. Divide dough into 1 lb. parts. Shape into strips 12" long and 4" wide. Place strips in buttered pan.

Bake 12-13 minutes at 350°. Cool and cut into 1" long strips. Return biscotti to pan.

Bake at 350° for 13-14 minutes. Let cool and dry before serving.

White Chocolate, Apricot & Pistachio Biscotti

12 oz. butter
3 cups sugar
8 eggs
2-1/2 cups dried apricot, chopped
3 cups pistachios
1 cup white chocolate, melted
> *Blend together.*

6 cups flour
3 cups whole wheat flour
2 tsp. vanilla extract
3 tsp. baking powder

Add in and mix well. Divide dough into 1 lb. parts. Shape into strips 12" long and 4" wide. Place strips in buttered pan.

Bake 12-13 minutes at 350°. Cool and cut into 1" long strips. Return biscotti to pan.

Bake at 350° for 13-14 minutes. Let cool and dry before serving.

Allspice was introduced to Europe around the 15th Century. The tree grows to about 4 feet with small white flowers. It is a very aromatic tree. The berries from allspice resemble peppercorns. They turn from green to brown after they are dried in the sun. The flavor is a cross mixture of cinnamon, cloves and nutmeg.

Allspice is believed to have been used by the Mayans and later the Aztecs.

Grinding a few at a time in a mortar will bring a fresher and more aromatic flavor.

Pistachio Biscotti

12 oz. butter
3 cups sugar
> *Blend well.*

8 eggs
9 cups flour
1 tsp. nutmeg
1 tsp. vanilla extract
3 tsp. baking powder
5 cups pistachios
> *Add in and mix well. Divide dough into 1 lb. parts. Shape into strips 12" long and 4" wide. Place strips in buttered pan.*
> *Bake at 350° for 12-13 minutes. Cool and cut into 1" long strips. Return bicotti to pan.*
> *Bake at 350° for 13-14 minutes. Let cool and dry before serving.*

❧

Pistachio, Fig & Amaretti Biscotti

12 oz. butter
3 cups sugar
8 eggs
2 dozen dried figs, chopped
3 cups pistachios
1 dozen amaretti cookies, crumbled
1 tsp. cinnamon
1 tbs. Amaretti liqueur
> *Blend together.*

6 cups flour
3 cups whole wheat flour
2 tsp. vanilla extract
3 tsp. baking powder
> *Add in and mix well. Divide dough into 1 lb. parts. Shape into strips 12" long and 4" wide. Place strips in buttered pan.*
> *Bake 12-13 minutes at 350°. Cool and cut into 1" long strips. Return biscotti to pan.*
> *Bake at 350° for 13-14 minutes. Let cool and dry before serving.*

Chocolate Chip & Almond Raisin Biscotti

12 oz. butter
3 cups sugar
> *Cream together.*

8 eggs
1 tsp. nutmeg
1 tsp. vanilla extract
3 tsp. baking powder
2-1/2 cups almonds
2-1/2 cups raisins
2-1/2 cups chocolate chips
1 tsp. almond extract
9 cups flour
> *Add in and mix well. Divide dough into 1 lb. parts. Shape into strips 12" long and 4" wide. Place strips in buttered pan.*
>
> *Bake at 350° for 12-13 minutes. Cool and cut into 1" long strips. Return bicotti to pan.*
>
> *Bake at 350° for 13-14 minutes. Let cool and dry before serving.*

Kahlua White Chocolate Biscotti

12 oz. butter
3 cups sugar
> *Cream together.*

8 eggs
9 cups flour
1 tsp. cinnamon
1 tsp. vanilla extract
2 tsp. baking powder
1 cup melted white chocolate
1/2 cup coffee
1 tsp. nutmeg
1/8 cup Kahlua
> *Add in and mix well. Divide dough into 1 lb. parts. Shape into strips 12" long and 4" wide. Place strips in buttered pan.*
>
> *Bake 12-13 minutes at 350°. Cool and cut into 1" long strips. Return biscotti to pan.*
>
> *Bake at 350° for 13-14 minutes. Let cool and dry before serving.*

Pinenut Raisin Biscotti

12 oz. butter
3 cups sugar
>*Cream together.*

8 eggs
7 cups flour
2 cups whole wheat flour
1 tsp. vanilla extract
1/2 tsp. cinnamon
3 tsp. baking powder
3 cups pinenuts
3 cups raisins
>*Add in and mix well. Divide dough into 1 lb. parts. Shape into strips 12" long and 4" wide. Place strips in buttered pan. Bake at 350° for 12-13 minutes. Cool and cut into 1" long strips. Return biscotti to pan.*
>*Bake at 350° for 13-14 minutes. Let cool and dry before serving.*

~❧~

Coconut Rum Biscotti

12 oz. butter
3 cups sugar
>*Cream together.*

8 eggs
5 cups pecans
5 cups toasted coconut
9 cups flour
1/4 cup dark rum
1 tsp. nutmeg
1 tsp. vanilla extract
3 tsp. baking powder
>*Add in and mix well. Divide dough into 1 lb. parts. Shape into strips 12" long and 4" wide. Place strips in buttered pan.*
>*Bake 12-13 minutes at 350°. Cool and cut into 1" long strips. Return biscotti to pan.*
>*Bake at 350° for 13-14 minutes. Let cool and dry before serving.*

~❧~

Political unrest in Cuba in 1895 made it impossible for the merchants to raise cash for imported consignment. Having had a difficult time getting paid for his flour, Franklin Baker, a miller of Philadelphia, accepted a cargo of fresh coconut instead of cash.

Baker was unable to sell the coconut so he bought machinery and developed a method of producing shredded coconut meat of uniform quality.

The coconut business proved so successful that Baker sold his flour mill and established the Franklin Baker Co.

~❧~

Biscotti Glyfadas

1 cup butter
2-1/2 cups vegetable oil
1-1/2 cups sugar
 Mix well.

10 eggs
4 tsp. vanilla extract
2 tsp. ground anise
1 tsp. ground cloves
 Add in and mix just to incorporate.

9 cups flour
1 cup whole wheat flour
4 tsp. baking powder
1/2 tsp. salt
 Add in and mix well. Divide dough into 1 lb. parts. Shape into strips 12" long and 4" wide. Place strips in lightly buttered pan.
 Bake at 350° for 15 minutes. Remove biscotti from the pan and let cool. Cut the biscottis approximately 1/2" thick.
 Return biscotti to the pan and bake again at 350° for approximately 15 minutes, until dry and golden.

❦

Caramel *is sugar cooked with water until it turns light brown. Use 1-1/2 cups sugar and 2/3 cup water. Place in a saucepan over medium heat. Shake pan in a circular motion until the sugar boils and turns light brown. It takes about 4 minutes. Use immediately. This will make about 1 cup.*

❦

❦

Over the summer of 1993, I took a much-needed month long vacation in the Grecian Islands. Greece had never seemed so beautiful before. Santorini was breathtaking; the green isle of Thassos was peaceful; and Macedonia's scenery and people made me wonder why I would live anywhere else. Traveling through my birthland of Korinthia brought back happy memories of my childhood, the vineyards, the beautiful sea. It was all as perfect as I remembered.

While in Athens, I stayed with my sister Sofia and her husband, Stavros, who were my faithful sightseeing companions that month. One morning I went with Stavros to the post office in Glyfada to fax a letter to Phoenix. We stopped in at a little bakery nearby and purchased a half kilogram of biscottis for our trip the next day. Needless to say, there was not a crumb remaining the next morning. Of course, not satisfied simply to savor the delicious treats, I had to duplicate the recipes. Above is my version.

Different Variations

Use your imagination to create your own biscotti recipe by using the basic ingredients; butter, sugar, eggs, flour, baking powder and vanilla extract.

Let biscottis dry out for a couple of days, then store them in a container with a tight lid. If you like your biscottis to be softer, keep them refrigerated. Biscottis stay good for several days.

If you do not like your biscottis to be be hard and you like them crumbly, follow the same recipe except use half the butter and substitute the other half with vegetable oil.

Baking time of biscottis will vary depending on the oven used. Biscottis are done when lightly browned.

❦

Chocolate Dipped Biscottis

I like to dip one side of the cherry almond biscotti with dark chocolate icing or one side of pistachio biscotti with white icing or both sides of the hazelnut biscotti one with dark icing and the other with white icing. But don't stop there use your imagination and dip any of the biscottis with your icing of choice.

**Nick is part of the local landscape.
You've got your mountains,
your plateaus, your saguaros –
and then you've got Nick.**

New Times, 1998

❧

After a few months of loyal customers and numerous re-arrangements of the tiny restaurant on McDowell Road, the dry case was replaced with a long refrigerated case that separated the kitchen and the dining room.

In that case, over the next few years, would reside cakes and pies that our customers would grow to love ... perhaps addiction played a key role. That dessert case earned the nickname "Torture Case."

As with any cheesecake, there are two things critical to good results. First, you must cream the cream cheese and sugar well (about 8-9 minutes) to avoid a crumbly cake. Second, exact baking times are crucial. Some like to overbake cheesecakes. I like to slightly underbake them, and let them sit longer in the refrigerator. That makes the cake smooth and creamy, rather than hard and crumbly.

For a cheesecake that calls for baked topping, place a second springform pan on top of the one that the cake is baked in, then spread the topping on the cheesecake. Return to oven and turn it off. This will prevent the topping from running over the cheesecake and will give it a nice and even form.

Crust Recipe for Cheesecakes

1 cup grated walnuts
1 cup rolled oats
1 cup graham cracker crumbs
1/2 cup sugar
1/2 cup melted butter
> *Mix well.*
> *Butter a 10" springform pan and press the sides and the bottom of the form with the mixture.*
> *If you have to leave out the walnuts, add 1/2 cup of rolled oats and 1/2 cup of crunchy cracker crumbs.*

<p style="text-align:center">❧❧</p>

Peanut Butter Cheesecake

One cheesecake crust.

Filling
1 lb. cream cheese
1-1/2 cups sugar
> *Cream together well.*
1 cup creamy peanut butter.
> *Add in and mix well.*
5 eggs
1 cup sour cream
Juice of 1/2 lemon
> *Add in and mix well.*
1 cup chocolate chips
> *Add in and mix gently.*

Topping
3/4 cup chocolate chips, melted
1 cup sour cream
1/2 cup sugar
> *Blend well.*
> *Line a buttered 10" springform pan with crust and pour in filling. Bake in a 350° preheated oven for one hour. Turn oven off and remove cake. Spread topping and return cake to oven for 30 minutes longer. Refrigerate 6 to 8 hours before removing from pan.*

New York Cherry Cheesecake

One cheesecake crust

Filling
1-1/2 lbs. cream cheese
1-1/2 cups sugar
Cream well with an electric mixer.

6 eggs
2 cups sour cream
Juice of 1/2 lemon
2 tbs. cornstarch
1 tsp. vanilla extract
Add in and mix well.

Pour filling into pan and bake in a preheated 350° oven for one hour. Turn off oven and leave cake in for 30 minutes. Exact baking time is very important. Remove cake from the oven and cover with a pie pan. Refrigerate for 8 hours. Remove cake from pan and cover with topping.

Topping
8 oz. cherry pie filling (canned)
4 oz. dark cherries (canned)
Juice of 1/2 lemon
1 tsp. orange peel, grated
Mix well.

❧

Vanilla – unknown to most of the world until the 16th Century. The delicious aroma of vanilla develops as if it is a miracle of nature.

At first the thin white flowers, which come from a climbing tropical plant, are scentless. It was after the long thin pods fell to the ground and fermented that people noticed that they developed a delicious aroma. The pods were used to give flavor to the drink of cocoa by the Aztecs. Vanilla trees are found in Central America and Northern Africa.

There are several kinds of vanilla plants in the tropical forests of Central America. Growing vanilla away from Central America seemed impossible. The bees of the forest which provided the honey for the Aztecs, also by an idiosyncratic and skillful act of nature, fertilized the vanilla by entering the flower part through its thin skin.

In the 1830s, a technique of artificial pollination was perfected in Paris. A vanilla cutting from those plants became the ancestor of the vanilla plants in Madagascar, Comoros Islands and Tahiti.

❧

In 1861, Philadelphia's D. Basett Co, was founded to produce cream cheese and ice cream.

Red Berry Cheesecake

One cheesecake crust.

Filling

1-1/2 lb. cream cheese
1 cup sugar
Cream together well.
4 eggs
Juice of 1/2 lemon
1/2 tsp. vanilla extract
1 cup whipping cream
1 cup sour cream
1 lb. white chocolate, melted
1/2 cup raspberries
1/2 cup boysenberries
1 tsp. Chambourd
1 tsp. boysenberry liqueur
Mix in well. Line a buttered 10" springform pan with crust. Pour in filling. Bake at 350° for one hour.

Topping

3/4 cup white chocolate, melted
1 cup sour cream
1/2 cup sugar
1/8 cup boysenberries
1/8 cup raspberries
1 tsp. Chambourd
1 tsp. boysenberry liqueur
Mix well. Remove cake from oven and spread with topping. Place cake back in oven and turn oven off. Leave the cake in for 30 minutes longer. Refrigerate 12-14 hours before removing from pan.

❧

Sugar: the "sweet calamus" of the Bible was brought to the Mediterranean by the merchants of the caravans.

Sugar cane is a native of India, even though the Chinese claim to have been the first to make cane sugar. Many medical authors of antiquity mentioned this "indian salt." Dioscorides, a Greek naturalist of the 3rd Century B.C. claims that there was a solid honey called "saccharon" which is found in India. It resembles salt and crunches in the mouth. In the 17th Century, the demand for sugar made sugar cane a precious commodity because of the popularity of coffee, tea and cocoa. In the 18th century, the sugar beet was discovered as an alternative source. Beet sugar is identical to the sugar cane.

Today, sugar is obtained from both sugar beets and sugar cane.

❧

"Best Cheesecakes"

New Times 1994

White Chocolate Cheesecake

One cheesecake crust.

Filling
1-1/2 lb. cream cheese
1 cup sugar
> *Cream together.*

4 eggs
Juice of 1/2 lemon
1/2 tsp. vanilla extract
1 cup whipping cream
1 cup sour cream
1 lb. white chocolate, melted
1/2 cup pistachios, finely chopped
1 tsp. Cointreau liqueur
> *Add in and mix well. Pour in 10" springform pan lined with the crust.*

Topping
3/4 cup white chocolate, melted
1 cup sour cream
1/2 cup sugar
1/2 cup hazelnut, finely chopped
1 tsp. Frangelico liqueur
> *Mix well.*

Remove cake from oven and spread with topping. Place cake back in oven and turn oven off. Leave the cake in for 30 minutes longer. Refrigerate 12-14 hours before removing from pan.

Kiwi White Chocolate Cheesecake

One cheesecake crust
> *Spread along bottom and sides of a 10" springform pan.*

Filling
1-1/2 lb. cream cheese
1 cup sugar
> *Cream together.*

4 eggs
1 cup sour cream
Juice of 1/2 lemon
4 kiwis, peeled and cut into small pieces
1 tsp. vanilla
1 lb. white chocolate, melted
1 cup whipping cream
1 tsp. rum
> *Blend well.*

Topping
3/4 cup white chocolate, melted
1 cup sour cream
1/2 cup sugar
2 peaches, cleaned and chopped
1/8 cup coffee
> *Blend well.*

Pour filling over crust in a 10" springform pan and bake at 350° for one hour. Remove from oven. Spread topping over cake and return cake to oven. Turn oven off and let sit for 30 minutes. Refrigerate 12-14 hours.

Chocolate Truffle Cheesecake

One cheesecake crust with only 1/4 cup graham cracker crumbs; plus 1 cup crumbled chocolate wafer cookies added.

Filling

2 lbs. cream cheese
1-1/2 cup sugar
Cream together well.
5 eggs
1/4 cup whipping cream
1 tbs. corn starch
1 lb. milk chocolate, melted
Add in and mix well. Pour into crust and bake at 350° for one hour.

Topping

1 cup milk chocolate, melted
1 cup sour cream
1/2 cup sugar
Blend well.

Remove cake from oven and spread with topping. Return to oven and turn oven off. Let cake sit for 30 minutes longer. Refrigerate 12-14 hours before removing from pan.

Spearmint Cheesecake

One cheesecake crust with only 1/4 cup graham cracker crumbs; plus 1 cup crumbled chocolate wafer cookies added.

Filling

2 lbs. cream cheese
1-1/2 cups sugar
Cream well.
5 eggs
1/4 cup whipping cream
1 tbs. cornstarch
1/2 lb. chocolate chips, melted
1/2 lb. mint chocolate chips, melted
 (if not available, increase the chocolate chips to 1 cup and the mint extract to 1 tsp.)
1/2 tsp. mint extract
1 tbs. green Creme de Menthe
Add in, blend well.

Topping

1/2 cup mint chips
1/2 cup chocolate chips
1 cup sour cream
1/2 cup sugar
1 tbs. Creme de Menthe
Blend well.
Line a buttered 10" springform pan with crust and bake at 350° for one hour. Spread topping on cake. Turn oven off and let cake sit in the oven for 30 minutes. Refrigerate 10-12 hours before serving.

Pumpkin White Chocolate Cheesecake

The following recipe was so popular that our guests called one month before Thanksgiving and Christmas to order a cake for their family table at home. The holidays were the only time we made this cheesecake, but its popularity forced us to keep it in the display case on a daily basis.

One cheesecake crust.

Filling
1 lb. cream cheese
1 cup sugar
 Cream together well.
4 eggs
Juice of 1/2 lemon
1 tsp. vanilla extract
1 cup pumpkin puree
1 lb. white chocolate, melted
1/2 cup sour cream
1/2 cup whipping cream
 Add in and mix well. Pour into crust.

Topping
3/4 cup white chocolate, melted
3/4 cup sour cream
1/2 cup sugar
1/2 cup pumpkin puree
 Mix well. Line a buttered 10" springform pan with crust. Bake at 350° for one hour. Remove cake from oven and spread with topping. Place the cake back in the oven and turn oven off. Leave the cake in for 30 minutes longer. Refrigerate 12-14 hours before removing from pan. With a pastry bag, make rossettes of whipped cream around the top edges of the cake. Sprinkle chocolate vermicelli on top of whipped cream.

Cinnamon
This extraordinary spice with its delicate fragrance and semisweet taste traces far back in ancient China. It was also used by the Romans and Greeks.
 Cinnamon comes from a small tree. The spice is peeled away from the outer part of the branches leaving the inner to be cinnamon sticks. Then the outer part is ground or used whole. Cinnamon is a must in the kitchen for desserts and it is a perfect marriage with honey.

Nutmeg
This evergreen tree, native of Southeast Asian Islands, carries a fruit with the seed that bears two separate flavors. When the fruit is split open the nut inside is covered with a thin-laced skin. That skin is red-colored and is where mace comes from. The inside seed is where nutmeg is produced. In the old days nutmeg was so precious it was shipped in special containers of silver.
 Nutmeg is used in breads, fruits, custards, cakes and eggnog. It has a warm performed flavor and is friendly to strong foods not only for its flavoring but also for its digestive properties.

Now, in my new restaurant, "Café Nikos", I had room in my dessert case for one more cheesecake. Not that long ago, a lady celebrating her birthday asked me for a glass of champagne with strawberries, and I said . . . "Why not?!"

Poppyseed

Poppyseed is a plant with pink and white flowers. Its seeds are crunchy with a nutty flavor. The ripe seeds are used widely for baking and cooking. Many countries prohibit cultivation of the opium poppy without a permit.

The medical derivations come from the unripe seed pods and the alkaloids in the sap (opium, morphine, codeine). The ripe poppy seed head has an outer casing which holds several chambers holding hundreds of poppy seeds.

Sesame Seeds

Sesame seeds come from tall growing plants with deeply veined leaves and white flowers. The seeds burst out from their capsules when they are ripe. Because of their tendency to scatter, sesame seeds are harvested while still green. Sesame seeds have a nutty flavor and contain 50% oil.

Strawberry Champagne Cheesecake

One cheesecake crust.

Filling
1-1/2 lb. cream cheese
1 cup sugar
> *Cream together well.*

4 eggs
2 cups sour cream
Juice of 1/2 lemon
1 tbs. cornstarch
1 tsp. vanilla extract
1/2 lb. white chocolate, melted
1/8 cup champagne
> *Add in, mix well, remove bowl from mixer.*

2 cups strawberries

> *Cut strawberries into large pieces, mix in with filling by hand. Line a 10" buttered springform pan with crust. Pour in pan and bake in a 350° oven for 1 hour. Turn oven off. Leave cheesecake in oven for 30 more minutes. Remove and refrigerate overnight.*

Topping
2 cups strawberries, cut in half
1/2 cup strawberry jam
Juice of 1/4 lemon
1 tsp. lemon peel
1 tsp. orange peel
> *Mix by hand, arrange on top of cheesecake.*

1/4 cup white chocolate, melted
> *Use a serving spoon with holes to sprinkle lines on top of strawberries.*

*A*t first strawberries were grown wild, mainly in the woods. This deliciously scented wild wonder drove people in the outskirts of the woods of temperate climates to pick them. Once the aromatic seductive scent was infused into man's senses it was impossible to resist the calling of the siren. And back to the woods they went to find the wild beauty. It was after the 15th Century that strawberries were cultivated. At first the cultivation was not widely practiced. The reason was that the surface that the strawberry occupied permanently produced only a crop one month a year. The strawberry also exhausts the soil, strawberry beds must be moved to a new site every three or four years. The plant was cultivated in medieval times when runners of wood strawberries were transplanted to their gardens. Because of its aroma, the strawberries had a reputation of love potion. After all, strawberry was as delicious as its aroma.

Today the so called "wood" strawberries are seen occasionally in the market, although they never had seen a woodland. They are high priced even though they are cultivated in polythene tunnels. They are much bigger than the wild strawberries and they have lost most of that wonderful perfume.

The real thing lays in the depths of what woods are left. Strawberries will grow in almost every soil, but it crops best in soils with clay and siliceous elements. It also likes acid soils and temperate climates. Spring frost will damage strawberry blossoms. The plant is prone to disease and the fruit is extremely fragile. Humidity, drought and slugs are strawberry's mortal enemies. Today, Italy is the biggest strawberry growing country with France second. Strawberry consumption is greater in Europe than anywhere else in the world. Europeans love their strawberries and they have self-picked strawberry farms everywhere.

Strawberries are manufactured into many favorite products; ice cream, jams, syrups, cakes, pies, sorbets. The freezing of the strawberry is now widely practiced. The freezing guarantees that the strawberry will keep, but it is not entirely a successful process. The delicate fruit turns into a soggy mess after it is defrosted, besides, there is not much flavor left in the fruit. Frozen strawberries are worthless, unless you want to use them in a smoothie or another frozen drink. They becomes a disaster in a salad, or cake especially in a cheesecake or a pie. Strawberries contain a large amount of water and that seeps out when they are defrosted.

An idiosyncractic recipe of a strawberry mango pie with banana topping is included in this cookbook. It is a must recipe to try. The triangle of the three fruits creates the Bermuda Triangle for the senses.

Strawberry and champagne is another erotic combination and it comes alive in my Strawberry Champagne Cheesecake, a creation that your guests will be buzzing for satisfaction, the same way our ancestors buzzed into the woods for the wild beauty.

Strawberry
Siren of
Sensuality

Coffee

Coffee originally grew in Ethiopia and in the kingdom of Yemen in the Aden and Moka areas. Records show coffee cultivation there as early as the 6th Century. By the 14th Century, coffee roasting and grinding spread throughout the Arab world.

By the 17th Century, coffee was spreading throughout Europe. First it was brought to London, then to Paris and Vienna.

In the 18th Century, Marseilles was the gateway to the Orient. The merchants of Marseilles had trading stations at all main Mediterranean ports. Marseilles was the only port that coffee would pass through and you needed connections to get coffee supplies back then. Everyone wanted it but very few could get it.

The first true coffee plant was in Brazil in the early 17th Century. Today, Brazil is the main coffee supplier to the world and it accounts for half of the revenue of Brazil.

Early in the 19th Century, a young man on the island of Crete had an idea to take this drink with its irresistible aroma from door to door and sell it by the cup. People who couldn't resist the aroma of the coffee pot waited daily for the young man to appear. The sale of coffee from door to door was adopted by others and became very popular in other parts of the world. In those years, coffee was expensive and difficult to find.

Shortly after this, coffee houses started to open rapidly all over Europe and became the favorite meeting places for politicians and artists. It was the place to argue about politics and intellectualize life.

After harvesting, the fruits are called "berries". They ripen over a period of about 8 months and they are of a deep red color. There are two beans inside the fruit. After the beans are separated they are dried, usually under the sun. Later, a wet method was developed when the cherries are soaked and fermented then washed and dried and finally the skin is removed. In this stage, the beans are of a green color, sorted out to qualities and shipped to exporters.

Roasting is done usually by the country of import. The roasting process reduces the acidity of the bean and develops the aromatic oils. Decaffeinated coffee is produced after the caffeine is removed by soaking the beans in water or by using carbon dioxide.

The soil and the climate are both factors in shaping the taste of the coffee bean. The flavor and quality of coffee varies tremendously from the coffee plants around the world. Coffee that grows on steep mountain slopes at high altitudes is rich in aroma and strong in flavor. Coffee that grows on lower slopes has a flavor that is not as smooth and its earthy flavor lacks delicacy. It contains more caffeine and is less expensive because it is easier to cultivate.

Brazilian coffee is usually medium roasted with a full body flavor and mellow taste. Colombian is usually dark roasted with a nutty and good balance of flavor. Costa Rican is an elegantly flavored coffee and very popular for breakfast. Guatemalan has a smoky, spicy character and when it is medium roasted, brings out a full body and pleasant flavor. Kenyan has a classic sharp taste with a clean aromatic taste. Ethiopian coffee has a rich complex flavor with an excellent aroma and good balance.

Indonesian coffee has a heavy but smooth flavor with a slightly smoky taste and a hint of chocolate flavor. Jamaican is a smooth gentle coffee with a nutty flavor. Hawaiian coffee is one of the world's finest and rarest coffees. It is full flavored, rich and earthy when medium roasted. Mexican is a good quality coffee with rich flavor and fine taste. Indian coffee has a delicate and smooth aroma and a soft flavor. Nicaraguan is mild and smooth tasting. Tarzanian is a strong and distinctive flavor.

These are the general characteristics of coffee, but the flavor can be different among the region they are produced.

Tea

The Chinese regarded tea as "the drink of immortality" since the 1st Century B.C. By the 6th Century, tea drinking became a ritual in China, involving intellectual discipline, politics, poetry and philosophy. By the 9th Century, tea drinking had spread to Japan and its brewing became a ceremony there as well.

Tea houses became places of cultural gatherings first in China and then in Japan, just like coffee houses were in Europe later. Even though tea drinking started in England in the 16th Century with the first tea house opening there in the 1640s, tea did not become popular in Europe until the end of the 18th Century.

Tea now is widely cultivated in India, Africa, China and Japan. Tea is classified as "black" or "green" depending on whether they have been fermented or not, even though the tea leaves have a brown look.

Green teas come almost exclusively from China and Japan. Chinese teas are so good that they need no sugar, lemon or milk. Some of those teas include: Yunnan - a full bodied tea with the aroma of chocolate; Pekoe - whose leaves are picked at a young age; Earl Grey - which is considered the aristocrat of teas.

Indian teas are regarded by most as the best teas today with Darjeeling being the champagne of teas. It has a honeyed fruit after taste.

Today there are hundreds of flavored teas perfumed with mint, jasmine, orange, rose and many more flavors. Tea is grown like coffee, in the shade of tall trees. Altitude, soil and climate all have an effect in the quality and the flavor of tea.

New York's tea and coffee wholesaler Thomas Sullivan who operated a small retail shop in the city's spice district, sent samples of various tea blends to his customers in small hand sewn muslin bags. The year was 1908. Sullivan used the bags instead of the small metal cans generally used for economical reasons. His customers discovered that they could brew tea simply by pouring boiling water over a tea bag in a cup, and began to place hundreds of orders for Sullivan's tea bags which would soon be packed by a machine designed specifically for this purpose.

Dessert is poetry of high expectations. It is the lyrical point of the meal. It's addictive taste is used by mothers all over the world to bribe their children to obey.

At a dinner party every guest wonders through the courses of food with anticipation if there is a dessert at the end. Dessert is a function of pure gratification. I've seen it in my restaurant hundreds of times. "We are on a diet," the guests would say. But after eating a vegetable salad with a low calorie dressing, they would approach the dessert cases to their moment of intense pleasure, never mind the concentration of calories. This is a prize earned for themselves.

"This is the last piece of dessert I'll eat for a long time," I heard them say, but next time sitting in front of the dessert case they forgot their promise. Eating a rich dessert gives a sinful pleasure, but later on brings despair. The next time we want to have dessert we must decide between the feeling of satisfaction for the addictive taste or the joy of victory for overcoming the temptation. Frequently, the satisfaction overcomes the joy.

Baking is a form of love, it feeds people to their senses. Baking is about imagination and energy, energy that wraps sensually the senses. It can not be life without dessert. Baking is a gesture of love towards the person to whom you are baking for. Dessert arouses the senses, it is a seduction of the moment, a moment that awakens the instinct of reproduction.

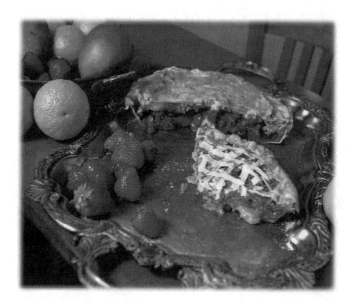

A larger-than-life force of nature known as Nick Ligidakis, he is a restauranteur legend in the Valley.

New Times, 1997

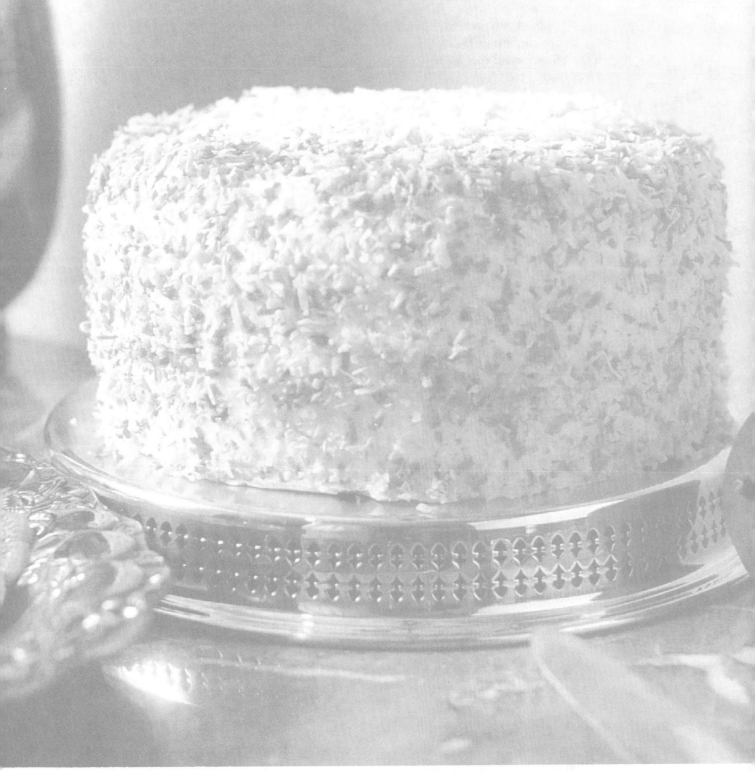

Chocolate Cake

This recipe makes one 10" round cake, one 8" square or an 11"x17" or 12"x16"

4 oz. butter
1 cup sugar
> *Beat in a mixer until creamy.*

2 eggs
> *Add in, one at a time.*

1 tsp. vanilla
> *Add in, mix well.*

1-1/2 cups all purpose flour
6 tbs. unsweetened cocoa
1 tsp. baking soda
> *Run ingredients thru a shifter, place in a bowl.*

1 cup of very hot water
> *Add to the dry ingredients and mix, add flour mixture into the mixer, mix gently.*

2 oz. semisweet chocolate, melted
> *Add in, mix well.*
> *Pour the cake mixture into a 10" springform pan that has been well buttered. Bake in a 350° preheated oven for 45-50 minutes.*

Sponge Cake

This recipe makes one 10" round cake, one 8" square or an 11"x17" or 12"x16"

1/4 cup milk
2 tbs. unsalted butter
> *Heat in a saucepan until butter is melted, remove from heat.*

1 tsp. baking powder
3/4 cup flour
> *Sift together, place in a bowl.*

3/4 cup sugar
3 large eggs
3 egg yolks
> *Whisk in a bowl, over soft boiling water, then beat in an electric mixer on high speed until the mixture is thick. Remove from mixer, fold in flour, by hand, a little at a time. Pour in the hot milk / butter mixture. Bake in a preheated oven of 350° for 25-30 minutes.*

For a buttermilk cake, substitute the milk for buttermilk.

Dark Sponge Cake

3/4 cup sugar
5 large eggs
2 egg yolks
> *Whisk in a bowl over soft boiling water, then beat in an electric mixer on high speed until mixture is thick, remove from mixer.*

1 cup flour
1/4 cup unsweetened cocoa powder
> *Sift together, fold into the eggs by hand, a little at a time.*

3 tbs. warm milk
3 tbs. vegetable oil
1/2 tsp. vanilla extract
> *Pour into the mixture, mix well. Bake in a preheated oven of 350°. Bake 25-30 minutes.*

❦

In 1949, Pillsbury & General Mills introduced prepared cake mixes initially in chocolate, gold and white angel food cake with other flavors to be added at a later date.

❦

❦

Genoise

4 tbs. butter, melted and clarified, set aside
> (It will give you 3 tbs. of clarified butter)

1 cup sifted cake flour
1/3 tbs. sugar
> *Mix cake flour and sugar in a bowl.*

4 eggs
1/3 cup sugar
> *Whisk in a bowl over gently boiling hot water. Remove into a electic mixer and beat on high speed until thickened. Fold in the flour, mix by hand, fold in the butter and mix gently but mixed well. Bake in a 350° preheated oven for about 20-25 minutes.*

Makes 1 cake

❦

This Genoise is a classic plain butter sponge cake. It's open grain texture makes it perfect for moistening with sauces and filling it with various fillings.

❦

If my cake recipe calls for a sponge cake, don't hesitate to substitute a buttermilk cake or a citrus cake or a genoise, and if it calls for a chocolate cake, dare to use a dark sponge cake or a chocolate genoise.

Chocolate Genoise

4 tbs. butter, melted and clarified, set aside (This will give you 3 tbs. clarified butter)

3/4 cup cake flour
1/3 cup unsweetened cocoa powder
Sift together, place in a bowl.
4 eggs
2/3 cup sugar

> For coffee flavored Genoise, substitute the cocoa with instant coffee.

Wisk in a bowl over gently boiling hot water. Remove into an electric mixer and beat on high speed until thickened. Fold in the flour/cocoa mixture by hand.
1 tsp. vanilla extract
Fold in together with butter, mix well. Bake in a 350° preheated oven for 20-25 minutes.

Buttermilk Spiced Cake

1 lb. butter
1-1/2 cups sugar
Cream together.
4 egg yolks
2 eggs
Add in, mix well.
1 tsp. vanilla
1 tsp. almond extract
2 cups buttermilk
1/2 tsp. baking soda
1 tsp. cinnamon
1 tsp. ground cloves
2 cups flour
Add in, mix well. Pour in a 10" springform pan, baked in a preheated 325° oven for about 35-40 minutes.

Citrus Cake

1/4 cup margarine
1/4 cup butter
3/4 cup sugar
Cream together.
2 egg yolks
2 eggs
Add in, mix well.
1 tsp. lemon peel
1 cup flour
Juice of 1/2 lemon
1/4 cup milk
1 tsp. baking powder
Add in, mix well. Pour in a 10" springform pan, baked in a preheated 350° oven for about 35-40 minutes.

Simple Syrup

2 cups water
1/4 cup sugar

Bring to a boil. Reduce heat. Simmer 5-6 minutes.

Use your imagination to flavor this simple syrup and turn it into a fruit or liqueur syrup to flavor your desserts by brushing on top of cake.

In this book, you will find syrup flavorings of rum, grand marnier, coffee, raspberry, boysenberry. Simply add the liqueur or the juice of the fruit into the syrup 1-2 minutes before removing from heat.

Use between 2 to 5 tbs. of flavoring in the syrup, according to the strength of the liquor or juice.

❦

Many dessert recipes call for egg whites beaten stiff. The success of the recipe depends on how stiff you have beaten the eggs and how carefully you fold them into the other ingredients. Use the wire whip of your mixer. Unlike whipping cream, the egg white needs a warm bowl and whip. Egg whites are also stiffened by the air incorporated by beating them. Egg whites may be folded into either hot or cold ingredients. For more stiffness add a little powdered sugar toward the end of the beating time.

Beating egg yolks with sugar to pale yellow, add the sugar gradually into the bowl. The mixture will turn pale yellow and will be thickened enough so when a bit of it is lifted it will fall back into the bowl forming a ribbon on the surface. Do not overbeat.

❦

Whipped cream should be light and smooth and be doubled in volume. Make sure the whipping cream is chilled as is the bowl and the wire whip. Use your electric mixer on a medium-high speed. The cream is whipped by incorporating as much air as possible by beating it. Do not fold whipping cream with hot ingredients because it will be thinned out and if you fold it into hot chocolate, it will be full of granules. Always fold the whipping cream into cold or room temperature ingredients.

❦

Assemble all your cakes in a springform pan, most of the fillings need to set for a while before you spread the icing on the cake. Refrigerate it until fillings are set. It will then be easier to ice the cake.

A s the months went by, the small place on McDowell Road became a Nirvana for dessert-seekers. Its 40 seats were exhausted as customers returned again and again for our cooking. Many asked for a chocolate dessert, a decadence that was already brewing in my head. This creation was, and still is, a favorite of many. I will never forget that one Friday night when two customers fought for the last piece. It was, almost, a fight to the death ... Sweet Chocolate Death.

Sweet Chocolate Death

Chocolate Meringue

4 egg whites
3/4 cup sugar
Pinch of cream of tartar

Flush your mixing bowl with very warm water. Eggs must be at room temperature. Mix ingredients at high speed until eggs are stiff, about 10 minutes.

2 tsp. unsweetened cocoa

Add in, mix gently. Line the bottom of the springform pan with aluminum foil. Butter the the rest of the pan and spread mixture on the bottom of the form. Bake at 175° for approximately two hours or until meringue is hard. Turn off oven and let meringue set inside for a few more hours or leave in overnight. Before assembling the cake, remove foil from the bottom of the meringue and place meringue back in the springform pan.

Chocolate Icing

12 oz. milk chocolate, melted
1-2/3 cup whipping cream, heated

Pour hot cream into the bowl with the chocolate chips and mix well. Pour half of the icing on top of meringue. The rest of the icing will be used to ice the cake. Set aside.

One Chocolate Cake

Cut into three horizontal slices. Place one of the slices on top of the meringue.

Chocolate Mousse

8 egg whites
1/2 cup sugar

Beat well in a mixer for about five minutes.

1-1/4 lbs. of semisweet chocolate, melted

Add in, mix gently.

6 egg yolks

Add in, one at a time and mix well. Pour half of the mousse on top of the cake, lay another slice of cake on top, pour the rest of the mousse on the cake and cover with the remaining slice of cake. Refrigerate until mousse is set. Remove cake from the springform pan and ice it with the remaining icing (if icing is too liquidy, refrigerate for a while).

2 cups of natural sliced almonds

Cover the sides and top of the cake.

Back Alley Cake

Crust:
1/2 cup grated walnuts
1/2 cup oats
1/2 cup graham cracker crumbs
1/4 cup sugar
1/2 cup melted butter
Blend and spread on the bottom only of a 10"
springform pan.

Dark Chocolate Blend
1-1/2 lb. semisweet chocolate
1/2 lb. butter
Melt together.
1/2 cup sugar
8 eggs
Blend with chocolate.
Divide into three parts, place
each part in a separate bowl.
Set aside.

White Chocolate Blend
1-1/2 lb. white chocolate
1/2 lb. butter
Melt together.
1/2 cup sugar
4 eggs
Blend with
chocolate. Divide into
three parts, place each
part aside in bowls.

20 sheets of fillo, cut into 10" rounds, covered with a towel.

To one part dark chocolate blend, add:
1/2 cup boysenberries
1 tbs. bosenberry brandy
Mix well and spread in pan. Layer with four
rounds of fillo, buttering each one with a brush.

To one part white chocolate blend, add:
1/8 lb. cream cheese
1 tbs. sugar
1 tsp. Kahlua
1 tbs. coffee
Cream together. Mix well and spread in pan. Top
with four rounds of buttered fillo.

To one part dark chocolate blend, add:
1/2 cup raspberries
1 tbs. Chambourd
Mix well and spread in pan. Top with four rounds
of buttered fillo.

To one part white chocolate blend, add:
1/8 lb. cream cheese
1 tbs. sugar
Cream together.
1 tbs. whipping cream
1 tbs. orange juice
1/2 cup apricots
Mix well and spread in pan. Top with four
rounds of buttered fillo. *continued next page*

When I closed the restaurant on Thomas Road to open my new one on Indian School Road, there was a period of about two months during which I had no kitchen of my own to work in and I was concerned about my wholesale business.

I continued my work in the back of a restaurant that belonged to one of my students.

The hallway of EuroCafe in Mesa, AZ. was approximately 50 feet long and very narrow. There I snuggled my bakery equipment against the walls. I baked at night, so as not to interfere with their daily business. Every night was a challenge to finish the baking before morning. The challenge inspired creativity. The hallway was dark and narrow, just like a back alley.

The following "Back Alley" cake came to my mind during my short stay in this long, dark hallway.

The ingredients used here are a compilation of many different things, just like one might find in a back alley.

To the remaining part of dark chocolate blend, add:

1/2 cup blackberries

1 tbs. blackberry brandy

> *Mix well and layer in pan, cover with four rounds of buttered fillo.*

To the remaining part of white chocolate blend, add:

1/8 lb. cream cheese

1 tbs. sugar

> *Cream together.*

1 tbs. sour cream

1 tbs. orange peel

1/2 tsp. cinnamon

1 tbs. whipping cream

1 tbs. Grand Marnier

1/2 tsp. cocoa

> *Mix well, layer on pan.*

> *Place cake pan in second pan filled with 1" water. Bake at 300° for one hour. Turn oven off and let cake sit for 1/2 hour. Refrigerate cake for at least 12-14 hours. Remove from pan.*

Icing

12 oz. milk chocolate, melted

1-2/3 cups whipping cream

> *Blend together well.*

> *Spread icing over entire cake. Decorate with dark chocolate shavngs along sides and white chocolate shavings on top.*

I know I will not have lived until I get a taste of Sweet Chocolate Death.

Mesa Tribune 1987

"This cake hardly has time to chill in the dessert case at my restaurant. It is a huge favorite of my customers and friends."

Cappuccino Mousse Cake

One 10" chocolate cake, baked. Trim to 3" thick and place in a springform pan.

Syrup
1 cup simple syrup
1/4 cup coffee
1 tbs. cocoa
 Mix well and brush cake with all of the syrup mixture, the cake should be soaked with the syrup.

Cappuccino Mousse
6 egg whites
1/2 cup sugar
 Mix well.
1 lb. semisweet chocolate, melted
 Fold in.
5 egg yolks
1/4 cup coffee
1 tsp. cocoa
3/4 cup grated hazelnuts
 Add in and mix well. Pour on top of cake, refrigerate until mousse sets, about one hour.

Orange Cinnamon Topping
1/4 lb. cream cheese
1 tbs. sugar
 Cream together.
2 eggs
1/4 cup whipping cream
 Add in and blend well.
1/8 cup sour cream
1 tsp. orange peel
1/2 tsp. cinnamon
1/2 lb. white chocolate, melted
1 tbs. Kahlua
 Add in and blend well.
 Spread toppng on mousse. Refigerate 2-3 hours. Remove from pan.

Icing
1/2 cup milk chocolate, melted
3/4 cup whipping cream
 Mix well and spread on side of cake. Sprinkle sides of cake with chocolate shavings and sprinkle top wth a mix of cinnamon and cocoa.

Now settled in the Indian School restaurant, new recipes kept storming my brain. It was causing problems, as I often had to drop my work and hurry out to peruse my dessert case.

I had rejected many new recipes when I had been too unsettled by the move to concentrate on them. Now, I knew I should have at least written them down. Well, I believe they will come back to me someday.

And thankfully I had kept this recipe intact, because it is a remarkable blend of flavors. Why is it called Rated X? Not only for its decadent taste, but because it contains so many different alcohols that I recommend keeping it away from minors.

Rated X Cake

10" chocolate cake, sliced into two horizontal slices
10" sponge cake, sliced into two horizontal slices

Syrup
1/8 cup simple syrup
1 tbs. champagne
Place one chocolate cake slice in a pan and brush with syrup.

Almond Mousse
4 egg whites
1/8 cup sugar
Beat well.
10 oz. melted semisweet chocolate
3 egg yolks
1/2 cup sliced almonds
Blend together and spread on cake. Top with sponge cake slice.

Banana Rum Mousse
10 oz. white chocolate, melted
2 eggs
1/8 cup sugar
1/2 banana, sliced
1 tsp. rum
Blend well and spread on cake. Top with one chocolate slice.

Syrup
1/16 cup simple syrup
1 tsp. Kahlua
1 tbs. coffee
Mix and brush over cake.

Grand Marnier Chocolate
8 oz. semisweet chocolate, melted
3/4 cup whipping cream, warmed
1 tbs. Grand Marnier
Mix well and spread over cake. Top with sponge cake slice.

Syrup

1/8 cup simple syrup
1 tbs. orange juice
1 tsp. Grand Marnier

Blend and brush over cake.

Arrange 12 Amaretti cookies in a circle around outer edge of cake, and another smaller inside circle of cookies.

Icing

12 oz. milk chocolate, melted
2 cups whipping cream

Blend well.

Spread icing over cake, including cookies and sides. Sprinkle with white chocolate shavings.

⚬⚬⚬

Cream cheese, curd cheese and cottage cheese are the drained curds eaten fresh. Cream cheese was widely used by pastry chefs in the classical period. Eventually it was made from full cream milk. Many recipes have survived from that era today. Among them are the Russian "Pashka", the English "Cheesecake", the Sicilian "Cassata".

Before milk could be stored in jars, shepards used containers to store and transport the precious liquid. Milk turned to curds in those containers until a press was discovered. This form was like a press which was screwed down to drain the curds. The curds were than molded in a wooden box (forma in Greek and Latin). The result is what we now regard as cheese.

The drained cream cheese (tyros by the ancient Greeks) sometimes was put in brine to become hard and be preserved. Until the 18th century a great deal of cheese was eaten in Europe. Then sweet desserts made with cheese became popular and the only kind of cheese considered elegant was the cream cheese which was sweetened and flavored with aromatic oils or orange flavored water. By the 19th century most Europeans believed that a dessert course with no cheese was unacceptable.

⚬⚬⚬

Cherries were pressed to extract their juice before the invasion of wine made from grapes.

The characteristics and dietitics of cherries are described in books of Greek historians as far as the 4th Century B.C. Cherries have a high potassium content and like all red fruits, they contain vitamins A, E and B and also possess sodium, magnesium and calcium.

There is a cherry diet that eliminates toxins from the body and cleanses the intestines. Cherries are very popular in desserts, especially with tarts and pie fillings. Cherries must remain on the tree until fully ripened.

In my cherry-berry pie, the sweet, soft cherries complement well the tart, crunchy cranberries.

In another of my unique pies, the apple absorbs the sweetness of the cherry and the two popular fruits unite into an unforgettable taste.

One of my customers asked me one day for a black forest cake. I smiled in amazement; people can still ask for something else after looking at the dozens of desserts in my cases. But, being a person who never turns down challenges, I created a similar concoction with my own special signature of complicated tastes: a dark cake with dark cherries and a Napoleon-like topping.

Black Market Cake

10" chocolate cake, trimmed to approximately 3" thick, place in a 10" springform pan

Syrup
1 cup simple syrup
1/8 cup dark cherry juice, extracted from 1/4 lb. of fresh cherries, or the liquid from
 canned cherries
8 oz. dark cherries (if fresh not available, use good quality canned ones)
 Mix well and pour over cake. Arrange cherries to evenly cover cake.

Pistachio Mousse
6 egg whites
1/3 cup sugar
 Blend well.
1 lb. semisweet chocolate, melted
5 egg yolks
3/4 cup pistachios
 Add in and mix gently. Spread over cake.
 Cut off from a puff pastry sheet, two 10" rounds of puff pastry dough, baked for 10-12 minutes. Place one round on top of mousse.

White Chocolate Vanilla Cream
2 cups whipping cream
1 tsp. vanilla
1 tbs. powdered sugar
 Beat until stiff.
3/4 lb. white chocolate, melted
1 tbs. Kahlua
 Add in and mix well.
 Spread all but one cup of cream on to cake, and top with remaining pastry. Refrigerate cake for two hours and remove from pan.

Dark Icing
12 oz. milk chocolate, melted
1-2/3 cups whipping cream
 Blend well. Spread icing all over cake. Top icing with remaining cream, and swirl with your fingers for a white and dark chocolate pattern.

Butter is made by beating cream until it thickens and separates. The nomadic people of Euro – Asiatic plains discovered butter unintentionally as they travelled to cold climates. The milk that was carried on horseback in leather flasks was churned into butter by the constant motion. Butter was popular with the Celts and then the Vikings who passed the taste to their descendants.

The majority of butter is made from cow's milk. The influence of the Vikings and Normands where butter consumption began is obvious. Butter spread from Normandy to Switzerland, Netherlands and later France around the 14th century. The countries of northern Europe with a tradition of farming prefer butter. The countries of southern Europe prefer olive oil instead. The population which settled in America had preferred to eat the fats of their customary diets of their countries of origin. The people of English speaking countries do not eat much oil. Hispanic speaking and Mediterranian people consume a great deal of oil. French speaking people prefer half and half. The trend towards skim milk has led to half - fat butter and butter substitutes.

❧

Honey is made from the nectar of flowers. In the classical times, domesticated housekeeping was widespread. Since the bronze age, honey has been used as a sweetener and preservative. Bees fill their honeysacs with nectar, where changes occur, caused by the enzymes of the bee's saliva and gastric juices. The nectar becomes a mixture of invert sugar. The bee deposits this very liquidy honey into the wax cells of the combs. To concentrate it more the worker bees eat and reverse the honey again, beating their wings to ventilate the air in the hive. About 20 minutes later the process is completed. Then the wax making bees seal the cell with a topping from their abdominal glands. It takes a great deal of labor. The bees have to make from 15,000 to 50,000 trips to bring back the nectar enough to produce about one pound of honey. Since the quality of the honey depends on the flowers visited by the bees, the bee is particular in its choice of flowers. It travels several miles to find the best flowers. Since ancient times, honey has been a specialty food item. In Roman times the honey of Narrone was very famous because of its special flavor of rosemary. But the Greek honey from Mount Hyhettus was the beloved honey of the Gods and was sold in Rome and Athens only by specialty shops. This strong dark, thyme flavored honey is still produced today.

Blackout Cake

Two 10" round chocolate cakes, baked
Cut one cake into three horizontal slices.

Syrup

1 cup simple syrup
1 tsp. cocoa
1/8 cup coffee
> *Mix well.*
> *Place 1 slice of cake on a 10" springform pan* and brush well with syrup.

Coffee Walnut Mousse

8 egg whites
1/2 cup sugar
> *Blend well.*
1-1/2 lbs. semisweet chocolate, melted
> *Add in.*
6 egg yolks
> *Add in and mix well.*
1-1/4 cups grated walnuts
1/4 cup strong coffee
> *Add in and mix well.*
> *Spread 1/3 mousse on cake. Cover with second cake slice and brush with syrup. Spread 1/3 mousse on second slice and top with remaining cake slice. Brush with syrup. Spread remaining mousse on top cake slice. Cut the second cake into small, square pieces about 2" x 2". Starting from the edges and working toward the middle of the assembled cake, build cake squares into a dome shape. Sprinkle with syrup. Refrigerate for a few hours. Remove from springform pan.*

Icing

2 lbs. milk chocolate, melted
3-1/2 cups whipping cream
1/4 cup strong coffee
1 tbs. cocoa
> *Mix well.*
> *Spread icing from the top of the cake, making sure to cover entirely. Smooth out icing with a spatula. Dust cake with powdered sugar, then with grated walnuts and cocoa.*

Early one morning it was raining and there was complete darkness outside. Suddenly, my electricity went out, I went to work early. The power outage had inspired me to create the following cake. The flavor is so powerful that it sends the senses into a blackout on the first bite, and the cake's presence seduces with a look of darkness.

Champagne Mousse Cake

10" round chocolate cake. Trim the cake to approximately 2-1/2" tall.

Syrup
3/4 cup simple syrup
2 tbs. champagne
Mix together and brush syrup on cake until the cake is soaked with syrup.

Champagne Mousse
4 egg whites
1/4 cup sugar
Mix well.
3/4 lb. semisweet chocolate, melted
Add in and mix well.
3 egg yolks
Add in.
1 tbs. champagne
Add in and blend well. Spread mousse on cake.

Topping
1 cup whipping cream
Whip until stiff.
1 tsp. cocoa
1 tsp. vanilla
1/2 lb. milk chocolate, melted
Blend well with cream. With pastry bag and a star tip, pipe topping on cake, starting from the edges and ending in the middle.

Icing
6 oz. milk chocolate, melted
3/4 cup whipping cream, warmed
Mix well. Spread icing on cake sides. Sprinkle entire cake with white chocolate shavings.

❧

I woke up that Sunday, about 3a.m., not understanding what had disturbed me. As I lay there in the darkness, my mind wandered to apricots, white chocolate and heavenly tastes. I knew I had to go to my new restaurant on Indian School. I lived only five minutes away, but by the time I got there, I had created five new recipes. These are the confections that flooded my dreams: Champagne Mousse Cake, Heaven's Way, Chestnut Pistachio Pie, Creamy Fruit in Pastry and Angel Hair Pie.

❧

Pineapple - The Slim Beauty

Europe first learned of the pineapple in 1493 when Columbus landed in Guadalupe. When it was brought back to Europe, the reaction was mixed.

Many thought that it was very nasty tasting because the fruit had spoiled after the long voyage. In the 16th Century when pineapples were grown in the hot houses, Europeans had a better understanding of the taste of this exotic marvel.

Pineapples became extremely fashionable in the 18th Century. They were a luxury for certain because of their high price due to the cost of growing the fruit. Importing pineapple from the West Indies was out of the question because transporting was as slow as the days of the 16th Century.

Today, pineapple has become very popular since modern transportation can deliver the fruit to all corners of the world. Pineapples are grown in Hawaii, the West Indies, South Africa, the Ivory Coast, Kenya and Florida. Hawaii provides three-quarters of the world's consumption and it is the Ivory Coast's main export.

The fresh and deliciously tasting pineapple is high in vitamins, mineral salt and digestive properties. Many diets praise pineapple and claim that it can make you thin. In fact, pineapple contains an enzyme, bromelin, which can digest one thousand times its weight in protein. Some specialists in obesity have recommended a diet solely consisting of pineapple. The idea is that the enzyme will find nothing in the stomach and therefore will devour the extra fat.

One pound and a half of pineapple, one day of the week is said to work out wonders, but some dieticians disagree, especially the ones from the old school. In either case, pineapple is a delicious food, it is also a necessity in many sweet and sour dishes in exotic cooking of China and India, where it is often used in many spicey foods.

Pineapple is excellent in many distinctive desserts. It's unique flavor creates memorable tastes.

Carrot Cake

Filling

1 cup vegetable oil
2 cups sugar
>*Mix well for a few minutes.*

3 eggs
>*Add in and mix well.*

2-1/2 cups shredded carrots
1 tsp. vanilla extract
1 cup pineapple tidbits
1/2 cup pineapple juice
1/2 cup raisins
3/4 cup walnuts
1 tsp. cinnamon
1 tsp. baking soda
2-1/2 cups flour
>*Add in, mix well.*
>*Lightly butter a 10" springform pan or 13" x 9"*
baking pan and pour filling in. Bake at 350º for 1-1/4 hours.

Frosting

1-1/2 lbs. cream cheese
2-1/2 cups powdered sugar
>*Cream together.*

1/8 cup butter
1 tsp. vanilla extract
1 cup shredded coconut
1/2 cup grated walnuts
1/2 tsp. honey
>*Add in and mix well.*
>*Refrigerate frosting to set, then spread over cake*
while cake is still warm to lock in moisture.

Coconut is the fruit of a palm tree. In most countries, the coconut is cultivated and eaten while still green on the outside. After the fruit is cut open the sweet juice is drank and the soft flesh is spooned out and eaten. The coconut is familiar to use as a hard brown shell which is the matured form of the coconut.

Freshly ground coconut is superior to store bought coconut.

*To make **coconut milk**, place 5 oz. of ground coconut into a pot with 2-1/2 cups water. Bring to a boil and remove immediately. Cool off after stirring the mixture well. Place in cheesecloth and squeeze the juice out.*

White Chocolate Pistachio Cheesecake should only be served in the presence of paramedics.

Best of Phoenix, 1994

I have a friend, Sam, who is passionate about my desserts. He makes a point to visit me early in the morning, when the cake bowls are full of chocolates and icings. He has told me that no matter where he is, he gets an uncontrollable urge when he knows I'm making the following cake, 'No matter where I am,' he says, 'I can tell you're making it, and I turn around and head straight for your restaurant.'

Heaven's Way Cake

Two 10" round sponge cakes, cut one of the cakes into three horizontal slices. Place one slice in a 10" springform pan.

Syrup
1 cup simple syrup
1/8 cup coffee
 Mix well and brush over cake.

Filling layer 1
1/2 lb. white chocolate, melted
1 egg
 Blend well.
1/4 cup sugar
1/2 cup apricots
1 tsp. Kahlua
1/4 cup whipping cream
 Add in and mix well. Pour in pan. Top with second cake layer. Brush with syrup.

Filling layer 2
1/2 lb. white chocolate, melted
1 egg
 Blend well.
1/4 cup sugar
1/4 cup sour cream
1 tbs. coffee
 Mix well. Layer in pan. Top with remaining cake slice and brush with syrup.

Icing
1 lb. white chocolate, melted
1 tbs. coffee
1/2 lb. sour cream
 Blend well.
 Spread about 1/3 of the icing on the cake. Cut the second cake into small squares, approximately 2" x 2". Place around the cake, working from the edges into the middle, to create a dome shape. Brush with syrup. Refrigerate cake for 4-5 hours and remove from pan. Spread remaining icing over cake.

Topping
1/4 cup melted milk chocolate
1/4 cup whipping cream, warmed
 Blend well and drizzle over top and sides of cake.

*A*s I mentioned earlier, I knew I had to finish my first dessert book. But that posed another challenge. The last new recipe I created for publication had to be the most grand finale, something appropriate to the magnitude of this book, and something completely different than anything I had done before.

This recipe tortured me; my thoughts were awash in a flood of flavors. I tried to think back to what my customers traditionally have liked the most. Many of my guests adored the chocolate-dipped strawberries I'd made for them sometimes.

Those berries became the base inspiration for my Last Act cake. I added chocolate-dipped raspberries, then dark chocolate-dipped bananas, and then baked in a white chocolate cake.

The fruits were carefully chosen for their flavor and texture: the tart mushiness of raspberries plays off the sweet, firm strawberries, and all are balanced by the smooth taste of bananas. Then, I took my favorite thing, white chocolate, and I made the most delicious cake imaginable. To say that this final recipe came to me without struggle would be inaccurate, it was one of eight new cakes I created in just five days.

<center>⁂</center>

Cakes are associated with the most important moments in our life. How can it be a birthday or a wedding without indulging in the sight and the taste of a glorious cake?

The preparation and the decoration of a cake require love and imagination. It is the art which brings out both the powerful and sensitive side of our artistic self. The final result is fulfilling to the artist when he or she is awarded with the satisfaction of watching the ecstacy of the guests faces as they are enjoying the final creation.

<center>⁂</center>

*S*ome of my recipes are inspired by my dreams. One of my friends, John, a restaurateur himself, knows this. He has followed the blossoming of my restaurants and visits often to look for new dishes on my menu. "I know you dream up all these creations in your sleep," he laughs. "I often wish I could do the same." For the last eight years, in fact, he has been tryng to buy my bed, seriously offering large amounts of money. "If that bed is what gives you all those amazing dreams, then I want it in my home," he says.

Last Act

Chocolate Coating
6 oz. milk chocolate, melted
3/4 cup whipping cream, warmed
Blend well.

Fruit Filling
8 strawberries
1 banana, sliced
10 raspberries
Dip fruit in chocolate coating, one at a time. Refrigerate.

White Chocolate Cake
2 lb. white chocolate, melted
3 eggs
1/2 cup sugar
1 cup sour cream
1 tsp. vanilla
1 tbs. cake flour
1/2 lb. butter, melted
Blend well.
Pour half of batter in a 10" springform pan. Layer with the fruit. Top with remaining batter. Bake at 350° for 1-1/2 hours. Refrigerate for at least 14-16 hours and remove from pan.

Icing
1 lb. white chocolate, melted
1/2 lb. sour cream
Blend and spread over cake.

It's darn difficult to stroll the dessert cases without eventually surrendering to a slice of one of Nick's celebrated desserts.

Phoenix Downtown, 1995

White Passion Cake

One 10" white cake, baked. Cut into three slices. Place one slice on a cake tray.

Syrup
1 cup simple syrup with 1 tbs. white rum added
> *Mix well and brush over cake slice.*

Macadamia Cream Filling
1/8 lb. butter
1/4 cup sugar
> *Cream well.*

1/2 cup macadamia nuts
1/2 tsp. vanilla
Juice of 1/2 orange
1/2 cup whipping cream
1/2 lb. white chocolate, melted
> *Blend well.*

Mango Mousse
1/2 lb. white chocolate, melted
1 egg
1/4 cup sugar
> *Blend well.*

1/2 tsp. white rum
2 tbs. sour cream
1 mango, sliced finely
> *Add in and blend well. Spread macadamia filling on cake. Top with second cake slice and brush with syrup. Spread mango mousse on cake. Top with third cake slice and brush with syrup.*

Kiwi Chocolate
1/2 cup cream cheese
1/2 cup sugar
> *Blend together.*

2 eggs
1/2 tsp. vanilla
1/2 lb. white chocolate
> *Add in, mix well.*

2 kiwis, peeled, sliced
> *Add in, mix well.*

Icing
1 lb. white chocolate, melted
1-1/2 cups sour cream
> *Blend well, spread over sides and top of cake. Cover sides of cake with toasted coconut. Cover top of cake with white chocolate shavings.*

Blackberry Fudge Cake

Syrups are liquid forms of sugar. They are made from the liquid that is left after the sugar crystals have been removed. Syrups vary in flavor and consistency. Molasses is a dark syrup that is produced during the manufacturing of sugar cane. Corn syrup is derived from sweet corn kernels and it's mild flavor is popular in baking. Maple syrup is made from the sap of maple trees. It is thin with a very distinctive flavor. It is widely used for baking, glazing or over ice cream, pancakes or boiled vegetables.

Filling

1 lb. semisweet chocolate
1 lb. milk chocolate
1 lb. white chocolate
1/2 lb. butter
 Melt together.
16 eggs
1 cup sugar
1 cup blackberries
1/4 cup blackberry brandy
1 tsp. vanilla
 Place in a mixer and blend with chocolates.
 Place filling in a 10" springform pan and bake for one hour at 300°. Turn the oven off and let cake sit for 30 minutes. Remove the cake from the oven and let cool for 6-8 hours before removing from the pan.

Icing

2 cups milk chocolate, melted
1-1/2 cups whipping cream
 Blend together. Spread all over cake.

3 cups toasted coconut
 Sprinkle over cake.

The Rated X Cake is several chocolate and white cake layers spread with almond mousse, banana rum mousse and Grand Marnier chocolate surrounded by an amaretti cookie crust and balanced with chocolate ganache.
Tribune papers, Sept. 1999

I have long since lost count of how many people have requested this next recipe. I've sent this special creation to Canada, California, Ohio, Florida, Illinois and many more places around the world. The unique combination of whipped cream cake, fillo and cinnamon syrup excels a taste beyond expectations.

If I ever run out of this cake in my restaurant, many customers will never forgive me.

❦

The critics agree

"Some of the most tantalizing and novel desserts in the Southwest are displayed in dessert cases along one side of the dining room. How about a Cinnamon Stick Cake, for example? It's an epicurean extravaganza of cinnamon, walnuts, honey, orange zest and baklava crust."

Destinations of the Southwest, 1988

The question is asked of me frequently, "What is your favorite cake?" My answer is always the same. "I cannot have favorites among my children."

Cinnamon Stick Cake

"A crazy combination of cheesecake and baklava that silenced each of us"
Dec. 1997

One cheesecake crust, lay in a 10" springform pan

Filling
2 lbs. cream cheese
1 cup sugar
Cream together.
4 eggs
Add in and mix well.
1 cup sour cream
Juice of 1/2 lemon
1 tbs. vanilla extract
1 cup whipping cream
1/8 cup flour
1 tsp. cinnamon
1 tsp. cornstarch
Add in and mix well. Pour filling onto crust.

Topping
3 cups pecan pieces
1/2 cup sugar
1/2 cup melted butter
1 tsp. cinnamon
1 tsp. ground cloves
Mix together.

Syrup
2 cups of water
1 cinnamon stick
1 tsp. cinnamon
3 whole cloves
1/2 cup sugar
2 tbs. honey
Bring to boil, simmer for 15 minutes.

Cut 16 sheets of fillo into 10" diameters, sprinkle each sheet with melted butter and layer half on top of cake. Place topping on top of fillo and layer with remaining fillos. Sprinkle with top fillo with a little water. Place cake in a shallow baking pan filled with about 1" water.

Bake one hour at 350°, then turn off the oven and let the cake sit 30 minutes longer. Remove cake, slice top fillos into desired serving portions and pour 1 cup of the syrup on top of cake. Refrigerate at least 12 hours before serving.

Apple Cream Cake

Crust

3/4 cup oats
1/2 cup graham cracker crumbs
1/2 cup melted butter
Mix well and press against the bottom of a 10"
springform pan.

Apple Filling

4 apples, sliced
3/4 cup brown sugar
1/2 cup cornstarch
1/2 cup raisins
1/2 cup Amaretto
Mix and spread on crust.

Cream Filling

1-1/2 lbs. cream cheese
1/2 cup sugar
Cream together.
4 eggs
3/4 cup sour cream
Juice of 1/2 lemon
1/2 tsp. vanilla
1/4 cup whipping cream
1/4 cup flour
Blend well and spread over apple filling.
Bake for one hour at 350°. Turn oven off and let
cake sit for 30 minutes. Remove cake and sprinkle with
cinnamon. Refrigerate 8-10 hours before removing from
pan.

*N*uts *have been used as a source for oil and food since the 5th Century B.C. The Greeks widely used walnuts. The Romans used almonds. The Spanish brought peanuts and pecans back from the Aztecs.*

Today, nuts are used in both cooking and baking. Pistachios, hazel-nuts, almonds, walnuts, pine nuts and peanuts are extremely popular in most of Europe and the Middle East. Cashews and peanuts are used in stir frying in the Far East and Indonesia. In Africa, nuts are also a staple in their cuisine.

Nuts have an affinity with honey and chocolate.

Caramel Sauce

1 cup heavy cream
Heat in a saucepan, set aside.
1-3/4 cups sugar
1/2 cup water
In a saucepan, bring to a simmer, stir to mix sugar and water until syrup turns
to an amber color. Turn off heat. Immediately add the cream slowly, stirring with a wire
whisk until it bubbles and the mixture is smoothly combined.
5 tbs. unsalted butter
Cut into pieces, stir in to a complete mix.
1 tsp. vanilla extract
Add in, mix well.
For an extra flavor, add 1 tbs. brandy or 1 tbs. lemon juice, if you like.

Banana - The Extraterrestrial Mystery Gift

The banana tree is extraordinary. It is like a giant herb that can reach the height of 10 meters, rapidly, within a year's time. The leaves spring one above another, growing in the tubes of the older leaves.

When the last of the leaves are grown, a sperm appears and mounts the stem, eventually spreading into the main body of the plant and dropping towards the ground. Then groups of flowers around the stem become the bunches of bananas. No fertilization is needed for bananas. Chinese legend has Buddha meditating at the foot of the banana tree. He made the banana tree a symbol of the futility of earthly possessions.

A banana plant produces one bunch in it's life. Then it dies. That is what Buddha had in mind speaking of earthly possessions. A person should gather enough to maintain a good life, then let go, killing the desire of excess material wealth. You see, you can not grow a new banana plant from banana seeds, for the simple fact that bananas have no seeds or its flowers have no sexual organs. Only a new plant will grow spontaneously besides its dead brothers, mysteriously continuing life that towers from the earth to offer its fruit once then make room for others to enjoy the gift of the earth.

Bananas are a mystery. First, it looks like it has landed from another world; a tree that is not a tree but a herb. 'Flowers', 'fruits' names that are given to banana plants for lack of any other definition by normal earthy standards.

There are more surprises. The plant, at the dawn of time produced no bananas. In fact, there are many naturalized plants in Europe that still do not produce bananas.

Exactly how the miracle of the birth occurred, no one knows. The only thing we know is it happened in Southeast Asia. And so the banana was a gift from the gods, since no human was able to fertilize and produce.

The mystery unfolds farther, as the banana is found suddenly on the other side of the world, in the Caribbean and Central America, in a cultivating stage that produces bananas. How the banana was transported to the other side of the world is a total mystery. Some suggested that it was carried by sailors is not a convincing explanation because of the fact that the banana has no seed to be replanted. Many people believe the theory that we owe bananas to extraterrestrial forces complicating further the origination of the banana. The banana plant grows and bares fruit in climates with plenty of water available. The plant mysteriously passed through Arabia. It crossed the Red Sea in the opposite direction for the people of Israel and invaded Ethiopia in the 6th Century A.D. By the 14th Century, it was spread throughout Africa.

The Spanish name "platano", greek for plane tree, is puzzling because the banana plant, branches and leaves are quite different from those of the plane tree grown wild in the Mediterranean basin.

Bananas ripen quickly in warm temperatures and freeze in the slightest cold weather. They had to wait to reach Europe until the early 19th Century because of transportation problems.

This explains the reason why the food writers of the 16th and 17th centuries ignore the fruit, even though one of Napolean's last foods was the the banana fritter with honey.

During the decade of 1920, specially equipped boats with air tight containers started to bring bananas to Europe, where they became very popular and began to appear in many dishes, especially in sweets.

The banana, when ripened, contains a lot of starch but as it ripens the starch turns into glucose. The banana provides a lot of energy. It is rich in potassium, perfect to eat in hot climates where people lose a lot of moisture by perspiration.

The banana is used in cooking but it really excels in baking. Banana accompanies savory dishes in the West Indies.

Several types of banana breads are made in West Africa, and in other parts of the world. Bananas are spiced and fried in almost every country they are culivated in. In India, they are stuffed and baked. The smaller the banana, the sweeter it is. In Kenya, there is a beer made from bananas.

In my cooking there is a recipe of fried bananas breaded with coconut. In my baking, you will find the banana in several recipes often blended with white chocolate to compliment the smooth taste of both ingredients. Bananas appear in this book in cakes, mousses, pies and breads. One of my most popular cakes is a type of birthday cake which is layered with raspberries and bananas; the raspberries with dark chocolate cream, and the bananas with white chocolate cream layered between dark velvety cake and iced with white chocolate. Does it sound heavenly?

Another extremely popular cake is the After Death, where my unique banana mousse excels in this on a symphonic tones of taste.

A pharmacy apprentice, David Sticker, created the banana split in 1904 in Latrobe, PA. He placed three scoops of ice cream on a split banana, topped it with chocolate syrup, marshmallows, nuts, whipped cream and a cherry. He sold it for a dime. Soon he was imitated by others who used three different kinds of ice cream flavors (chocolate, strawberry, and vanilla), topped with chocolate, strawberry, pineapple, nuts, whipped cream and a cherry. Sticker eventually took over the pharmacy and continued making banana splits until he sold the place in 1965.

By now, the Sweet Chocolate Death cake was so popular I could barely keep up with the demand. It was time to come up with another delightful deadly chocolate cake.

In previous years, I had spent so much time reading, writing and thinking about cooking and baking that now I needed no trials in making a recipe. I could taste a successful creation in my mind. Oh, I had studied recipe books endlessly, and when I made this cake, I knew I would find perfection on the first try.

I wanted this cake to be all white chocolate and thus its name, 'After Death', like Heaven. Too, it was a natural after-life for my already popular all-chocolate 'Death' dessert.

To be honest, this cake puzzles my chef's mind the most, because I initially resisted using my banana chocolate mousse in it. In its creation I had to imagine rare flavors to complement the banana rum taste; not an easy task.

One Sunday morning I fell asleep about 2 a.m. By 5 a.m., I was awake again, with a cake recipe burning in my brain. As dawn broke, I searched grocery stores for white chocolate, because this cake could not wait until Monday. This is the final recipe, and my customers assure me it was worth every minute of creative energy.

Each one of us bent our heads in prayers of thanks to the Grecian God of Dessert.

Java Magazine, 1997

After Death Cake

Walnut Meringue

3 egg whites
1/2 cup sugar
1/2 tsp. vanilla
1/8 tsp. cream of tartar

Run mixing bowl through hot water, then beat all ingredents at high speed untl stiff, about 10 minutes.

Lightly butter a 10" springform pan and spread meringue evenly into pan. Sprinkle wth 1/2 cup grated walnuts.

Bake at 175° for 2 to 2-1/2 hours or until meringue is hard. Turn oven off, let meringue set for a few hours. Remove from oven.

Cream Almond Filling

1/4 lb. butter
1/2 cup sugar

Beat until creamy.

1/2 cup grated almonds
1/2 tsp. almond extract
3/4 cup whipping cream

Add in and beat 3-4 minutes.

2 tbs. orange juice
1 tsp. Amaretto
1/2 lb. white chocolate, melted

Add in and blend well.

Spread cream almond filling on meringue.

One 10" buttermilk Spiced Cake

Slice cake into three horizontal slices. Place one slice on top of almond filling.

Banana Mousse

2 eggs
3/4 cup sugar

Beat together about 3-4 minutes.

1/4 cup whipping cream

Add in, beat 1-2 minutes.

2 bananas, chopped

Add in and blend well.

1/2 lb. white chocolate, melted
1 tsp. cream of tartar
1 cup blond raisins, soaked in 1/8 cup rum

Add in and mix well. Spread banana mousse on top of cake and top with another spice cake slice.

White Chocolate Mousse

2 egg whites
1/4 cup sugar

Beat for 3-4 minutes.

3/4 lb. white chocolate, melted

Add in.

3 egg yolks

Add in one at a time. Blend well. Spread white chocolate mousse over cake and top with remaining slice of cake. Refrigerate 7-8 hours.

White Chocolate Icing

1/2 lb. white chocolate, melted
1/4 lb. sour cream

Blend together. Refrigerate to spreading consistency. Cover entire cake with icing. Sprinkle entire cake with 2 cups grated hazelnuts.

Nuts

The almond tree is a native of the Mediterranean and has been cultivated since the 4th Century B.C. When raw, they can be toxic in large quantities. It is best to use them roasted or blanched.

The cashew tree is a native of South America. They are found prominently in Chinese and Indian dishes.

Hazelnuts sweetness in flavor marries well with all kinds of pastries, especially with chocolate desserts.

Pecans are a native of the American south. Their refined flavor goes well in pies, cakes and ice cream. They are high priced because of the lengthy process of growing and harvesting them.

Pistachios are native of the Middle East. This irresistible nut is versatile. Besides its many uses in cooking, it is an essential ingredient for baking in the Middle East and the Mediterranean.

Walnuts are a native of Asia. It is probably the most popular of all nuts, popular in snacks, salads, pies, cakes, cookies and so much more. The lighter the color of the walnut, the highest grade of quality it is.

After years of creating such ambrosial confections, I am challenged to create a cake that insists 'outlaw!' from the first bite.

Such a dessert could only be created by blending white and dark chocolate. My quandary: I could not allow any flour to spoil the purity of the chocolate. I had to find a way to separate the cake layers without affecting the taste.

Then, I was unwrapping some delicate fillo dough, it hit me. I had found a way to separate the cakes, and I was anxious to start bringing this recipe of Sinful Act to life.

Sinful Act Cake

Crust
3/4 cup each of sliced almonds, grated walnuts, oats, graham cracker crumbs
1/2 cup each melted butter and sugar

Mix ingredients well.

Line the outside of a 10" springform pan with aluminum foil, overlapping the top about 5". Butter pan lightly and press crust against sides and bottom.

Chocolate Chambourd Cake
1 lb. semisweet chocolate
1 lb. milk chocolate
1/2 lb. butter
1/2 cup Chambourd
1/8 cup Raspberry Sauce (see below)

Melt together.

9 eggs
1/4 cup sugar

Beat well, fold into chocolates. Pour half of chocolate chambourd into the pan.

12 fillo dough, cut into 10" rounds

Lay 6 fillos on top of chocolate chambourd, buttering each one.

White Chocolate Cake
3/4 lb. cream cheese
1/4 cup sugar

Cream together.

1 lb. white chocolate, melted
1 cup sour cream
1/2 tsp. vanilla
3 eggs

Add in, mix well.

Pour batter on top of fillo. Layer remaining 6 fillos on top of white chocolate cake. Pour remaining dark cake batter across the top. Place pan in a larger pan filled with 1" water.

Bake at 300° for one hour, turn oven off and let cake rest in the oven for 30 minutes.

Raspberry Sauce
1/2 cup frozen raspberries
1/4 cup Chambourd

Blend well and press through a sieve. Puree raspberries. Push through sieve to remove.

Carefully pour remaining sauce on top of cake. Refrigerate 10-12 hours before serving.

Amaretti Fruit Cake

Filling

1/2 cup vegetable oil
1/2 cup butter
2 cups sugar
Cream together.
1 tsp. almond extract
2 eggs
Blend in.
3/4 cup papaya, chopped
1 cup fresh apples, chopped
1 cup dry apricots, chopped
1 cup shredded coconut
1 cup chopped almonds
1 tsp. baking soda
1 cup raisins
1/4 cup dry mangos, chopped
1 cup walnuts, chopped
1 tbs. orange peel
1 tbs. lemon peel
1 tsp. ground cinnamon
1 tsp. nutmeg
1 tsp. honey
1/2 cup grated hazelnuts
1 cup pineapple tidbits
1/2 cup pineapple juice
2 cups flour
Mix together and blend in.

Pour into a 10" springform pan or a 9" x 13" baking pan and bake at 300° for 1-1/4 hours. Cool and remove from pan.

Syrup

2 cups water
1/2 cup sugar
2 tbs. Amaretto liqueur
Bring to a boil. Pour on cake after baked.

*T*he best flavorings come from extracting the essential flavors of the plant. The natural liquid is the best ingredients to use, but they are very expensive to produce. Now the market is full of synthetic flavors. Fruits like raspberries and strawberries are ideal for syrups to be used for cake flavoring, ice cream, tarts and so much more.

Nut essences are a good way to flavor cakes and cookies.

Vanilla extract is probably the most widely used essence. It is used to flavor just about anything in baking.

Licorice, with its distinctive flavor, is used for candy.

Grenadine is a liquid made from pomegranate essence.

One smmer a few years ago, I enjoyed a week in Maui. Why I decided to vacation just after creating a new menu, I don't know. Final printing was scheduled for my second day of leisure. Trying to relax on golden beaches, I thought not of sand, but of flour.

Within hours, I was on the phone to my printer, describing a new cake I wanted added to my dessert list.

When I returned to the restaurant, I was faced with the challenge of producing the cake I had imagined in Maui – the cake that was already printed in my menus.

Here is the Fatal Obsession that is an instant favorite for many, and a wonderful memory for me.

Getting past the display cases of totally decadent and mouth-watering desserts takes a true showing of Herculean strength.

Mesa Tribune, 1986

Fatal Obsession

One 10" Citrus Cake, cut in 3 pieces lengthwise. Place one half in a 10" springform pan.

Boysenberry Sauce
1 cup boysenberries
1/8 cup Grand Marnier
1/8 cup sugar
Blend together and run through a sieve. Brush some of the syrup on top of cake.

Orange Fried Biscotti
1 egg
2 egg yolks
1/4 cup orange juice
1/4 cup sugar
1 tsp. lemon juice
2 cups flour
1/2 tsp. baking soda
Blend ingredients well. Open dough to very thin, cut into pieces and fry in shortening until light brown. Crumble in to small pieces and sprinkle over cake.

Boysenberry Mousse
4 egg whites
1/4 cup sugar
Beat together.
1/3 lb. semisweet chocolate, melted
Blend in.
3 egg yolks
Blend in one at a time.
1/8 cup boysenberries
Add in and mix well. Pour mousse on top of cake. Place another cake slice on top of mousse. Brush with some of the boysenberry sauce.

Coffee Mousse
1/2 lb. cream cheese
1/4 lb. sugar
Cream together.
3 eggs
1 lb. white chocolate, melted
1/8 cup Kahlua
Add in and mix well. Spread on top of cake. Cover with the third cake slice and brush with boysenberry sauce. Refrigerate cake for a few hours, remove from pan.

Icing
1 lb. milk chocolate, melted
2-1/2 cups whipping cream
Blend well and refrigerate until firm. Spread over cake with a thin spatula. Draw horizontal lines on top of cake with the tip of the spatula.

Final Addiction

Crust
1/4 cup walnuts, grated
1/4 cup oats
1/4 cup graham cracker crumbs
1/8 cup butter, melted
1/8 cup sugar
> *Blend and line the bottom of a 10" springform pan.*

Hazelnut Chestnut Filling
1/2 lb. cream cheese
1/2 lb. sugar
> *Cream together.*

1/2 cup chestnut cream
> *Add in and mix well.*

4 eggs
> *Add in and mix well.*

1 cup whipping cream
1 lb. semisweet chocolate, melted
1/4 cup grated hazelnuts
1 tbs. Kahlua
1 tbs. vanilla extract
> *Add in and mix well.*

24-26 ladyfinger cookies (approx. 5" long)
> *Pour cake batter onto crust. Press ladyfingers against the inside of the pan (perpendicular) and line them all around.*

White Chocolate Filling
1/2 lb. cream cheese
1 cup sugar
> *Cream together.*

3/4 lb. white chocolate, melted
1 cup sour cream
> *Blend well. Pour on top of hazelnut chestnut filling. Stick a butter knife in to the cake and swirl to mix both fillings, leaving a design of dark and white swirls on top of cake.*

Icing
1/8 lb. white chocolate, melted
1/4 cup sour cream
> *Blend well.*
> *Bake at 300° for one hour. Turn oven off, leave cake in 1/2 hour longer. Refrigerate 8-10 hours. Spread icing over sides of cake only. Sprinkle sides of cake with 1/2 cup grated walnuts. After baking the cake some of the ladyfingers may have risen up. Press cookies back down to reach the bottom of the pan again.*

*M*y first dessert book, "My Golden Collection" was completed in 1994. In the initial book signing which was held in my restaurant on Indian School Road, I decided to create four more cakes which, along with the rest of the cake collection, was going to be offered to the guests who would take the time to come out and stand in line for an autographed copy of my book. The event was a success to be talked about from the ones who attended for years to come. Over 600 people showed up and enjoyed unlimited tastes of their favorite treats.

The following four cakes are the ones which appeared in my dessert case for the first time at that event.

Lady Killer

One 10" white cake, sliced into 3 equal horizontal slices
Rum syrup
Place first slice in a 10" springform pan. Brush with rum syrup.

Banana Peanut Chocolate
8 oz. white chocolate, melted
4 oz. sour cream
1 banana, cut into pieces
2 oz. creamy peanut butter
Mix well on medium speed of a mixer. Layer on top of the cake. Place second slice on top of chocolate and brush with rum syrup.

Boysenberry Mousse
4 egg whites
1/4 cup sugar
Beat on high speed for 2-3 minutes.
1/4 lb. semisweet chocolate, melted
Add in and beat on low speed until mixed well.
3 egg yolks
Add one at a time and mix well.
1/4 cup boysenberries
Add in and mix well. Place mousse on top of cake. Lay the third slice on top of the mousse and brush with rum syrup. When the cake is set, remove from springform pan.

White Chocolate Icing
16 oz. white chocolate, melted
8 oz. sour cream
Mix well. Spread on top and around the cake.
24 ladyfingers (or enough to cover the side of the cake)

Chocolate Icing
8 oz. milk chocolate chips, melted
1-1/4 cup whipping cream, heated
Mix together while chocolate is hot. Dip the end of each ladyfinger in the chocolate and place it on the side of the cake with dipped chocolate end on top. Repeat the process until the ladyfingers have covered the whole side of the cake. Save the remaining icing.

126

(cont. on next page)

(Lady Killer cont.)

1 pint whipping cream
1/2 tsp. vanilla extract
 Beat on high speed with wire beater until cream is stiff.
4 oz. white chocolate, melted
1 tbs. cocoa
 Add in and mix on low speed. Place cocoa cream in a pastry bag with a star tip and fill top of cake with rosettes. Take the remaining icing and place it in a pastry bag with a narrow straight tip and make chocolate lines around the rosettes.

༝༚༚

People have been eating flour since many centuries B.C. But it was the Greeks who made baking bread and cakes a true art. By the 3rd century B.C. there were 75 different kinds of bread alone. The Greek bakers invented the molds to make bread and they also invented the bread oven which could be preheated and became the model for culinary use.

Even though cakes were made since the time of Pericles, there were no special pastry books until about the end of the Roman Empire. The list of cakes made by master bakers is long. About 100 types are known, including cream cheese and honey. Butter was non-existent at that time in Greece and Rome. Cream cheese was used instead alternately with oil or animal fat. Cakes were made for special occasions, for religious events or for the theater. Cheesecakes were also made back then containing dried fruits and walnuts.

The Greeks also made an array of fritters eaten mainly with honey. They also made puddings and a specialty of eggs and cream cheese beaten together, then wrapped in fig leaves and boiled in broth, then given a final cooking in boiling honey.

The Romans, despite their close links with the Greeks had very little interest in baking until several centuries later.

In this tiny hole-in-the-wall, dynamic chef-owner Nick Ligidakis single-handedly bakes luscious desserts.

Zagat Restaurant, Survey 1988

Deadly Possession

One 10" white cake, sliced to two horizontal slices

Syrup

3/4 cup simple syrup
1 tbs. Grand Marnier
> *Mix well. Place one cake slice in a 10" springform pan.*

White Chocolate Spread

12 oz. white chocolate
6 oz. sour cream
> *Mix well. Spread half of this white chocolate on top of cake. Save the other half in a bowl.*

Pastry for Cream Puffs

5 eggs
> *Beat on high speed of mixer for 2-3 minutes, set aside.*

3/4 cup milk
3/4 cup water
Pinch of salt
1 tsp. sugar
4 oz. butter
> *Heat slowly in a saucepan. When hot, remove from heat.*

1 cup flour
> *Add in and beat with a wooden spoon vigorously.*
>
> *Transfer the mixture into a warm bowl. Add half of the beaten eggs. As you are beating the dough with the spoon, add the rest of the eggs, beating to mix well. Fill a pastry bag with a star tip with the dough and make 4 circles with this dough on a lightly buttered baking pan, 2 of the circles approximately 8" and 2 circles approximately 4". With the remaining dough, make drops with the pastry bag of approximately 1" round. Bake about 25 minutes in a 425° oven.*

Chocolate Cream

3 pints of heavy cream
1 tsp. vanilla extract
> *Whip in a mixer on high speed with a wire beater.*

6 oz. white chocolate, melted
> *Add in and mix well. Place cream in a bowl. Take the large round pastry dough round and slice it in half. Place the bottom half in the springform pan.*

1 cup chocolate cream
> *Spread on top of the pastry dough and cover with the other half. Take the smaller round pastry dough and slice it, placing the bottom part inside the larger pastry dough.*

1/2 cup white chocolate cream
1 tsp. cocoa
> *Mix well and place the filling on top of the dough. Cover it with the other half.*
> *Cover the pastry dough rounds with a thin layer of white chocolate spread.*

(cont. on next page)

(Deadly Possession cont.)

Repeat this process with the remaining two rounds of pastry dough (one large, one small) only change the fillings in the middle of the pastry to the following:

1/2 cup white chocolate spread
1 tbs. instant coffee
Mix and fill the large round of the pastry with it.
1/2 cup white chocolate spread
1 tbs. raspberry jam
Mix and fill the smaller round with it.
Spread the remaining chocolate cream on top of pastry dough rounds and place the second slice of white cake on top. Brush with the Grand Marnier syrup.

Icing

8 oz. white chocolate, melted
2 cups sour cream
Mix well. Spread on the sides and on the top of the cake with the icing.
3 pints heavy cream
1 tbs. vanilla extract
Beat on high speed of mixer with a wire beater until stiff.
6 oz. of white chocolate, melted
Mix well with the cream. Fill a pastry bag with a straight tip and fill the individual puff dough (1" rounds) with it by punching a hole in the bottom of the puff with the bag's tip. At this stage, you have cream puffs.

Chocolate Dip

8 oz. milk chocolate, melted
1-1/4 cup whipping cream, heated
Mix together while chocolate is hot.
Dip the top of the cream puff into the chocolate and place it on the edge of the top of the cake. Repeat with the rest of the puffs until you have made a circle on top of the cake.
Take the remaining cream puff filling and mix it with 1 tbs. cocoa. Place it in a pastry bag with a star tip and make rosettes on the top of the cake to fill the middle between the cream puffs.
Fill the remaining of the chocolate dip in a pastry bag with a narrow straight tip and make lines on the side of the cake by starting on the top of the cake, squeeze the bag and let the chocolate drip on the side of the cake. Repeat every 1" (approximately).

Four Seasons

One 10" sponge cake, sliced in half horizontally

Syrup
1/2 cup simple syrup
1 tbs. raspberry sauce
Mix well and brush on top of cake.

Lingonberry Mousse
4 egg whites
1/4 cup sugar
Beat on high speed of mixer for 2-3 minutes.
1/4 lb. semisweet chocolate, melted
Add in and beat on low speed of mixer to mix well.
3 egg yolks
Add in one at a time until incorporated well.
1/4 cup lingonberry jam
Add in and mix well. Spread mousse on top of cake.

Kiwi Chocolate
6 oz. white chocolate, melted
2 oz. sour cream
1 kiwi, peeled and cut into pieces
Mix well. Spread on top of the lingonberry mousse.
One slice of a 10" chocolate cake, approximately 1" thick
Place on top of the kiwi chocolate.

Syrup
1/2 cup simple syrup
1 tbs. Grand Marnier
Mix well. Brush on top of cake.

Vanilla Chocolate
6 oz. white chocolate, melted
3 oz. sour cream
1 tsp. vanilla extract
Mix well and spread on top of cake.

Strawberry Chocolate
6 oz. white chocolate, melted
2 oz. sour cream
1 tbs. strawberry jam
Mix well and spread on top of vanilla chocolate.

Cover strawberry mousse with the second slice of sponge cake, brush with vanilla syrup.

Icing
10 oz. white chocolate, melted
5 oz. sour cream
Mix well and spread on top and sides of cake.
1/4 cup chocolate vermicelli
Sprinkle on top and sides of cake.

Deceitful Desires

One 10" chocolate cake, cut in half horizontally, place in a springform pan

Syrup

1/2 cup simple syrup
1 tbs. cherry juice
> *Mix well and brush on top of cake.*

Cherry Chocolate

2 eggs
2 tbs. sugar
> *Beat well.*
8 oz. semisweet chocolate, melted
> *Add in and mix well.*
1/4 lb. butter, melted
1 tbs. dark cherries
> *Add in and mix well. Pour the cherry chocolate on top of the cake.*
1 cup dark cherries
> *Place on top of the chocolate*
4 oz. white chocolate, melted
2 oz. sour cream
> *Mix well and spread on top of the cherries.*
One slice of a 10" sponge cake, approximately 1" thick
> *Place on top of the white cake.*

Syrup

1/2 cup simple syrup
1 tbs. rum
> *Mix well and brush on top of cake.*

Strawberry Chocolate

1 egg
1 tbs. sugar
> *Beat well.*
8 oz. white chocolate, melted
1/8 lb. butter, melted
1 tbs. strawberries
> *Mix well. Place on top of cake.*
1 cup strawberries, sliced
> *Place on top of chocolate.*
4 oz. chocolate chips, melted
3/4 cup whipping cream, heated
> *Mix well while chocolate is hot. Spread on top of strawberries.*
> *Cover with the second slice of the chocolate cake.*

Cont. next page

Syrup
1/2 cup simple syrup
1 tbs. rum
> *Mix well and brush on top of cake.*

Icing
10 oz. white chocolate, melted
5 oz. sour cream
> *Mix well and spread on top and sides of cake.*

2 oz. milk chocolate, melted
1/2 cup whipping cream, heated
> *Mix well while chocolate is hot.*
> *Place in a pastry bag with a narrow straight tip and make lines on top of the cake about 1" apart. Then make lines the opposite way to form squares.*

1 cup chocolate shavings
> *Sprinkle on the sides of the cake.*

❦

Cakes have always been part of ceremonies and also to convey a message. Cake was a big part of the ancient Greek wedding ceremony. It was an offering by the bridal pair in Rome. In France, the tradition was to exchange the first kiss of the newlyweds over a plate full of waffles. In Brittany, the proposal of marriage was made by sending a cake. If the proposal was refused, a similar cake was sent back.

Cakes were also part of funerals in many parts of Europe. Pieces of cake were distributed to the ones who could not attend the ceremony. Besides the wedding and funerals, there were cakes for birthdays, baptisms and many more occasions. Cakes were even used in some of the best known fairytales. It was inside Little Red Riding Hood's basket to show her love to her grandmother. In a French version of Cinderella, the princess's ring is inside the cake.

In the 19th Century in Provence, girls put little cakes in their baskets and gave them to young boys. The one who bit into the cake was interested in the baker girl.

*A*fter these four cakes were created, another chapter of new desserts started. More cakes, pies, bar cakes, puddings, biscottis and candies stocked up the nine display cases surrounding the dining room. I believe that this next cake was the most addictive from this new collection.

Symphony of Chocolates

1 slice chocolate cake, approximately 2" thick and place in a 10" springform pan

Syrup
1/2 cup simple syrup
2 tbs. Frangelico liquor
 Mix well and brush on top of cake.

White Chocolate Filling
1/2 cup butter
1/2 cup sugar
 Cream together in a mixer.
2 eggs
1 tsp. vanilla extract
 Add in and mix well.
6 oz. white chocolate, melted
 Add in, mix well. Spread on top of cake. Refrigerate for 1 hour for the filling to set.

Semisweet Chocolate Filling
1/2 cup butter
1/2 cup sugar
 Cream together in a mixer.
2 eggs
1 tsp. vanilla extract
 Add in and mix well.
6 oz. semisweet chocolate, melted
 Add in and mix well. Spread on top of white chocolate. Refrigerate to set.

Chestnut Chocolate Filling
1/2 cup butter
1/2 cup sugar
 Cream together.
2 eggs
1 tsp. vanilla extract
 Add in, mix well.
6 oz. white chocolate, melted
1 tsp. Kahlua
1/2 cup chestnut puree
 Add in and mix well.
Spread on top of semisweet chocolate.
Refrigerate for 2-3 hours, remove from pan.

Chocolate Orange Icing
1/2 lb. cream cheese, 2 tbs. sugar
 Cream well.
4 eggs, 1/2 cup whipping cream
 Add in and blend well.
1/4 cup sour cream
1 tbs. orange peel
1/2 tsp. cinnamon
1 lb. white chocolate, melted
1/2 tbs. Kahlua
 Add in and mix well. Spread on top and sides of cake.
1/4 cup dark chocolate shavings
1/4 cup chocolate vermicelli
 Sprinkle all over the top and sides of cake.

Classic Ecstacy

Macaroon Cake

Use 1/2 recipe of coconut macaroons
> *Lay macaroon filling in the bottom of a 10" buttered springform pan and bake in a 350° for about 45 minutes.*

Cherry Mousse

8 egg whites
1/2 cup sugar
> *Beat in a mixer for 4-5 minutes.*

1-1/4 lb. semisweet chocolate, melted
> *Add in and mix well.*

6 egg yolks
> *Add in one at a time and mix well.*

1/2 cup dark cherries
> *Add in and mix well. Place on top of macaroon cake.*

A 10" spongecake, cut in half horizontally
> *Place one slice on top of the mousse.*

1 cup simple syrup
1 tbs. rum
> *Mix well and brush on top of cake. Reserve half of the syrup for later.*

Boysenberry White Chocolate

1 lb. white chocolate, melted
1/2 lb. sour cream
1/2 cup boysenberries
> *Mix well. Spread on top.*
> *Place the second cake slice on top of chocolate and brush with reserved rum syrup.*

Raspberry Icing

1 lb. white chocolate, melted
4 cups sour cream
2 tbs. raspberry jam
> *Mix well. Spread all over the top and sides of the cake.*

1/4 cup white vermicelli
1/4 cup toasted coconut
> *Sprinkle all over the cake.*

**I've somehow survived the final addiction,
a near-death blend of white and
dark chocolates, hazelnut chocolate,
chestnut puree and Kahlua.**

New Times, March 1998

Always and Forever

One 10" white cake, cut in half lengthwise, place one slice in a 10" springform pan

1/8 cup Frangelico simple syrup
> *Sprinkle on top.*

3 oz. milk chocolate, melted
1/3 cup whipping cream, heated
> *Blend well and pour over cake.*

Coffee Cream Filling
8 oz. cream cheese
1/4 cup sugar
> *Cream together.*
2 eggs
> *Add in, mix well.*
1 cup sour cream
2 tbs. instant coffee
6 oz. white chocolate, melted
> *Add in, mix well. Pour in springform pan.*

One 10" dark cake, cut into two horizontal slices Place one slice on top of coffee cream filling

Coffee Simple Syrup
> *Brush the cake with*
1 cup white chocolate, melted
1 cup sour cream
> *Mix together, spread on top of cake.*

Hazelnut Cream
6 cups heavy cream
1 tsp. vanilla extract
> *Whip with an electric mixer on high speed until stiff, reduce speed.*
8 oz. white chocolate, melted
2 oz. dark chocolate, melted
1/2 tsp. hazelnut extract
> *Add in and mix well. Divide filling in two parts. Spread one of the parts on to the cake. Save the other half for icing.*

1/2 cup chopped hazelnuts
> *Sprinkle on top of the hazelnut cream. Place the second dark cake slice on top.*
Rum simple syrup
> *Brush cake with syrup.*
1/2 cup toasted coconut
> *Sprinkle on top of cake.*

cont. next page

Chestnut Filling

8 oz. white chocolate, melted

3 eggs

Mix well.

1/2 cup sugar

2 cups sour cream

1/4 cup chestnut puree

Add in, mix well. Spread all but 1/2 cup of this filling on top of cake. Top it with the second white cake slice. Refrigerate cake for a few hours to set. Use the remaining hazelnut cream to ice the cake, all except for 1/2 cup of it.

1/2 cup hazelnut cream

Put in a pastry bag with a small straight tip and draw lines on top of cake, spacing each line about 1/4" apart.

1/2 cup chestnut filling

Use the same bag and draw lines on the space between hazelnut cream lines.

1/2 cup toasted coconut

Sprinkle loosely all around and on top of the cake.

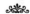

Secret Desires

Meringues

16 egg whites

1 cup of sugar

Flush mixing bowl with hot water. Eggs must be at room temperature. Mix ingredients at high speed until stiff, about 10 minutes. Remove from mixer. Divide meringue into four mixing bowls.

1 tbs. strawberry jam

Add to one of the bowls, mix well.

1 tbs. raspberry jam

Add to one of the bowls, mix well.

1 tsp. unsweetened cocoa

Add to one of the bowls, mix well.

1 tsp. vanilla extract

Add to one of the bowls, mix well.

Lightly butter four 10" springform pans lined with aluminum foil. Spread each flavored meringues on each pan. Bake at 175° for approximately two hours, or until meringues are hard. Turn oven off, leave meringue in for a few more hours. Remove meringues from their pans, remove aluminum foil. Place the cocoa meringue back in springform pan.

Cappucino Filling

1/8 lb. cream cheese
1/2 tbs. sugar
Cream together.
1 egg
Add in, mix well.
1/8 cup heavy cream
1/8 cup sour cream
1/2 tsp. orange peel
1/4 tsp. cinnamon
1/4 lb. melted white chocolate
1/8 lb. melted dark chocolate
Add in, mix well. Pour on top of meringue. Place the raspberry meringue on top of the filling.

8 cups heavy cream
1 tsp. vanilla extract
Whip in electric mixer on high speed until stiff. Divide cream into three parts and place them in to three bowls.

Coffee Kahlua Cream

1 cup white chocolate, melted
1 tsp. Kahlua
1 tbs. strong coffee
Add into one of the bowls, mix well. Spread on top of raspberry meringue. Place strawberry meringue on top of filling.

Raspberry White Chocolate Cream

1 cup white chocolate, melted
1 tbs. raspberry jam
Add in to one of the other bowls and mix well, spread on top of meringue. Place vanilla meringue on top.

White Chocolate Filling

1-1/2 cups white chocolate, melted
Mix with the cream of the remaining bowl and spread on top of meringue. Refrigerate for one hour. Remove cake from pan. Smooth out the sides and top of cake with spatula.

1 cup sliced almonds
Place them around the bottom part of cake.
1 cup chopped hazelnuts
Place them around the middle part of the cake.
1 cup chopped walnuts
Place them around the top part of the cake.

Icing

12 oz. milk chocolate, melted
1-2/3 cups heavy cream, heated
Mix well, pour on top in the middle of the cake while warm, letting the icing drip on the sides of cake.

Angel Hair Cake

Two 10" springform pans

In one, remove the bottom. Place the rim of the bottomless pan on top of the one with the bottom attached. Butter lightly bottom and sides of pans. The reason for this is that this cake is really high and it must be baked in the two springform pans.

12 cups milk
2 cups sugar

Bring to boil in a large saucepan.

2 tbs. butter

Add in, when melted remove from heat.

12 eggs
1 cup sugar
1 tsp. vanilla extract

Beat in a mixer, medium speed until frothy. Fold in to the hot milk.

2 cups semolina flour
12 tbs. cake flour

Add in, mix well. Divide mixture into three parts and place each part into a separate bowl.

1 lb. of shredded kataifi dough (available in specialty markets)

Spread it on a working surface.

1/2 cup melted butter

Sprinkle on top of the shredded dough. Cut the dough into strips, long enough to cover the bottom of the pan, bringing it up to the sides of the pan and overlapping a few inches. Arrange the dough in the inside of the pan. Repeat with all strips of dough so bottom and sides of pan are covered.

1 cup of lemon pie filling

Add to one of the bowls, mix well and pour in the bottom of the pan.

4 fillo doughs

Cut into 10" rounds, place on top of lemon filling.

1 banana, pureed

Mix with the custard of the second bowl, pour on top of fillo.

4 fillo dough, cut in to 10" rounds

Place on top of banna filling.

1/2 cup strawberry jam

Mix in to fourth bowl, pour on fillo. Fold in the shredded dough exiting the sides of the pan so the top of the strawberry filling will be covered. Bake in a 350° oven for approx. 1 hours, 15 minutes.

2 cups simple syrup
12 tsp. cinnamon
1 tsp. orange juice
1 tsp. lemon peel
1 tsp. vanilla extract

Mix well and pour on top of cake while warm. Refrigerate overnight before removing from the springform pan.

The Best of Times

1984 – *"It was the best of times ... it was the worst of times."* That was the year I finally experienced the realization of all my beliefs and idealisms. That also was one of the most financially challenging periods for my business.

Looking back today, I understand that those financial difficulties helped me discover what is most important in life. As it has been said so many times, money does not buy happiness. While it was a shock to watch my lifestyle spin 180°, it motivated me to put my strength and energy into something that would never change: my relationships with the people I love.

Abandoning my reliance on material things enabled me to see the pure, generous gift of goodness in my parents, my brothers and sister and, above all, my beautiful children.

1984 – That was the year I turned my long-time dream into reality and opened Golden Cuisine Restaurant. It was a small shop of 840 square feet at 5024 East McDowell Road that soon also became my home. Bringing it to life left me penniless, and for several months I slept on an air mattress in the tiny kitchen.

It was an exciting but lonely time, as most people told me I would not succeed. When I spoke of my dream to expand my menu to hundreds of original items and stock cases of unique desserts, people rolled their eyes in disbelief.

Yet those five years on McDowell were probably the most prosperous for my restaurant. Soon after opening, hundreds of hungry diners flocked to Golden Cuisine, often waiting hours for a precious seat and reserving tables weeks in advance.

Perhaps I never should have moved to that second location, the 8,000 square foot Golden Cuisine of Southern Europe at Tower Plaza. I was inexperienced with investors, I underestimated my overhead demands and was dismayed to discover increasing crime in the area. It was a horrible three years that almost brought me to my knees, but I think it helped me learn how to be a smarter businessman.

Through it all, I refused to give up, partly out of sheer stubbornness, partly because I never wanted my children to see me give up, and largely due to the commitments of my annual Thanksgiving feast for the less fortunate. Even as my restaurant entered bankruptcy and people around me urged me to give up the expensive, time consuming Thanksgiving feast, I knew that thousands of hungry citizens depended on me. With this determination and little else, I opened Nick's Cuisine of Southern Europe at 3717 East Indian School Rd. The first several years were an acrobatic act of juggling the daily demands of business while paying back enormous debt from leaner times.

Moving to the San Carlos Hotel with the help of it's owners, I hoped that this would be the best of times. A year later, the hotel was sold to a big corporation and the worst of times came in the form of a corporate mask. They wanted immediate changes and again out of sheer stubbornness, partly because of pride and largely due to the commitment of my annual Thanksgiving dinner to the less fortunate that they refused to honor, I left everything behind and walked out penniless.

But what seemed the worst of times turned out to be the best of times.

The year away from the restaurants allowed me to stop the time and give a little of that time to myself. I began to converse to myself, in paper, and I discovered my other passion; writing. My story-cookbook "5024 E. McDowell" came to life, shortly after "The Heroes of My Thoughts" brightened my life and now my "Private Collection" makes me feel proud. And there will be more; "Songs of Freedom" is next; maybe a children's cookbook, who knows?

All I know is that no challenge in life is too great to overcome. Believe in yourself and you will find true peace and happiness. Now there is a little place again, the name is Café Nikos. It is here because of what we call "the best of times" and after a while it may no longer be here, it does not matter because the worst of times will never come around for me again. And come to think of it, the "worse of times" have never been around for me anyway.

In the middle of 1996 I was approached by the owner of a historic Phoenix downtown hotel. He planted the idea in my head that I should bring my following to the downtown area.

I went to the San Carlos Hotel only out of curiosity and to satisfy the owner's persistence. From the first time I walked in to that hotel, I was intrigued by the character and historic value.

I saw the opportunity of being in an atmosphere that I enjoyed and also helping the downtown area of Phoenix bring back some life to its streets.

A great effort was made in the past few years to increase the traffic in the downtown area. For me it was a new challenge and as usual, I took the opportunity.

The hotel was built in 1928. I pay tribute to that year with this following cake recipe which became a favorite among many.

Nineteen Twenty-Eight

Make two chocolate meringues. Place 1 meringue in the bottom of a 10" springform pan

4 pints heavy cream
1 tsp. vanilla extract
Beat on high speed in a mixer using a wire beater until cream is stiff. Divide into two separate bowls and set aside.

In one bowl add 6 oz. melted semisweet chocolate. In the other bowl, add 6 oz. melted white chocolate. Use two pastry bags with a wide straight tip. Fill one bag with the dark cream. Fill the other bag with the white cream.

Start with the dark cream and make a thick circle on the edges of the top of the meringue. Then use the white cream and make a circle inside the dark circle, then make a dark circle inside the white and so on.

One slice of chocolate cake, approximately 1-1/2" thick
Place on top of the cream.
1/2 cup simple syrup
1 tbs. raspberry syrup
Mix well and brush on top of cake.
Repeat the cream circles on the top of the cake. This time starting with the white cream. By doing this, when you slice the cake you will have a black and white checkered effect.
Place the other meringue on top of the cream.

Dark Icing
3 pints heavy cream
1 tsp. vanilla extract
Beat on high speed of mixer using a wire beater until stiff.
6 oz. semisweet chocolate, melted
Add in and mix well. Spread icing all over cake. Reserve 2 cups of icing for rosettes.

White Chocolate Cream
4 oz. white chocolate, melted
1/4 cup heavy cream, heated

Mix well. Brush on the sides of the cake. This will give an antique effect. Reserve 1/4 cup of the white chocolate cream for later.

Spread reserved dark icing in a pastry bag with a star tip. Make rosettes on the edges of the top of the cake.

Place the reserved white chocolate cream on the middle, top of cake.

1 tbs. raspberry syrup

Pour on the white chocolate cream and swirl it with your finger to mix with the chocolate.

4 oz. semisweet chocolate, melted
1/2 cup heavy cream, heated

Mix well. Place in a pastry bag with a narrow straight tip. Make lines on the side of the cake every 2" (approximately) by placing the tip of the bag on the top edge of the cake. Squeeze the bag and let the chocolate run down to the side of the cake.

4 oz. white chocolate, melted
1/2 cup heavy cream, heated

Mix well. Place in a pastry bag with a narrow straight tip.

Repeat the preceding process making white lines now, between the dark lines.

The Fig Berry Pie is fabulous ...
Creamy Cinnamon Stick cake is not far behind ...
scarf up Final Addiction, a rich chestnut cake with
coffee laced white and dark chocolate.

Best of Phoenix Restaurant Guide, 1993

*I*n my opinion, this original recipe pie crust is the best ever made. I like it so much I use it in all my pies. The following makes dough for four pies.

All the pie recipes are measured for a 10" pie plate. Use the deep glass pie plate. You will get better results by baking in the glass.

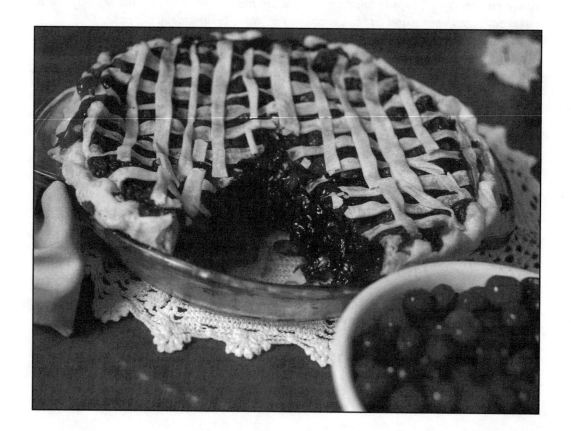

Pies

Pie Crust

1 lb. margarine
2 tbs. sugar
> *Mix gently.*

4 tbs. milk
2 tbs. white vinegar
2 tbs. olive oil
4 egg yolks
> *Add in and mix well.*

1-1/2 cups cold water
8 cups flour
> *Add in and mix well. Divide dough into four parts, and roll into desired rounds.*

> *To bake an empty pie shell, prick the bottom of it with a fork. Fill the shell with lentils or dried beans, this will prevent the dough from rising. If you are filling the unbaked dough with fruit and then baking it, do not prick the bottom of the shell because the juice will soak through the bottom and your crust will be soggy.*

Chocolate Pie

Crust
1 cup chocolate wafer crumbs
1 cup oats
1/2 cup sugar
1/2 cup butter
> *Mix together and press along the edges of a 10" pie plate.*

Filling
1 cup butter
1 cup sugar
> *Cream together.*

3 eggs
1 tsp. vanilla extract
> *Add in and mix well.*

8 oz. semisweet chocolate
> *Add in and blend well.*

> *Bake crust for 8-16 minutes at 300°. Remove from the oven and spread 3 tbs. of peanut butter on the bottom of the crust. Place filling in a pastry bag with a star tip and fill the pie plate to a dome shape. Decorate top with dark chocolate shavings. Refrigerate 5-6 hours.*

"Who said great-tasting things are hard to make?"

Section 2

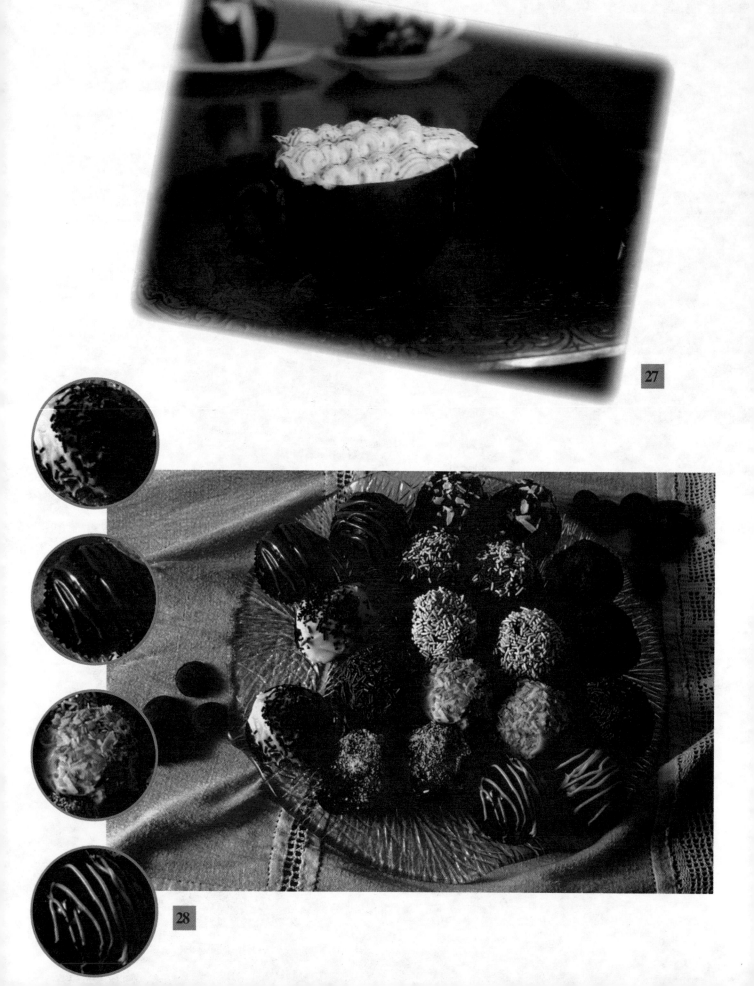

27

28

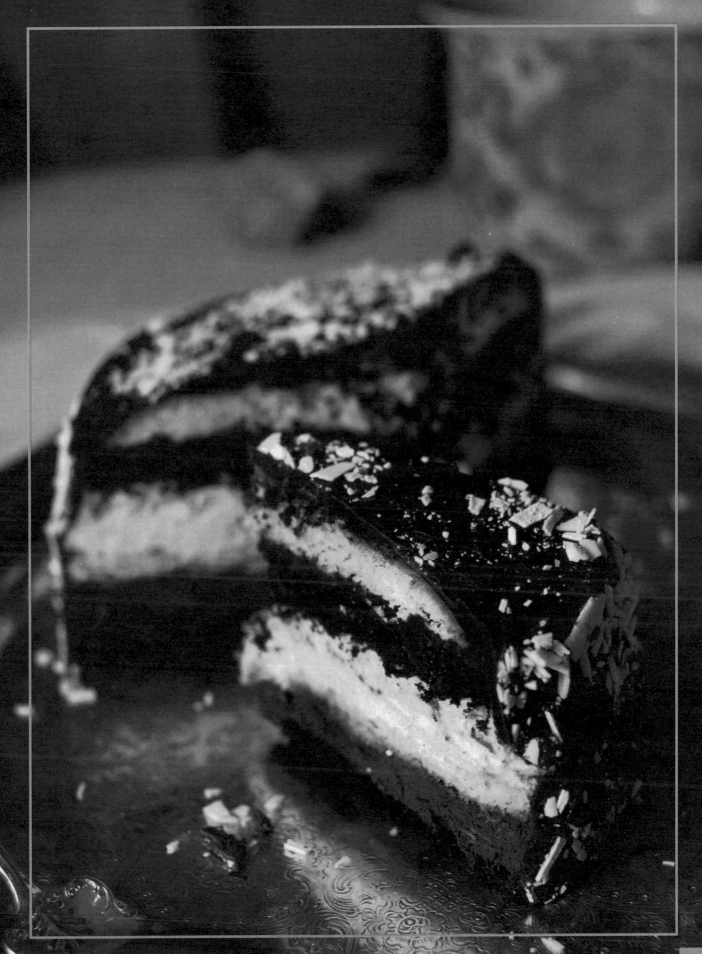

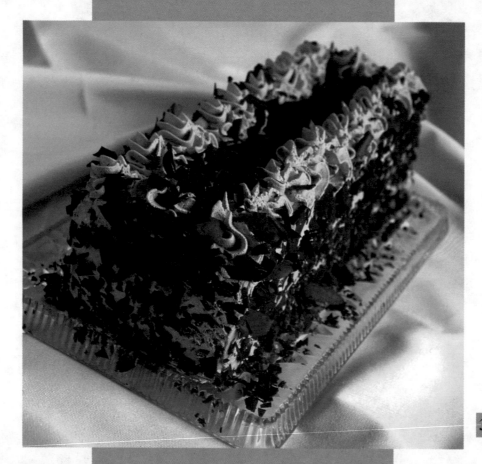

30

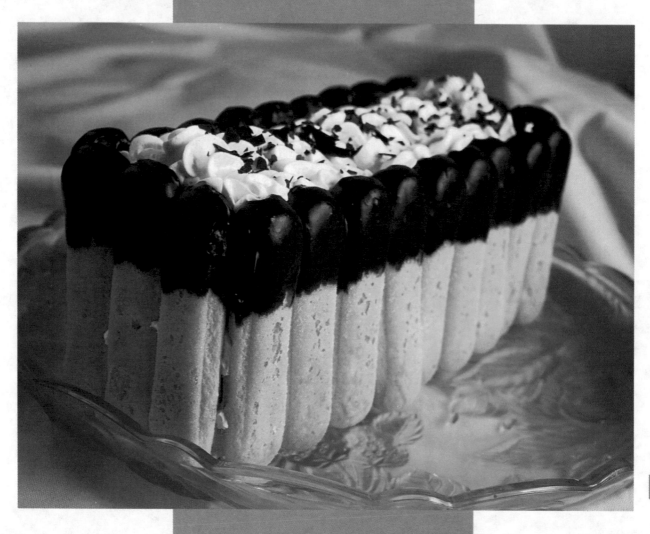

31

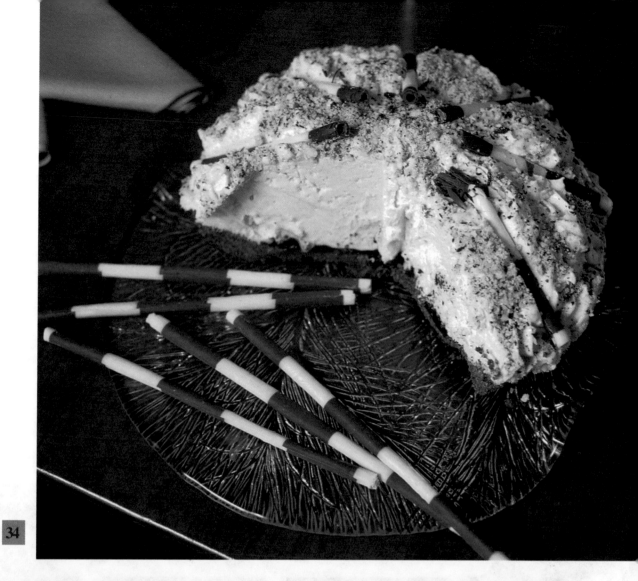

34

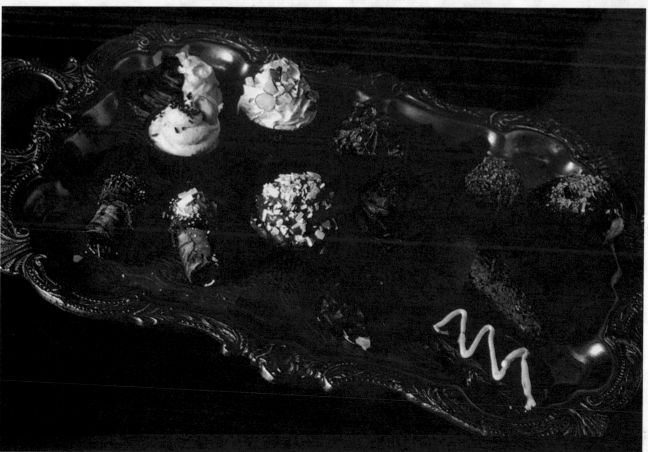

35

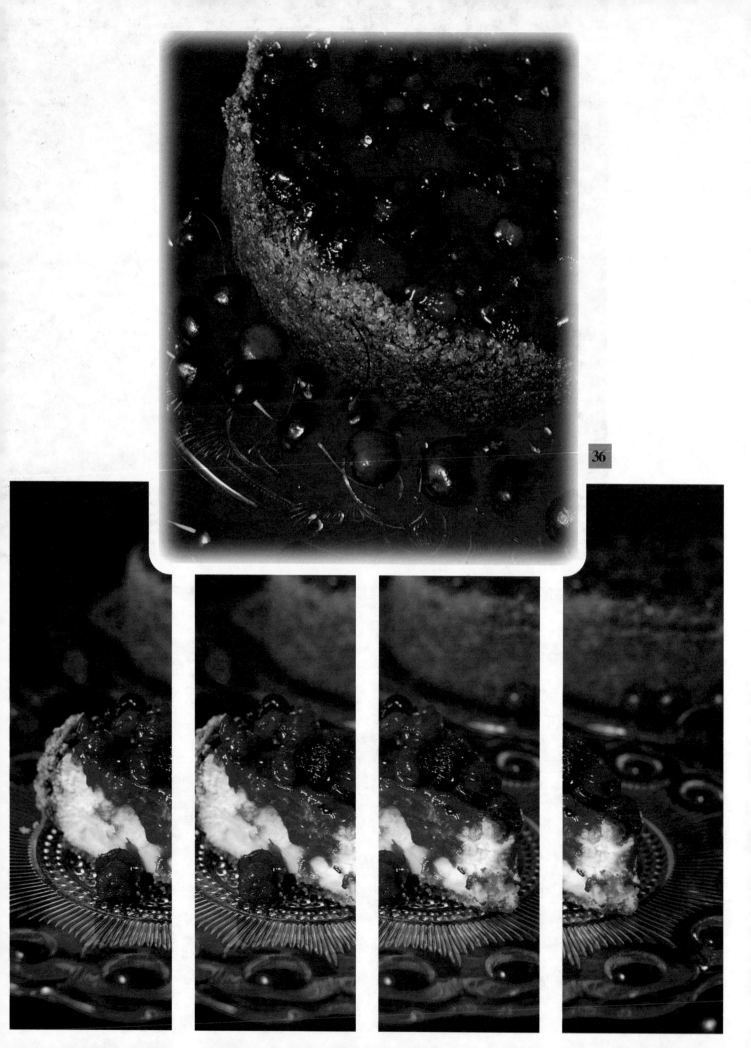

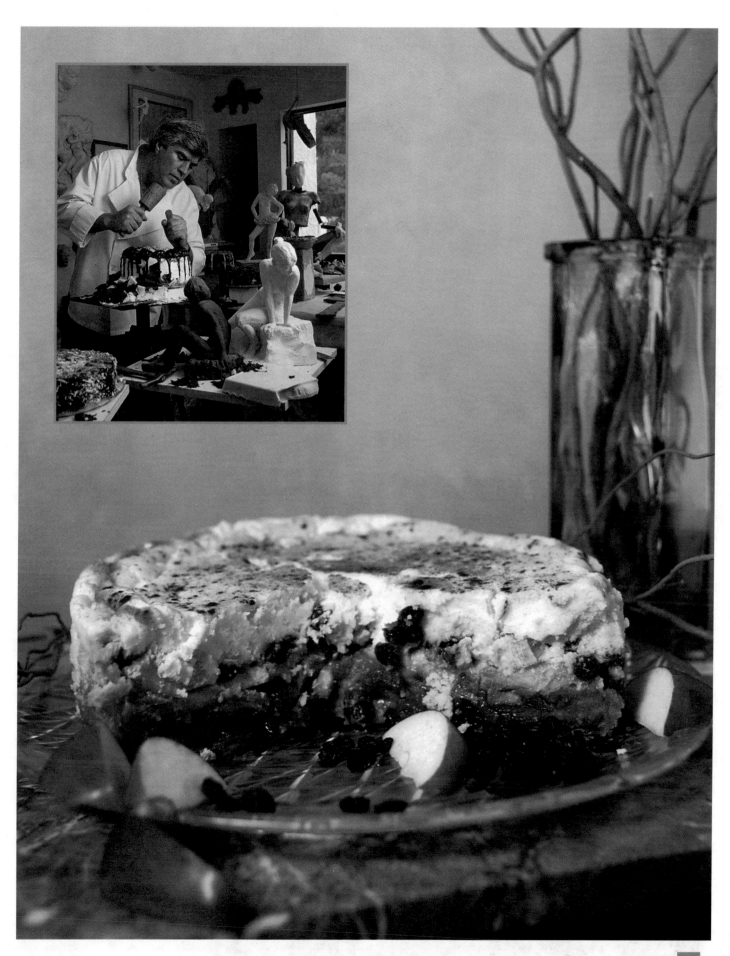

38

39

41

42

43

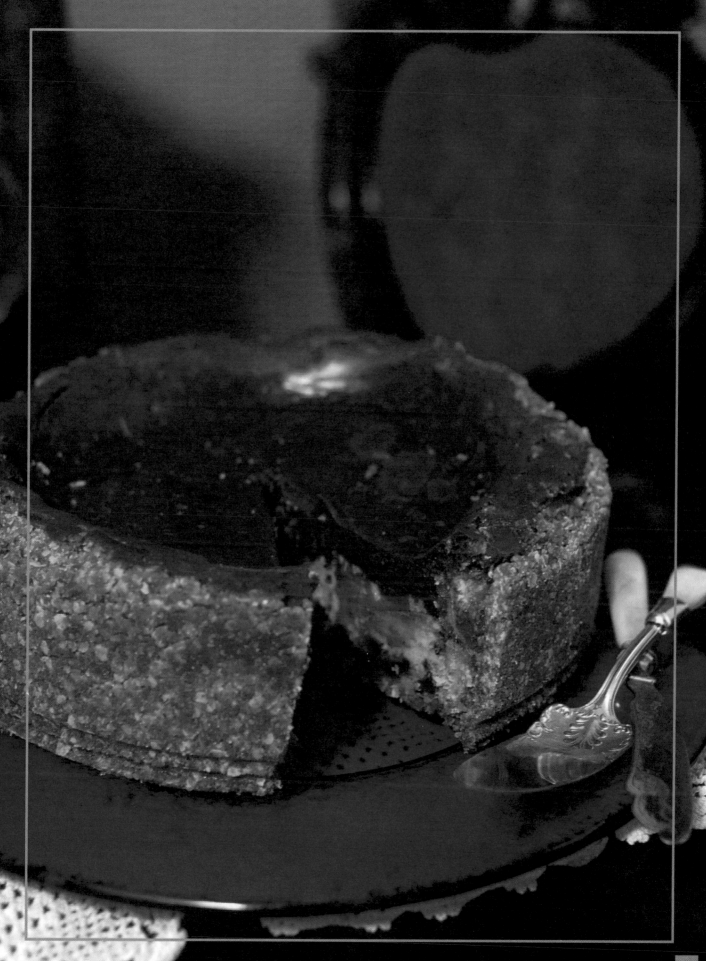

45

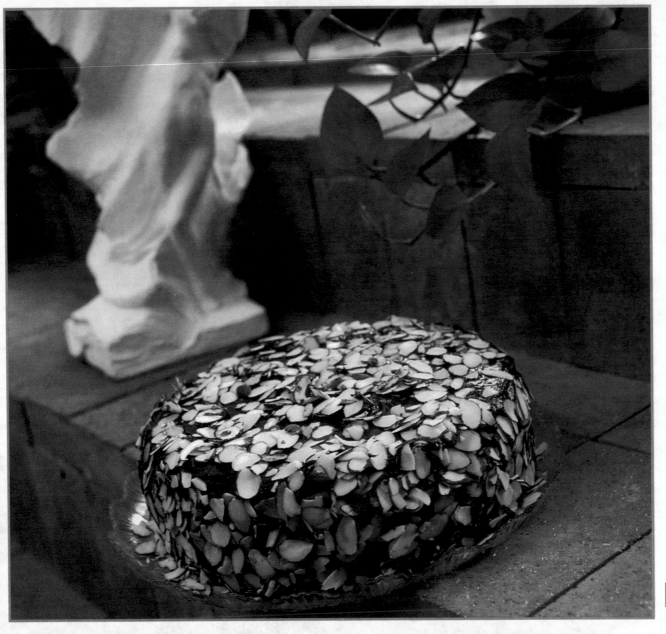

46

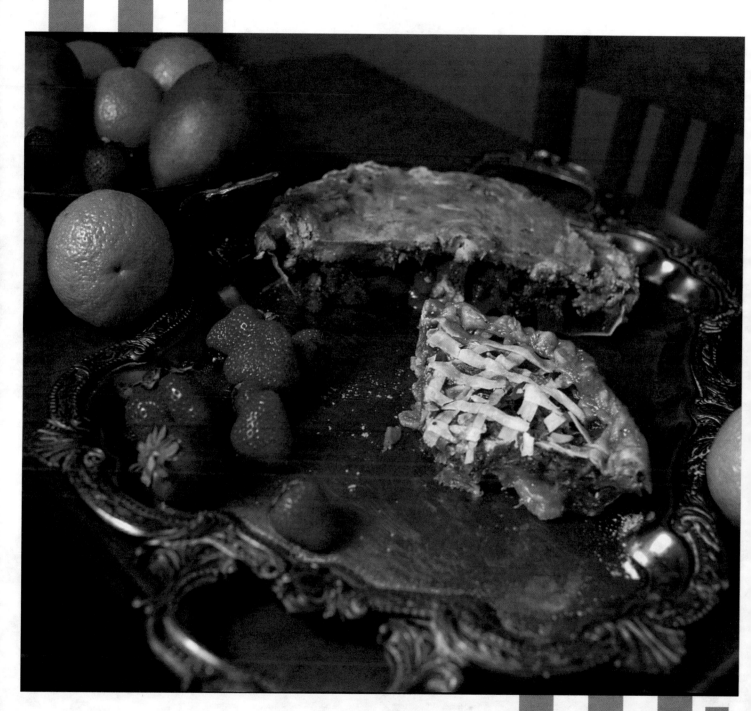

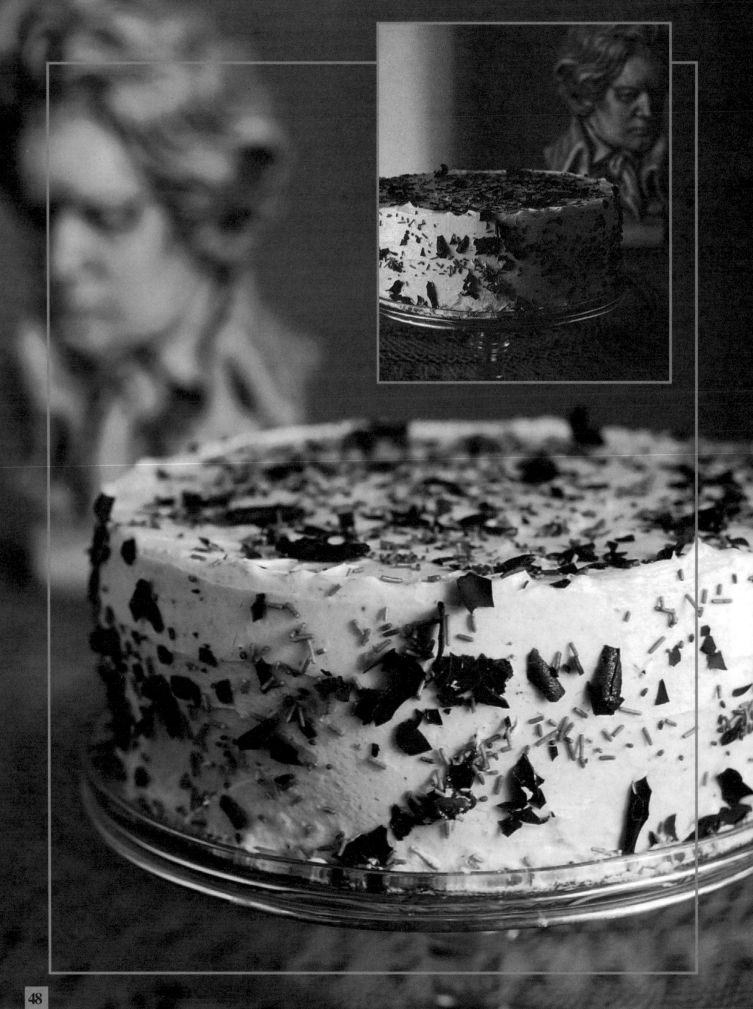

Apples: Celestial and Satanic

Despite the mythology that has spread around the world for centuries, the apple is not the forbidden fruit. Eve is said to have been cast out of earthly paradise forever because she ate an apple, which is an error of translation.

The word "apple" appears nowhere in the Book of Genesis. The Bible speaks only of a fruit without specifying what kind. The Bible mentions that Eve took the "fruit" and did eat and gave it to her mate, and he did eat.

In the Latin translation of the Bible, the fruit (karpos in Greek, as it originally was written) became an apple. In an amazing coincidence, the word for apple in Latin is malum (melon in Greek). Malum also means "evil" in Latin. Perhaps this convinced the translators that the "fruit" of the Bible can only be the apple.

The apple was introduced into Greek mythology when Dionysos, along with the grapevine and the wine, also introduced the apples. This apple wine was called "meliti".

The apple bears an ambiguous weight of symbolism both celestial and satanic.

The golden apple in the garden of Hesperides conferred immortality. Apples were eaten in Brittany before prophecies were made. Apples were given to the Irish legendary hero Candle, to confer immortality to him. Apples made the gods of the Scandinavian Pantheon immortal. The enchanted Merlin sat under the apple tree to teach. An apple was given to Snow White. An apple was given to King Arthur by a woman from the other world before taking him to the eternal kingdom.

Priests and monks through history credited their longevity on the juice from the apples. An apple was awarded by Paris in a beauty contest which began the Trojan war. Hippomenes enticed the nymph Atlanta with gifts of apples, convincing her to break her vow of chastity and lose her virginity to him. The highest priests of Egypt, who were the guardians of knowledge, were given apples to eat daily. Greek poets and philosophers mentioned apples since the 9th Century B.C. Since that time, the apple was regarded as magical and beneficial.

The apple tree will naturalize almost everywhere. It grows spontaneously all over the world and it is one of the most widely grown in the world's orchards. American apple varieties account for most of the world's markets.

Red Delicious apples originated in West Virginia. They are picked in August and kept in cold storage until April. There are other less known varieties of American apples with juicy sweet flesh, great for all baking uses.

The Richard and the Starking both have thick, shiny skin and are sprinkled with pale freckles. Another variety, this with a slight acid flesh, is the Winesap. It has a very red skin with firm and juicy flesh. Another popular apple is the Granny Smith, which originated in Australia in the late 18th Century by a grandmother who gave it her name. It is green with large pale spots, waxy skin and a very juicy, crisp and acidy flesh. It is now widely cultivated in France.

Popular European varieties of apples are the Einette Blanche, the Calville, the Belle De Boskoop, varieties that are not very robust but very well flavored.

Most apples mature between September and October. The apple is the most widely eaten fruit in the world. Apples that are picked early do not have the same nutritional qualities or flavor as the would had they been allowed to tree ripen. Although the apple tree was found in every orchard by the Biblical times, it is difficult to identify the year of the first "apple pie".

Apples are used in various methods in the kitchen. They go well in both savory and sweet dishes. In my Rum Apple Pie, I use apples with firm, sweet and juicy flesh, like the Red Delicious. The sweetness of the fruit combines well with rum for a unique flavor and allows us to use less sugar. This apple also works well for my Caramel Apple Pie. This recipe calls for the apple to be baked with the skin on because the Red Delicious apple's skin is thin and soft.

Rum Apple Pie

Dough for one pie
 Open dough and place it into a 10" buttered pie plate. Fold and flute excess edges of dough.

Filling
2-1/2 lbs. red apples, peeled and sliced
1 cup brown sugar
1/4 cup cornstarch
1/4 cup dark rum
1 tsp. cinnamon
 Mix well. Arrange in pie plate.

Topping
1/2 cup oats
3/4 cup pecans
1/2 cup butter, melted
1/2 cup flour
1 cup brown sugar
 Mix well. Cover filling with it.

 Bake at 350° for approximately 1-1/2 hours. This pie is best served hot with a scoop of ice cream.

Harvest Pie

Dough for two pie crusts

Filling
3 cups red apples, peeled and sliced
2 cups pears, peeled and sliced
1 tbs. lemon juice
1 tsp. cinnamon
2 cups seedless grapes
2 tsp. lemon peel
1/2 cup sugar
1/2 tsp. nutmeg
2 tbs. flour
 Mix ingredients well.
 Line a 10" pie plate with one round of dough. Spread in filling. Cut the second dough round into long strips and criss-cross over top. Fold in excess dough and flute edges. Bake at 350° for one hour.

Pistachio Chestnut Pie

10 sheets of fillo dough
Place 6 buttered fillo sheets in a 10" pie plate, overlapping the plate.

Pistachio Filling
3 cups pistachios
1/2 cup sugar
1/2 cup butter, melted
1 tsp. cinnamon
Mix together. Place in the pie plate. Cover with the four remaining fillo sheets, fold the ends of the fillo around the edges of the plate like you would a pie crust. Bake at 350° for one hour. Pour in 1/2 cup of cinnamon syrup. Refrigerate to cool.

Chestnut Filling
1 cup butter
1 cup sugar
Cream together.
1 cup chestnut puree
Add in.
1 tsp. vanilla extract
3 eggs
1 tbs. Kahlua
1 lb. white chocolate, melted
Add in and mix well.
Pour filling on top of crust, forming a dome. Drizzle top with 2 tbs. white melted chocolate mixed with 1 tbs. heavy cream.

Orange: The Charming Prince

Today, oranges are taken for granted because they have saturated the market, but throughout the centuries, though, it has been a great specialty and a precious gift. Not too long ago, poor children did not dream of gifts on Christmas. They anticipated Christmas because they were getting an orange as a present. Most of those children did not know what an orange tasted like. Some would not dare to eat that golden magical fruit.

The orange is mentioned in several historical writings, like Homer's Odyssey, also by Sophocles, Hesiod and Plutarch, by the Chinese, the Egyptians, the Indians, the Romans. Oranges appear in everyone's history frequently. The citron, an ancestor of the orange, set out its travels before the orange. It was first cultivated in Nipour, the capital of Sumerians. It was a sacred fruit, dedicated to the god of air and earth, Enlil.

It was singled out by Alexander and it was used by the Egyptians and praised by historians for its virtue as an antidote. Oranges began their cultivation in Southern Italy, Sicily and Corsica in the 4th Century B.C. The citron was used only medicinally and in perfume in classical times. The lemon was unknown to classical writers. It was widely used in the middle ages. After the 17th century, it was regarded as an essential part of every kitchen. The lemon originated in the foothills of Kasmir and it reached China in 1900 B.C. There it was given the name Limung and from that, more contemporary names were given: lemon in English; limon in Spanish and Russian, lemoni in Greek. In other

languages, it's name is derived from the Latin Citron.

Lemon reached the Arab world in the 10th Century and from there arrived in Greece and on to Spain. The lime, which is a small green lemon, was introduced by the Spanish in the 16th Century. The orange crossed India and reached China about 2200 B.C. Originally, the orange was bitter like today's pink grapefruit. Another bitter citrus was the pemelo, which is today's grapefruit. This grew wild in Indonesia, Indiochina and the West Indian isles.

Two other fruits related to the orange and were originated in China are the mandarin and the kumquat. The kumquat stayed in China until recent years because it was too small and delicate to travel.

The first orange groves appeared in North Africa and then started to appear at banquet tables in Rome. By the time the Roman Empire was declining, the barbarians were destroying the roman orangeries by burning them or not caring for the water-greedy trees. But centuries later, there were plenty of oranges left in Sicily and Calabria.

By now the orange taste had improved to sweet and delicious. Orange juice began to be recognized for its medical benefits by physicians and historians alike. Oranges were very much a Spanish fruit where they were cultivated to excellence. From there they spread like wildfire to Europe and to the world. The orange loves the brightness of the sun, the scent of the wind with humidity from the sea nearby. It needs to be treated like a prince, with loving care. The fruit must be gathered with respect, as if the orange tree has a personality of its own. It is free spirited and demands respect. It is determined to bare the best, in the most magical parts of this world - Spain, Greece, Portugal, Israel, Cyprus, Morocco, Florida and California.

The orange was brought by Columbus to the New World on his second voyage. The first orange tree was planted in Haiti in 1493. From there it spread to the islands of West Indies and reached America while the first orange plantation flourished in Florida in 1579 and then went on to California, where the first orange plant was planted in 1707. From there, it spread to Mexico where it became one of the country's major source of income. By the middle of the 18th Century, the period of the Gold Rush waves had overtaken California. Many people realized that the cultivation of the beautiful and delicious fruit was a better way to become rich than the metal from the earth.

Because of the high vitamin C content in the orange, it became the principal cure for scurvy, an illness that until now was widespread with sailors who were deprived of fresh food. The symptoms now were becoming widespread among the prospectors who were exhausted from the search of gold, who were often alcoholic and poorly nourished on canned foods. Because of its medicinal wonders, the frozen orange juice was invented to satisfy the demand of the golden juice of the orange to places that it can't be grown; to the sailors, to the prospectors and remote homes. Originally, that frozen juice was as expensive as gold.

By now the orange growing was spread throughout the whole American continent. At Bahia, in Brazil one day a tree produced a great orange, sweeter and juicier than usual and with even more vitamins than any other kind of orange. This orange had a naval on the other end of the stem. This seedless orange became the most wonderous of all citrus fruits. From Brasil, it was taken to Washington by the missionaries and Washington Navel became the golden prize to the world of citrus. Meanwhile, the orange growing became big in Africa, especially in the northern parts where it grew best.

Every orange has a personality taken from the sunny country where it was raised. The orange is available year round. Today, the best regarded orange is the one from Morocco, with Spain, Florida, California, Portugal, Greece, Italy, Algeria, Brazil following close behind. As we can see, the orange grows best in the countries that the imagination of beauty runs wild, where the climate is heavenly, the sun sensuous, the water pure and abundant, the breeze caressing, the soil light and mature, the nights cool and restful, the man patient, skillful and caring; where the orange is treated like a prince, both by the environment and by the people handling it.

The orange is not as perishable as other delicate fruits, yet it requires delicate handling. The orange travels much and far. It can be easily contaminated by traveling companions and spoiled by the slightest of scratches. Oranges are picked as soon as they reach the right degree of maturity. Judging the right pick is a delicate business. The packing process requires precautions. At this stage, the orange is full of water and easily damaged.

In some countries, pickers have to show their hands for inspection. Their fingernails must be short and clean, and in other countries the pickers wear gloves. In the packing station, the orange is put through a beauty treatment, much like a beauty salon. First, the oranges are fed into a bathtub with soapy water, after they bathe for several minutes, they take another bath to disinfect them. The drying process takes several hours in an aerated room where the skin of the fruit firms up by evaporating the moisture from it. After this, the fruit is nicely dried by a powerful hot air ventilation and then it is polished with soft brushes and lightly waxed to give it an attractive, clean, shiny appearance. This also helps to seal in the vitamins. Then they are loaded on the conveyor belt where a strick process of sorting begins. All injured, insufficiently ripe, abnormal fruits do not make the trip to export. Their visa is denied and they find their way to a local market or to a manufacturer for production. Sometimes, the oranges are wrapped in tissue which prevents contamination. The basic material of the thriving industry is the outstanding vitamin content which combines with the delicious taste, availability year round and reasonable prices making the orange a part of every household in the world. It makes a healthy and satisfying dessert or snack.

Hundreds of different products are made from the orange: juice, liqueurs, confectionary, marmalade, cosmetics, essential oils, and some chemicals. It is used in cooking and baking. Its peel also flavors dishes and delicate desserts. I mentioned my Portokali Pie (orange in Greek) baked with apricots, as it comes out from the oven is a deadly force of temptation.

Portokali Pie

Two pie crusts
Open both pieces of dough. Place one pie crust in a 10" buttered pie plate.

Filling
2 cups orange jam
2 cups apricot jam
2 cups sugar
2 cups brown sugar
6 oranges, peeled, cut into pieces
8 apricots, peeled, cut into pieces
1/2 cup cornstarch
Juice of 1 lemon
1/2 tsp. nutmeg
1 tbs. Grand Marnier
1 tbs. apricot brandy
1 cup sliced almonds
Mix well.

Spread filling on crust. Cut second pie crust into strips approximately 1/2" wide. Criss-cross strips on top of filling. Fold in excess dough and flute edges. Bake at 350° for approximately 1-1/4 hours.

The orange is not as perishable as other delicate fruits, yet it requires delicate handling. The orange travels much and far. It can be easily contaminated by traveling companions and spoiled by the slightest of scratches. Oranges are picked as soon as they reach the right degree of maturity. Judging the right pick is a delicate business. The packing process requires precautions. At this stage, the orange is full of water and easily damaged.

In some countries, pickers have to show their hands for inspection. Their fingernails must be short and clean, and in other countries the pickers wear gloves. In the packing station, the orange is put through a beauty treatment, much like a beauty salon. First, the oranges are fed into a bathtub with soapy water, after they bathe for several minutes, they take another bath to disinfect them. The drying process takes several hours in an aerated room where the skin of the fruit firms up by evaporating the moisture from it. After this, the fruit is nicely dried by a powerful hot air ventilation and then it is polished with soft brushes and lightly waxed to give it an attractive, clean, shiny appearance. This also helps to seal in the vitamins. Then they are loaded on the conveyor belt where a strick process of sorting begins. All injured, insufficiently ripe, abnormal fruits do not make the trip to export. Their visa is denied and they find their way to a local market or to a manufacturer for production. Sometimes, the oranges are wrapped in tissue which prevents contamination. The basic material of the thriving industry is the outstanding vitamin content which combines with the delicious taste, availability year round and reasonable prices making the orange a part of every household in the world. It makes a healthy and satisfying dessert or snack.

Hundreds of different products are made from the orange: juice, liqueurs, confectionary, marmalade, cosmetics, essential oils, and some chemicals. It is used in cooking and baking. Its peel also flavors dishes and delicate desserts. I mentioned my Portokali Pie (orange in Greek) baked with apricots, as it comes out from the oven is a deadly force of temptation.

Portokali Pie

Two pie crusts
Open both pieces of dough. Place one pie crust in a 10" buttered pie plate.

Filling
2 cups orange jam
2 cups apricot jam
2 cups sugar
2 cups brown sugar
6 oranges, peeled, cut into pieces
8 apricots, peeled, cut into pieces
1/2 cup cornstarch
Juice of 1 lemon
1/2 tsp. nutmeg
1 tbs. Grand Marnier
1 tbs. apricot brandy
1 cup sliced almonds
Mix well.

Spread filling on crust. Cut second pie crust into strips approximately 1/2" wide. Criss-cross strips on top of filling. Fold in excess dough and flute edges. Bake at 350° for approximately 1-1/4 hours.

Pears: Temperant Souls

Pears have been popular with chefs for a very long time. The pear tree is a native of the Middle East, and it grows in all temperate regions of Europe and Asia.

The varieties of the pear tree has improved since the wild pear tree that used to produce few and small fruit. The pears are distinguished from each other by the taste and succulance of the fruit. The Romans ate pears both raw and cooked. The Byzantines made jelly and preserves, and also a specialty with pears cooked in wine. Today, pears come in different colors: golden, pink, brown, yellow, and green. They ripen in different seasons; the summer, the autumn and the winter. The pear tree encourages fertilization and it needs a rich deep soil and does not tolerate drought.

The fruit usually is large with a thick, rough and not very waxy skin. Most of the pear varieties are yellowish green in color and when they are fully ripened, turn to yellow. In my Pear Walnut Vermouth Pie, the dry vermouth compliments fully the semisweet flesh of the pear. The combination creates a soft silky texture, combined with the crunchy walnut crust with fillo dough. It brings an unforgettable taste of baked walnuts and succulent vermouth drenched pears.

Walnut Vermouth Pear Pie

10 sheets of fillo

Crust
3 cups walnuts
1/2 cup sugar
1/2 cup butter, melted
1 tsp. cinnamon
Mix well.

Place 6 sheets of buttered fillo in a 10" buttered pie plate, overlapping the pan edges. Spread crust filling across the fillo. Top with remaining buttered fillo and fold edges like a pie crust.

Filling
10 whole pears, cut in quarters
2 tbs. cornstarch
1 tbs. vermouth
1-1/2 cups brown sugar
1/2 tsp. nutmeg
Mix and pour over fillo crust.

Topping
1/2 lb. white chocolate, melted
1 tbs. sour cream
2 tbs. walnuts, grated
1 tbs. butter, melted
1 egg
1 tbs. whipping cream
1 tsp. sugar
Mix well.

Spread topping over filling. Bake at 350° for 1-1/4 hours.

Peaches: Goddess of Purity

The peach tree was first cultivated in China 5,000 years ago. Since then the Chinese have venerated the peach tree. Its blossom is regarded as a symbol of virginity. The peach tree arrived in Persia and after a long time, went to Europe and much later, America.

The peach is a typical summer fruit. There are two main varieties of peaches: the white, a very tempermental, thin-skinned, succulent fruit that does not like refrigeration, heat and doesn't travels well and ripens in July; or the yellow, which is of American origin, a less fragile fruit that stores and travels well. This handsome fruit is in the market in abundance and very popular for its unique flavor.

In Japan and China, the blossoming of the peach tree symbolizes the spring. The bride wears wreathes of peach blossoms. It stands for virginity and fertility. Siwang Mou, the Royal Mother, was said that the peach tree she grew in Western China bore fruit only once in 3000 years. Its sap made anyone who touched it luminous.

The monk, Ling Yun, received enlightenment from eating the flowers of the peach tree. The peach tree of immortality is vast, it takes 1000 men hand in hand to encircle it.

The legend continues that at the first fork of its branches, an invisible gate opens and the spirits of the dead are able to slip out. The guardians of the gate only allow good souls to pass, the bad souls are seized and thrown to the tigers.

Sometimes the bad ghosts, swift and cunning, manage to get past the descent to human habitation, where they enter to torment people. After many complaints, Emperor Huang Ti ordered the shapes of the guardians to be painted or carved on door lintels of peach wood. Since then the bad ghosts have turned back, returning to their place where they tirelessly await a chance to try again, hoping to slip through the guards.

The peach is used widely in the kitchen, especially when baking cakes, tarts, puddings, and pies. The peach is a great marriage with the tart boysenberries in my Peach-Boysenberry Pie. It splits the personality of the taste and the white chocolate builds that bridge of taste to connect into a smooth memorable dessert. The taste overcomes the senses and you will reach for a second helping.

Peach Boysenberry Pie

One pie crust
> *Open the dough and place it in a 10" buttered pie plate. Flute edges.*

Filling

8 peaches, cleaned and sliced
> *Line along bottom of crust.*

4 cups boysenberries
> *Layer over peaches.*

3 cups white chocolate chips
> *Layer over boysenberries.*

Topping

1/2 cup butter
1/2 cup sugar
1/2 cup flour
> *Cream together.*

1 cup almonds
2 tbs. Amaretto
2 eggs
> *Add in and mix lightly.*

Spread topping over filling and bake at 350° for one hour.

Angel Hair Pie

Filling

1 quart milk
1/2 cup cake flour
1-3/4 cup sugar
1 cup semolina flour
1 cup butter
2 tsp. lemon peel
2 tsp. vanilla extract
2 tsp. Grand Marnier
8 eggs
1 lb. Kataifi shredded dough*

Heat milk, cake flour and 1 cup sugar until warm. Add in semolina and butter, stirring well. Remove from heat when butter melts. Add in lemon peel, vanilla extract and Grand Marnier, blending well. Add eggs and remaining sugar beating well.

Arrange 1/2 of the dough on a 10" buttered pie plate. Top with filling and remaining dough. Fold the overlapping dough on top of the pie. Bake at 350° for approximately one hour.

Syrup

1 cup water
1/2 cup honey
1/4 cup sugar
1 tsp. cinnamon

Blend and boil for 10 minutes, pour over pie while warm.
**Available at specialty stores.*

"Cherry Berry Pie is a unique combination of berries. Lovers of tart pies will adopt this creation as one of their lifetime favorites."

Cherry Berry Pie

Dough for two pie crusts
Open both pieces of dough. Line a 10" buttered pie plate with one piece of dough.

Filling

12 oz. cranberries
1 cup brown sugar
1 tsp. cinnamon
1 tsp. ground cloves
1/2 cup cherry juice (from the dark cherry can)

8 oz. dark cherries (canned)
8 oz. can cherry pie fillling
2 tbs. cornstarch
Juice of 1/2 lemon
1 tsp. almond extract

Blend berries, sugar, cinnamon, cloves and juice. Simmer 15 minutes. Add in lemon and extract, remove from heat. Add in remaining ingredients and mix well.

Spread pie shell with filling. Cut second pie crust into 1/2" strips. Cross-cross strips on top of the filling. Fold excess dough and flute edges.

Bake at 350° for 50-60 minutes.

White Chocolate Pie

Crust

1 cup ladyfinger crumbs
1/2 cup oats
1/2 cup sugar
1/2 cup butter

Mix well, press along bottom and sides of a 10" pie plate. Bake at 300° for about 8-10 minutes, let cool.

Filling

1 tbs. hazelnuts, finely grated
1/4 lb. semisweet chocolate, melted

Cream well, spread on crust.

1 cup butter
1 cup sugar

Cream together.

3 eggs
1 tsp. vanilla extract
8 oz. white chocolate, melted

Blend well and add in to the butter mixture. Refrigerate to set. Pour in a pastry bag with a large star tip and pipe in to pie plate forming a dome.

1/2 cup hazelnuts, finely chopped

Sprinkle on pie.

꧁꧂

Bourbon Pecan Pie

Dough for one pie

Line a 10" buttered pie plate, flute edges.

Filling

1 cup butter
1/2 cup brown sugar
1/2 cup sugar

Cream together.

4 eggs
1 tsp. vanilla extract
1 cup corn syrup
1/4 cup Bourbon
1 cup flour
12 oz. chocolate chips
1-1/2 cups pecan pieces

Add in, mix gently but thoroughly. Bake at 350° for 1-1/4 hours.

Figs: Father, Son and the Holy Fig

The fig tree, sacred in all ancient religions, was also the first tree to be mentioned in the Bible. When Adam and Eve ate the forbidden fruit, their eyes were opened. They noticed that they were naked and sewed fig leaves together to make aprons to cover themselves.

The fig has been symbolic of knowledge and health throughout history. Plato called figs a food for athletes. Archeologists have gone through pain to preserve Plato's 4000-year-old fig tree.

Fig trees are found in the Mediterranean basin in almost every yard. For the rest of the world it is a luxury because of its high price. Figs have been a part of the diet for the Mediterranean countries since the classical times. A handful of fresh or dried figs made a nourishing meal. Figs have also been important for the economy of those countries. The Greeks, who always regarded the fig as precious as gold, forbade the export in order to protect the main resource. Figs were only picked after the priests declared them ripe.

Syko is Greek for fig. The name Sykofantis, was given to those who denounced the contraband fig trade. Later, Sukofantis (Sykofant) became an epithete for all informers. The fig has hundreds of family members but only comes in two colors and it has almost the same shape. White figs are thin skinned and the purple ones have thick skin. The fig tastes best if matured naturally and not forced. Real lovers of the fruit prefer the fruit of the late summer which is very sweet and oozing with flavor. Many of those figs are so exquisite as they are both firm and melting. Throughout the centuries, the fig was eaten before the meal, between courses or as a dessert.

Dried figs are featured among the traditional desserts of Christmas. A popular treat for children was a dried fig, split open and stuffed with a walnut. Roasted or dried were a part of all the ancient people of the Mediterranean, at times it even replaced the bread at the table. The figs were also made into a type of wine that was very popular.

The Romans and the Gauls followed the example of the Greeks in fattening geese's livers to make the best foa gras of the time. The dried figs were made into a pudding, also into a cereal-like meal, chopped with dates and other dried fruit and soaked in milk. In Rome, there was a dessert made with figs soaked in wine.

In the 18th Century, dried figs were poached in water and then soaked in whiskey. Lovers of figs, who are many in the deep history, proclaimed "You may deprive me of anything except coffee and figs". In Greece today, after a meal, to compliment the chef you announce that "the meal tasted just like a cold fig".

The fig and the fig tree have symbolic meaning in abundance since ancient times. Egyptian priests ate them before ceremony. The desert hermits ate them for longivity. To many cultures the many seeds of the fig bonded together use to signify unity, understanding, knowledge, and faith.

African women use the white sap of the fig tree as an ointment against sterility and to encourage lactation. The Indians consecrated the fig tree to god Vishnu, savior of the world; the Greeks to Dionysos, God of Renewal. Remus and Romulus were sheltered under a fig tree on their birth. The fig tree in East Asia was sacred by Buddah to symbolize power, life and knowledge, acquired by meditation.

The Arabs regarded the fig tree as symbolic in association with fertility. The Greeks and Romans collected the milk of the fig tree to make a soft creamy cheese;similar to today's riccota. In 1941, Americans discovered that the fig, papaya and pineapple contain an enzyme that makes the skin soft and silky. Besides eaten fresh and dried, figs are also used in the kitchen. My Fig Berry Pie is very popular among my guests who dare to try this unusual blend of the raspberry with the delicate fig and the intrusion of the sinful chocolate.

"Nick's homemade desserts will make you regret you had no room left for them. The fig berry pie is fabulous – a buttery crust enfolding berries, figs and intense chunks of dark chocolate. It's a fantastic combination,"

New Times, 1992

Fig Berry Pie

Pie crust for one pie
> *Flatten with rolling pin and place in a 10" buttered pie plate. Flute edges.*

Filling
10 figs, cut in half
2 cups raspberries
1-1/2 cups chocolate chips
> *Place figs on crust, with cut ends facing up. Layer with raspberries and sprinkle with chocolate chips.*

Topping
1/2 cup butter
1/2 cup sugar
> *Cream well.*

2 tbs. flour
1/2 cup hazelnuts, grated
1/4 cup whipping cream
1 tbs. Frangelico liqueur
2 eggs
> *Add in and blend well. Spread topping on filling. Bake at 350° for 1 to 1-1/4 hours.*

Chestnut Pie

Dough for one pie
> *Flatten with rolling pin and place in a 10" buttered pie plate. Flute edges.*

Filling
1/4 lb. chestnuts puree
1/2 cup whipping cream
> *Blend well.*

1 tsp. vanilla
1/2 cup brown sugar
1/8 cup Kahlua
1/2 lb. white chocolate, melted
3 eggs
1/2 cup flour
> *Add in and mix well.*
> *Spread filling on crust. Bake at 350° for one hour. Glaze with sauce.*

Sauce
1/8 lb. white chocolate, melted
2 tbs. Kahlua
1 tbs. sour cream
> *Blend well.*

Creamy Fruit in Pastry

Two 12" rounds of pastry dough, unbaked
Layer one pastry round into a 10" buttered pie plate.

Filling
3/4 lb. cream cheese
3/4 lb. sugar
Cream well.
2 eggs
1/2 cup sour cream
1/2 tsp. vanilla
1/2 lb. white chocolate, melted
Juice of 1/2 lemon
Blend in well.
1/4 cup papaya, chopped
1/4 cup passion fruit, chopped
1/4 cup guava, chopped
1/4 cup pineapple tidbits, chopped
1/4 cup banana, chopped
Add in and mix gently.
Pour filling into pie plate, fold on top of the filling the excess of the bottom pastry dough. Cover with the second pastry round. Tuck in the edges of pastry dough. Bake at 375° for 1-1/4 hours, until pastry is golden brown.

Peach Fillo Pie

16 sheets of fillo dough
Place half of the sheets in a buttered 10" pie plate, brushing each fillo sheet with butter and slightly overlapping pan edges.

4 lbs. ripe peaches, peeled, sliced
Juice of 1/2 lemon
1 tsp. pumpkin pie spice
1 tsp. ground allspice
8 oz. pineapple pieces
1/8 cup pineapple juice
1 tsp. ground ginger
1 tbs. cornstarch
1/2 tsp. ground cloves
5 tbs. honey
1/2 tsp. ground cinnamon
1/2 tsp. nutmeg
Mix ingredients well and spoon filling into pie plate, fold in overlapping fillo.. Cover with remaining fillo, buttering each sheet. Tuck in ends of fillo. With a sharp knife, cut diamond shapes across the top fillo. Bake at 375° for about one hour, until lightly brown.

Moura Cream Pie

Dough for one pie crust

Open the dough into approximately 16" rounds. Cut a triangle from the end of the dough approximately 5" deep. Make another triangle cut approximately 4" from the first cut . Repeat the process all around the dough until you have formed a big star. Place dough in a 10" buttered pie plate.

1/2 lb. cream cheese
1/8 cup sugar

Cream together.

1 egg
1/2 cup sour cream

Add in and mix well.
Place cream cheese filling on the pie plate.

Filling

8 oz. cranberries
1 cup brown sugar
1 tsp. cinnamon
1 tsp. ground cloves
Juice of 1/2 lemon
8 oz. raspberries
8 oz. blueberries
1/2 tsp. almond extract
1/2 cup raspberry sauce

Place in a pot and simmer for about 15 minutes.
Place filling in a bowl and mix in 3 tbs. cornstarch. Then pour filling into the pie plate. Fold the edges of the star dough over the filling.
Bake in 350° oven for about 1 hour.

In 1834, Lewis Seacor of Rochelle, New York cultivated blackberry bushes on his farm. His neighbor, William Lawton, also began growing blackberries. As a result, the fruit will become known as "New Rochelle Blackberries", which were exhibited at the 1852 New York's Farmers Club meeting. Blackberries would also become known as Lawtons.

New Jersey botanist Frederick Covine developed a blueberry in 1910 that was plump and almost seedless. This blueberry will revolutionize the blueberry cultivation and will be the basis of a multimillion dollar industry.

In 1920, the boysenberry was developed by U.S. breeder Rudolph Boysen. It is a cross between a blackberry, a raspberry and a loganberry.

In 1933, grower Walter Knott of Anaheim, CA., makes the boysenberries the basis of the Knott's Berry Farms. He harvests five tons of the long reddish-black berries per acre.

Apple Cherry Pie

One pie crust recipe
> *Open dough and place in a 10" buttered pie plate. Flute edges.*

7 red apples, peeled and cut into pieces
1 tsp. cinnamon
1/2 cup brown sugar
Juice of 1/2 lemon
2 tbs. Grand Marnier
> *Mix in a bowl. Pour into the pie plate.*

8 oz. cherry pie filling
8 oz. dark cherries
Juice of 1/2 lemon
1 tsp. orange peel
> *Pour on top of the apples.*

Topping
2 eggs
1/2 cup sugar
> *Beat well.*

1 tsp. nutmeg
1 cup whipping cream
> *Add in and mix well.*

1/2 cup flour
> *Add in and mix well.*
> *Pour on top of the filling.*

Strussel
1/4 cup flour
1/8 tsp. cinnamon
1 tbs. brown sugar
1 tbs. butter
> *Mix well.*
> *Separate the strussel into little pieces and drop them on top of the pie topping.*

Bake in 350° oven about 1 hour.

In Nick's restaurant, there is a monstrous dessert selection, including a wicked Fig Berry Pie with raspberries and dark chocolate.

Best of Phoenix, 1993

174

Strawberry Mango Pie

One pie crust recipe
Open dough and place in a 10" buttered pie plate. Flute edges.

Mango Filling
4 large mangos, peeled and cut into pieces
Juice of 1/2 lemon
1/4 tsp. nutmeg
1/4 tsp. cinnamon
1/4 tsp. ground cloves
2 tbs. butter, cut into small pieces
Mix in a bowl and pour into the pie plate.

Strawberry Filling
2 lbs. strawberries, sliced
1/2 cup sugar
1/2 cup brown sugar
2 cups strawberry jam
1 tbs. Grand Marnier
1 tbs. cornstarch
Mix well. Place on top of mangos.

Topping
1/2 lb. cream cheese
1/2 cup sugar
Cream together.
1 egg
1 tsp. vanilla extract
Add in and mix well.
2 bananas, cut in small pieces
Add in and mix well.
1/2 cup sour cream
1/2 cup whipping cream
1/2 cup flour
Add in and mix well.
Spread on top of filling. Bake in 350° oven for about 1 hour.

**When it comes to cheesecake at Nick's,
nothing succeeds like excess. These are some of the
most decadent cheesecakes on the planet.**

Best of Phoenix, 1994

I was thinking about caramel apples and I asked myself "Why not a Caramel Apple Pie?"

Caramel Apple Pie

Two pie crust recipes
 Open to about 12" in diameter. Place one of the pie crusts in the bottom of a buttered 10" pie plate.

10 red apples
 Do not peel them, cut them in large pieces. Discard seeds.
2 cups brown sugar
1 cup quick oats
1 cup cornstarch
1/4 cup strong coffee
1 tbs. Kahlua
1 tsp. cinnamon
2 cups pecans
1 tbs. lemon juice
3 cups caramel sauce
1 baked meringue, crumbled
 Mix all ingredients in a bowl and pour into a pie plate. Cut the second pie crust in to 1" strips, arrange strips on top of pie criss-crossing them. Fold in the excess pie dough, folding in the ends of the strips and flute them. Bake in 350° oven for about 1 hour.

Social Necessity

Foods have such an intense emotional significance that they are often linked with events that have nothing to do with nutrition. In all societies, both simple and complex, eating is the primary way of initiating and maintaining relationships. In cultures, where eating is a ceremony, one eating alone is unthinkable. The fact of sitting down to eat together conveys an important statement about a society.

The culture of a society is transmitted to children through eating with the family. It is a setting in which personalities develop, kinship obligations emerge and the customs of the group are reinforced.

The many associations between eating and human behavior can be seen clearly in simple and isolated societies where eating is not considered a biological necessity for sustaining life, nor do they consciously recognize certain foods as having a higher nutritive value than others.

They eat not simply because they have an appetite but because eating is a social necessity. To give food is a virtuous act and the man who distributes large amounts of it is by definition a good man. For all that we denigrate the magical believes connected with food in simpler societies it should be remembered that some of us throw salt over a shoulder to ward off bad luck, or eat fish in the belief that it is a superior brain food or order oysters with the hope of inspiring sexual potency.

A people's niche in the environment is determined as surely as it is for other animal species by people's eating behavior. That is because eating inevitably brings humans into broader contact with their total environment, not only with their natural surroundings, but also with their social, economic and political relations with neighbors.

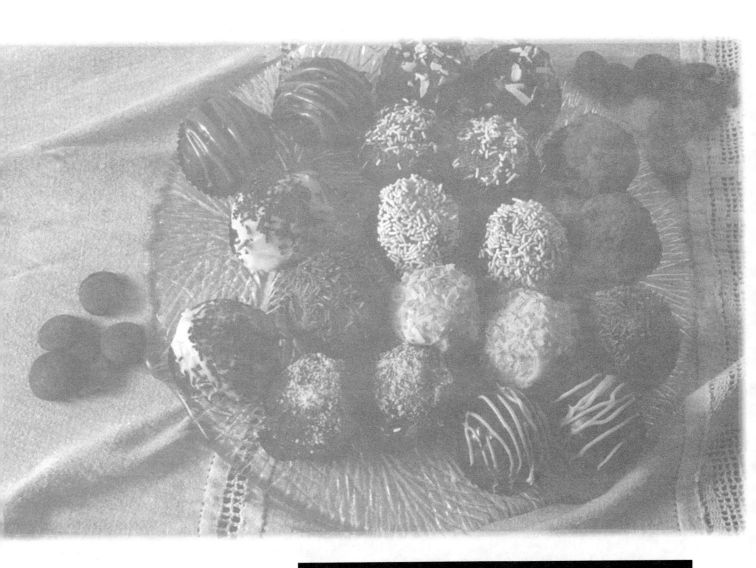

Brownies, Bars
& Truffles

Brownies were created when a careless chef failed to add baking powder to a chocolate cake batter. The first published recipe book for brownies appears in the Sears, Roebuck catalogue In 1897. Before this, housewives were making the dense, fudgy squares for sometime. They received the recipes by word of mouth.

I want to impart a distinctive touch to everything that has to do with cooking and baking, even simple things like brownies. If it is done correctly, simplicity can be very exciting, and often is more impressive than complicated dishes.

Use baking pans with tall ends for the brownie recipes (at least 2" high). You may use a 11" x 17" or a 12" x 16" baking pan.

Cheesecake Brownies

First Layer

3/4 lb. butter
3 cups sugar
> *Cream together well.*

6 eggs
1 tsp. vanilla extract
1/2 lb. semisweet chocolate, melted
1-1/2 cups coconut
1-1/2 cups pecan pieces
1-1/2 cups flour
> *Add in and mix well. Pour in a buttered 11" x 17" baking pan.*

Second Layer

1-1/2 lb. cream cheese
2 cups sugar
> *Cream together well.*

6 eggs
> *Add in.*

1/4 cup unsweetened cocoa
1 tsp. vanilla extract
1/2 tsp. almond extract
1/4 cup flour
> *Add in and mix well.*
> *Pour on top of first layer. Starting from one corner of the pan, run a butter knife in a zig-zag pattern through the pan. Bake at 350° for 45-50 minutes.*

White Pistachio Brownies

First Layer

1 lb. butter
1 lb. margarine
3 cups sugar
> *Blend well.*

1 tbs. vanilla extract
12 eggs
> *Add in and blend well.*

1 lb. white chocolate, melted
2 cups flour
1 cup whipping cream
> *Add in and mix well.*
> *Pour into a 11" x 17" buttered pan.*

> *Bake at 350° for 45-50 minutes.*

Second Layer

1-1/2 lbs. cream cheese
1-1/2 cups sugar
> *Mix well.*

6 eggs
2 tsp. vanilla
2 cups pistachios
> *Add in, mix well. Pour on top of first layer. Run a butter knife across the brownie batter in a zig-zap pattern to incorporate the two layers.*

Peanut Butter Brownies

Brownies
1-1/2 cups margarine
1-1/2 cups sugar
1-1/2 cups brown sugar
Cream together.
6 eggs
Add in.
1-1/2 cups peanut butter
3 cups flour
1-1/2 cups oats
1-1/2 cups walnuts
2 tsp. baking soda
Add in and mix gently. Spread in a buttered 11" x 17" pan. Bake at 350° for 45-50 minutes. Cool.

Icing
6 cups powdered sugar
1-1/2 cups creamy peanut butter
1 cup milk
3/4 cup cocoa
Blend well.
Top brownies with icing.

Mocha Brownies

Brownies
1 lb. butter
3 cups sugar
Cream together.
9 eggs
1-1/2 lbs. semisweet chocolate, melted
1-1/4 cups chopped walnuts
1 tsp. vanilla extract
Add in and mix well.
1 tsp. cocoa
1 tsp. baking soda
3/4 cups sour cream
1 tbs. instant coffee
1-1/2 lbs. Kahlua
Add in and mix well.
3-1/2 cups flour
Add in and mix well.
Spread batter into a buttered 11" x 17" baking pan. Bake at 350° for 45-50 minutes. Cool.

Icing
1/2 lb. milk chocolate, melted
2 cups sour cream
1/2 cup coffee
Blend well.
Top brownies with it after they are baked and cooled.

Double Fudge Brownies

Bottom Layer

1 lb. cream cheese
1 cup sugar
> *Cream together.*

6 eggs
> *Add in and mix well.*

1 cup whipping cream
1 tbs. vanilla extract
1 tbs. Kahlua
> *Add in.*

1 lb. semisweet chocolate, melted
> *Add in and mix well.*

1/4 cup flour
> *Add in.*
> *Spread bottom layer in a 11" x 17" buttered baking pan.*

Middle Layer

3/4 lb. white chocolate, melted
1 cup sour cream
1/2 cup chestnut puree
> *Mix well. Spread on top of first layer.*

Top Layer

1 lb. cream cheese
1 cup sugar
> *Cream together.*

4 eggs
> *Add in and mix well.*

1 lbs. white chocolate, melted .
1 cup sour cream
> *Add in and mix well. Spread on the middle layer.*

1 cup chocolate chips
> *Sprinkle on top. Bake in 350° oven for 40-45 minutes. Remove and cool.*

Icing

1 lb. white chocolate, melted
1/2 lb. caramel syrup
> *Mix well and spread on top.*

Food trends come and go. Only the recipes that respect value, consistency, quality and true taste remain with us in history.

I seek to perfect those recipes that embrace the comfortable familiarity of people from every shore of life, while remembering the rich existence dining offers us.

Every dish may be someone's final feast – so strive to make every meal the best anyone has ever had.

Caramel Truffle Brownies

Bottom Layer

1-1/2 lbs. cream cheese
1 cup sugar
> *Cream together.*

4 eggs
> *Add in and mix well.*

1/8 cup whipping cream
1/2 lb. dark chocolate
1 tsp. vanlla extract
> *Add in and mix well. Spread in a buttered 11" x 17" buttered pan. Bake at 350° for 40-45 minutes. Remove from oven and cool.*

Top Layer

1 lb. semisweet chocolate, melted
1-1/4 lb. butter, melted
1/4 cup sugar
3 eggs
1 cup flour
1/2 cup cocoa
1/2 cup caramel sauce
> *Mix well and spread on top of the cooled brownies. Refrigerate until the top layer is set.*

Icing

1 lb. milk chocolate, melted
2 cups of heavy cream, heated
> *Mix well and spread on top of brownies.*

Pecan Coconut Bars

Crust

1 cup butter
1 cup brown sugar
2 cups flour
> *Mix ingredients well and line the bottom of a lightly buttered pan. Bake at 375° for 6-8 minutes.*

Filling

4 eggs
2 cups brown sugar
> *Cream together.*

1 tsp. vanilla extract
4 tbs. flour
2 tsp. baking soda
3 cups coconut
2 cups chopped pecans
> *Blend well. Spread filling on crust and bake at 375° for 20 minutes.*

Frosting

1 cup butter
4 cups powdered sugar
> *Cream together.*

1 tsp. vanilla extract
1 tbs. orange peel
1/4 cup orange juice
> *Blend well.*
> *Spread on filling.*
> *Cool and cut into bars.*

Apricots - The Handsome Rebel

Five thousand years of domestication have not tamed this temperamental tree. Apricots are another delicious fruit that comes from China. It ripens perfectly in sunny slopes on higher altitudes, but it is very unreliable in temperate regions. A slight frost or a strong wind can destroy all hope for the blossoming of the apricot tree. The mediterranean climate seems to be apricots' favorite land.

Many scholars believe that apricots contribute to longevity. The apricot is richer than any other fruit in carotenes. It is beneficial for growth, hastens the formation of scar tissue, counters anemia and improves vision. It is also good for maintaining healthy teeth. This golden fruit also contains vitamin C, magnesium, phosphorus, calcium, potassium, sodium, sulphur, manganese and fluoride.

Apricots are good for baking and make a great filling for delicate cakes. I also use it in a pie with oranges, a perfect marriage of these two golden wonders. Apricots are perfect mixed wth white chocolate and blends great with coffee-flavored desserts.

Apricot Bars

Crust
1/2 cup butter
1 cup sugar
3 cups flour
 Mix gently and press against the bottom of a 12" x 17" baking pan.

Filling
1 lb. raspberries
1 tbs. Chambourd
1/2 cup sugar
 Mix well and spread over crust.
2 cups coconut shavings
 Sprinkle on top of filling.
1 piece of 12" x 17" puff pastry dough, baked until golden brown.
 Layer over coconut
4 cups apricots, sliced
1 cup sugar
 Blend together and spread over pastry.
2 cups walnuts, chopped
 Sprinkle over apricots. Bake at 350° for 1-1/4 hours.

Topping
1 lb. white chocolate, melted
2 cups sour cream
1 tbs. Kahlua
1/2 lb. butter, melted
 Blend together.
 Spread on top.

Lime Coconut Bars

Crust
1 lb. butter, softened
1 cup powdered sugar
1 tbs. lemon peel
1 tsp. ginger
1-1/2 cups flour
> *Mix gently. Press over a 12" x 7" lightly buttered pan.*

Filling
6 eggs
2-1/2 cups sugar
> *Blend well.*

1 tbs. lemon peel
1-1/2 cups lime juice
1/2 cup flour
1 tsp. baking powder
1-1/2 cups toasted coconut
> *Add in and blend gently.*
> *Spread on top of crust. Bake at 350° for 15 minutes then let cool. Cut into desired size bars.*

Pecan Bars

Crust
1-1/2 cups sugar
1 lb. soft butter
3 cups flour
> *Mix gently and spread over a 12" x 17" lightly buttered pan.*

Filling
1-1/2 cups butter, melted
1 cup brown sugar
1-1/2 cups honey
1/4 cup heavy cream
10 cups pecans
> *Blend lightly.*
> *Spread filling over crust. Bake at 350° for 20 minutes then let cool. Cut into desired size bars.*

Pistachio Bars

Use the Pecan Bar recipe, only substitute the pecans for pistachios.

Gingered Lemon Bars

Crust

1 lb. butter
1 cup powdered sugar
1 tbs. lemon peel
2 tsp. ginger
> *Cream together.*

1-1/2 cups flour
> *Add in and mix well.*
> *Press into the bottom of a buttered 12" x 7" pan, and bake at 375° for 6-8 minutes.*

Filling

6 eggs
1-1/2 cups sugar
> *Beat 3-4 minutes.*

1 cup lemon juice
1 tbs. lemon peel
> *Add in and beat well.*

1/2 cup flour
1 tsp. baking flour
> *Add in and mix well. Spread on crust and bake at 375° for 20 minutes.*

Icing

2 cups chocolate chips, melted
2 cups sour cream
1 tsp. mint extract
1 cup sugar
> *Blend well.*
> *Top with icing, let cool until set and cut into bars.*

Awaiting us were Nick's specialty desserts.
Mere words cannot describe. With names like
Last Act, Fatal Obsession, they should all be
rated X and considered a Sinful Act.
Need we say more?

Echo Magazine, 1996

Cocoa Tree

The cocoa trees have grown deep in the Amazon forest, between stiffing greenery and the multitude of singing colored birds. The bark of the cocoa tree is fine, a dark green color with silver patches. The tree's trunk is slender, smooth, towering gracefully into a canopy of thick foliage. Its leaves are oblong and they carry small white and pink flowers in dense clusters.

The cocoa tree bares large fruit, called pods, which contain the precious cocoa beans. Cocoa pods have no stems, they sprout out from the trunk and grow to various sizes. The pods have a reddish-violet color when young, but by the time they are ready to be picked they have turned to a yellowish-orange color.

The cocoa tree is delicate and it is protected by the wonder of nature: other trees that always seem to surround it and grow taller to protect it from the hot sun. Without shade the cocoa tree would not thrive. Very little has changed throughout the years in the technique to pick the pods. At the time of picking, the air resounds with machete on timber.

Cocoa plantations are buried by the dense foliage, deep in the jungle. The majority of the plantations are not very large, two to four acres at most. In the region of the tropical Amazonian forest, its birthplace, the cocoa tree grows wild at the foot of giant trees. The temperature is always 70° to 90°F. After the Mayans and the Aztecs cultivated the first cocoa tree, cultivation thrived in Central and South America, especially in Brazil. From there it moved to the Caribbean Islands of Trinidad, Haiti, the Dominician Republic, Martinique and Jamaica. In the 19th century, Brazilian samplings of cocoa trees were planted in the African coast, first in the island of Sao Tomé, then in Bioco and from there to West Africa, the Ivory Coast, Nigeria and Camaroon. Today, it is also found in Java, Sumatra, Sri Lanka, New Guinea, Samoa, Indonesia, the Phillipines and Southeast Asia. Brasil, Malaysia and the Ivory Coast are the leading producers of cocoa beans. They produce almost 50% of the world's supply.

Central America, however, still possesses the best plantations, those which provide the finest cocoa beans and are high priced by chocolate manufacturers all over the world. Cocoa has never forgotten its origins. All cocoa trees belong to the theobroma genus, the name derived from the Greek words, Theos meaning God and Broma meaning Beverage; literally meaning "the drink of the gods".

The Criollo tree is the original "chocolate tree" of the Mayans. It produces the finest cocoa beans, very aromatic with a slightly bitter taste and delicate flavor. The chocolate manufacturers use these beans in combination with other varieties to create different types of chocolate. This delicate cocoa tree has a low yielding and their cultivation requires meticulous care. This exceptional cocoa is only produced in the small scale today. It accounts for no more than 10% of the world's production, and it is only cultivated in regions where cocoa originated: Mexico, Guatemala, Nicaragua, Venezuela and Columbia.

The Forastero tree produces the majority of the African cocoa crop. Forastero was introduced by the Spanish on the island of Sao Tomé during the Colonial era. It gradually spread to the western side of Africa. This tree is also cultivated in Brasil, Central America and the West Indies. The Forastero grows faster then the Criollo and produces more fruit. It accounts for about 75% of the world's production. This bean has a strong, bitter flavor and an acid aroma. It is frequently used in blends.

Then there is the Trinidarios, which is a crossbreed between Criollos and Forasteros. This one was originated in the island of Trinidad, from which it takes its name.

At the beginning of the 18th century, a hurricane destroyed the plantations in which the Spanish colonists had cultivated Criollos, because of the soil and the climate of this Caribbean island. After the hurricane, the islanders planted Forasteros. Some Criollos had survived the wrath of nature and so the new group of varieties was born from natural intercrossings.

Trinidaros produce cocoa beans with high fat content. This represents about 15% of the world's production. Today, they are cultivated mainly in Central and South America, Sri Lanka and Indonesia. However, the best Trinidario cocoa beans are grown in their native land. Each region produces beans with special characteristics and different aromas. Chocolate, like wine, has its mythical places of cultivation, comparable to the great wine producing vineyards.

One of these places is Chuao in Venezuela. The legendary Chuao bean produced there is a chocolate connoisseur's dream. It has a fine delicate aroma, but it is very rare to find because the beans from that plantation are blended with other varieties from the region before being exported. The Chuao plantation was cultivated in the 17th century on the coast near Caracas, at the base of the steep mountains, that drop sharply into the Caribbean. One can only get into this place by boat following the wild coastlines.

In Chuao, nothing has changed for centuries. On the shore is the landing stage from which the boats transport the beans. Up in the mountains wood houses appear, scattered around. In the forest, where the air is humid and the sun is hot, under the tall mango trees, bamboo groves and serrated foliage, cocoa trees appear protected from the sun. Deeper in the forest, the vegetation is dense and many more cocoa trees appear. On the plantation, the routine is identical as it is in every plantation throughout the world. The cocoa trees are pruned by men who move slowly between the trees. The pruning allows the branches to form a canopy of foliage to protect the fruit. The ground around the cocoa tree is constantly weeded. The broken branches are cut off. The quality of the chocolate depends on the meticulous care of the tree. In the wild, the cocoa tree can grow up to 30 feet high but on the plantations are pruned down to about 20 feet so that the cocoa pods are easier to reach.

The buds emerge from the bark and the flowers appear at the beginning of the rainy season, if there is one. In regions where there is no seasonal change, the flower appears year round. The cocoa pods develop from a fertilized flower. Only one out of about 100 flowers is destined to develop fruit. The cocoa pods grow straight out of the trunk and turn golden in the sun. Cocoa pods are very hard and have an elongated, pointy shape. It seems almost impossible that such a fruit could come from such a delicate flower.

The following cycle is uninterrupted. Pods grow among the flowers in all stages of development. It takes six to seven months for the pods to reach their full size, about ten inches long. Twenty or 40 precious almond shaped seeds are concealed inside, surrounded by a bittersweet pulp.

The productivity of the tree depends on its age, the variety, the care and the soil. In South America, a tree yields about 35 pods. In Africa, it yields about 20. A healthy cocoa tree lives an average of 60 years. For centuries, the plantation workers have carried out the same routing tasks. The heat is almost unbearable. If it was not for the breeze of the nearby ocean, it would almost be impossible to endure. The forest is alive with birds singing, animals running and humans moving between the foliage, pruning, weeding, waiting for the precious bean to fertilize.

The samplings of the cocoa tree are planted closely together in a line. After a few months, they are bedded out under a shade tree. They flower two or three years later, but they bare fruit only after they are four years old.

Best Truffles - Nick's Way

6 cups of chocolate cake
> *(Use leftover cake if you have it)*

2 lbs. semisweet chocolate, melted

1-1/2 lbs. butter, melted

1/2 cup of sugar
> *Mix well.*

6 eggs
> *Add in one at a time. Add the flavor you desire (See Truffle variations)*
>
> *Place mixture in a bowl and refrigerate until firm enough to scoop out. Use an ice cream scoop of your desired size to form round balls and place them on a flat pan. If the balls are still a bit soft, refrigerate them until firm. Place truffles on a screen with a pan in the bottom. With a large spoon, pour the icing (see below) on top of the truffles to cover them completely.*

Basic Truffles

1 lb. semisweet chocolate, melted

1 lb. butter, melted

1/4 cup of sugar
> *Mix well.*

3 eggs
> *Add in, mix well.*

1 cup flour

1/2 cup unsweetened cocoa
> *Add in, mix well. Follow the same steps as the Best Truffle recipe.*

Truffle Icing, Dark

1 lb. semisweet chocolate, melted

2-1/2 cups heavy cream, heated
> *Mix well while chocolate is warm, let cool. Do not refrigerate. Pour over truffles while icing is at room temperature. Refrigerate truffles until icing is set. Decorate truffles (see truffle variations).*

Truffle Icing, White

1 lb. white chocolate, melted

1 cup of sour cream

1/2 cup heavy cream, heated
> *Mix well, while icing is warm, pour over truffles.*
>
> *After you pour icing over truffles, lift them up with a spatula, place them in a flat pan and refrigerate until icing is firm. Decorate truffles (see truffle variations).*

Truffle Variations

Strawberry: Add to the truffle mix 1/2 cup strawberry jam. Insert from the bottom of the truffle, with your finger, 1 small strawberry or 1/2 of a larger one. With a spoon pour white icing on top of truffle while icing is still warm. Sprinkle with dark vermicelli.

Raspberry: Mix the truffle with 1/2 cup raspberry jam and insert 1 raspberry on the bottom of the truffle with your finger. With a spoon pour dark icing on top of the truffle while icing is still warm. Refrigerate and cool. Roll truffle in cocoa.

Champagne: Mix truffle with 1/4 cup champagne. With a spoon pour dark icing on top while icing is warm. With a pastry bag with a narrow straight tip using white chocolate icing, make 3 white lines on top of the truffle.

Dark Cherry: Mix the truffle with 1/4 cup cherry syrup. With your finger insert one dark cherry in the truffle from the bottom. With a spoon pour dark icing on top of the truffle while icing is warm. Sprinkle with vermicelli.

Caramel: Mix 1/2 cup caramel sauce in the truffle. With a spoon pour dark icing on top of the truffle while icing is still warm. Refrigerate and cool. Mix white icing with 1 tbs. caramel sauce and with a pastry bag with a narrow tip make 3 lines on top of truffles.

Tropical: Mix with truffle 1/8 cup finely chopped mangos, 1/8 cup finely chopped papaya. With a spoon pour white icing on top while icing is still warm. Sprinkle with toasted coconut.

Hazelnut Mocha: Mix truffle with 2 tbs. instant coffee, 1/8 cup grated hazelnuts and 2 tbs. hazelnut chocolate spread. With a spoon pour dark icing on top of truffles and sprinkle with grated hazelnuts.

Orange Peanut Coffee: Mix truffle with 1/4 lb. white chocolate, melted, 1/4 cup sour cream, 1 tbs. orange peel, 1 tbs. cinnamon, 2 tbs. instant coffee and 2 tbs. creamy peanut butter. With a spoon pour dark icing on top while icing is warm. Sprinkle with white vermicelli.

Grand Marnier Chestnut: Mix truffle with 2 tbs. Grand Marnier and 1/2 cup chestnut puree. With a spoon pour dark icing on top while icing is still warm. Sprinkle with both white and dark shavings.

For more flavors use your imagination and for presentations, use your creativity! There are hundreds of tastes one can create.

TIPS FOR BETTER BREAD BAKING:

PROBLEMS

There are two elements that are critical to making good bread. First is the weather. The more humidity there is, the better. When people move from one end of the country to the other, their results of their favorite recipes differ. The problem is that their recipes are being affected by the weather and the water. Living in a dry climate, like Arizona, bread-making becomes a challenge because the air locks the necessary moisture needed to raise the dough properly. The second element is the water. Chemicals in water will affect the rising of the dough. In fact, if your mixing bowl has the slightest amount of soap residue on it, it will kill the yeast, so be sure to wash your bowls well.

SOLUTIONS

To overcome the problems mentioned above, I have developed a process to make the bread better. First, when you mix your dough, let it rise for about 20 minutes, Then cut the dough into one pound pieces and form it in to balls. Place them in an aluminum pan, cover with plastic and refrigerate overnight. As the dough slowly rises, it will break out the chemicals from the water without killing the yeast, it will at the same time absorb the moisture of the refrigerator, which will effect the dough as the humidity would have done. The next day the dough should be double the size. Knead the balls into a desired shape, always working on a floured surface. Place in a lightly buttered baking pan. Cover with a damp cloth and let rise to double in size, about 1-1/2 hours. Then bake.

This is a process of three time rising, make sure that the dough is always covered with a damp cloth and that it is kept away from drafts. Use filtered or bottled water for best results. Use quality unbleached flour. Make sure the water is lukewarm and that the yeast is completely dissolved in the water before mixing it with the dry ingredients.

Breads

Sour Dill Bread

1/4 oz. dry yeast
1/4 cup warm water
> *Mix 5 minutes with a bread hook.*

1 egg
2 tbs. butter, melted
2 tbs. sugar
1 tsp. salt
1 tsp. dill weed
1 cup sour cream
> *Add in and mix well.*

1/4 cup Parmesan cheese, grated
1 cup unbleached flour
1-1/4 cups rye flour
> *Stir in. Knead dough until smooth and elastic. Place in a lightly greased bowl and cover with a plastic bag. Let rise until doubled in size, about 1-1/2 hours. Shape into two small loaves. Cover and let rise until doubled. Mix 1 egg white with 1 tbs. water and brush top of loaves. Bake at 375° for 40 minutes.*

<div align="center">◦❧◦</div>

Chocolate Bread

3/4 oz. dry yeast
4-1/2 cups warm water
> *Mix 5 minutes with a bread hook.*

1/3 cup sugar
1 egg
2 tbs. butter, melted
1 tsp. salt
> *Add in and mix well.*

12 cups flour
1 cup unsweetened cocoa
> *Add in, knead until smooth.*

1 lbs. semisweet chocolate chips
> *Blend in well.*
> *Place dough in a greased bowl and cover with a plastic bag. Let rise for one hour until doubled in size. Divide into eight pieces and shape into loaves. Place on a baking sheet and cover with parchment paper. Let rise until doubled, about 45 minutes. Bake at 375° for about 40 minutes.*

Nine Grain Loaf

1 pint lukewarm water
3/4 oz. dry yeast
> *Mix for 5-6 minutes with a bread hook.*

1/8 oz. salt
1/2 oz. sugar
2 oz. soybean oil
1 oz. molasses
3/4 lb. high gluten flour
1 lb. whole wheat flour
1/4 lb. nine-grain mix*
> *Add in and mix for 10-12 minutes.*
> *Cover dough with a towel and let rise in a warm place for one hour until doubled. Sprinkle working surface with flour and cut dough in half. Knead into loaves and place in an oiled baking pan. Cover and let rise for one hour. Bake at 375° for 35-40 minutes.*
> **Available in health food stores.*

Baba Dough

This is a dessert more than a bread. You can flavor it to your taste with rum or Grand Marnier, and can be filled with whipped cream or a fruit salad.

1 tsp. yeast
1-1/2 tbs. warm water
> *Dissolve.*

1 tbs. milk
1-3/4 cups flour
1/2 tsp. salt
> *Add to the yeast, mix at low speed.*

3 egg
> *Add, one at a time, increase the speed to medium, mix 3-4 minutes longer.*

5-1/2 tbs. milk
1 tsp. sugar
5 tbs. soft butter, cut into pieces
> *Add gradually as the dough is being mixed. Place the dough in to a large bowl and let it rise in a warm place for approx. 15 minutes. Do not let it rise too long. Punch the dough down. Lightly butter a 8" or 9" ring mold. Place the dough in it. Let it rise in a warm place for about 40 minutes. Bake in a preheated 400° oven for about 20 minutes. Turn out while warm.*

1-1/2 cups sugar
2 cups water
> *Bring to a boil.*

1-1/2 tbs. alcohol of your choice
> *Add in, mix. Spoon syrup over baba to soak it completely. To fill with cream of your choice: use a pastry bag with a star tip and fill the center.*

Glaze (optional)
> *Brush top with hot apricot jam.*

Potato Bread

1/4 oz. dry yeast
3 tbs. flour
1-1/4 cups warm water
> *Dissolve in 1/2 cup water. Let stand 1/2 hour.*

1 tsp. caraway seeds
1 tsp. salt
> *Add in with remaining water.*

1/2 cup mashed potatoes
4 cups unbleached flour
> *Mix in and knead 10 minutes. Place dough in a lightly greased and floured bowl. Cover with a damp towel and let rise 1/2 hour until doubled. Place in loaf pan and brush top with water. Cut a 1/4" deep criss-cross over the top. Bake at 375° for 1 hour.*

Herb Bread

1/2 oz. dry yeast
1-3/4 cup warm water
> *Dissolve yeast.*

2 tbs. oil
2 tbs. sugar
> *Add in.*

1/2 tsp. thyme, crumbled
1/2 tsp. tarragon
1/2 tsp. salt
6 cups unbleached flour
> *Add in. Knead until smooth and elastic. Place dough in a lightly greased and floured bowl. Cover with damp cloth and let rise one hour until doubled. Divide into three loaves. Place in loaf pan and cover until doubled. Brush loaf tops lightly with milk and sprinkle with 1 tbs. fennel seeds. Bake at 375° for 40-45 minutes.*

Honey Whole Wheat Bread

1 pint lukewarm water
3/4 oz. dry yeast
> *Mix 5-6 minutes.*

1 oz. molasses
2-1/2 oz. honey
2 oz. soybean oil
1/2 oz. salt
> *Add in. Mix 3-4 minutes.*

3/4 lb. whole wheat flour
1 lb. high gluten flour
> *Add in. Mix 10-12 minutes. Cover dough with a towel and let rise in a warm place for one hour until doubled. Sprinkle working surface with flour and cut dough in half. Knead into loaves and place in an oiled baking pan. Cover and let rise for one hour. Beat well 1 egg and 1 tbs. water, brush on loaves. Bake at 325° for 45-50 minutes.*

Rye Bread

1 pint lukewarm water
5/8 oz. yeast
>*Mix 5-6 minutes.*

2 oz. sugar
1 oz. molasses
1/2 oz. salt
1/4 cup caraway seeds
>*Add in. Mix 3-4 minutes.*

1 lb. high gluten flour
3/4 lb. rye flour

>*Add in. Mix 10-12 minutes. Cover dough with a towel and let rise in a warm place for one hour until doubled. Sprinkle working surface with flour and cut dough in half. Knead into loaves and place in an oiled baking pan. Cover and let rise for one hour. Beat well 1 egg and 1 tbs. water, brush on loaves. Bake at 325° for 45-50 minutes.*

❧

Black Coffee Bread

1 pint lukewarm water
5/8 oz. yeast
>*Mix 5-6 minutes.*

2 oz. sugar
1 oz. molasses
1/2 oz. salt
1/4 cup caraway seeds
>*Add in. Mix 3-4 minutes.*

1/2 cup cocoa
1/4 cup strong coffee
1 lb. high gluten flour
3/4 lb. rye flour
1 tbs. cornstarch

>*Add in. Mix 10-12 minutes. Cover dough with a towel and let rise in a warm place for one hour until doubled. Sprinkle working surface with flour and cut dough in half. Knead into loaves and place in an oiled baking pan. Cover and let rise for one hour. Beat well 1 egg and 1 tbs. water, brush on loaves. Bake at 325° for 45-50 minutes.*

Tuscan Bread

1 pint lukewarm water
5/8 oz. yeast
Mix 5-6 minutes.
1/4 oz. salt
1/2 oz. sugar
2 oz. soybean oil
Add in. Mix 3-4 minutes.
1-3/4 lb. high gluten flour
Add in. Mix 10-12 minutes. Cover dough with a towel and let rise in a warm place for one hour until doubled. Sprinkle working surface with flour and cut dough in half. Knead into loaves and place in an oiled baking pan. Cover and let rise for one hour. Beat well 1 egg and 1 tbs. water, brush on loaves. Bake at 325° for 45-50 minutes.

Oat Bread

1 pint lukewarm water
5/8 oz. yeast
Mix 5-6 minutes.
1/4 oz. salt
1/2 oz. sugar
2 oz. soybean oil
1/2 cup oats
1/4 cup molasses
1/8 cup milk
Add in. Mix 3-4 minutes.
1-3/4 cups high gluten flour
Add in. Mix 10-12 minutes. Cover dough with a towel and let rise in a warm place for one hour until doubled. Sprinkle working surface with flour and cut dough in half. Knead into loaves and place in an oiled baking pan. Cover and let rise for one hour. Beat well 1 egg and 1 tbs. water, brush on loaves. Bake at 325° for 45-50 minutes.

Vegetable Cheddar Bread

1 pint lukewarm water
5/8 oz. yeast
> *Mix 5-6 minutes.*

1/4 oz. salt
1/2 oz. sugar
2 oz. soybean oil
> *Add in. Mix 3-4 minutes.*

1-3/4 lb. high gluten flour
> *Add in. Mix 5-6 minutes. Mix in 1 tbs. of each:*

Onion, chopped
Red pepper, chopped
Green pepper, chopped
Garlic, chopped
Green olives, chopped
Black olives, chopped
Green onions, chopped
Romano-Parmesan cheese

> *Cover dough with a towel and let rise in a warm place for one hour until doubled. Sprinkle working surface with flour and cut dough in half. Knead into loaves and place in an oiled baking pan. Cover and let rise for one hour. Beat well 1 egg and 1 tbs. water, brush on loaves. Bake at 325° for 45-50 minutes. Halfway through baking, top with two cheddar cheese slices.*

Focaccia Bread

1 pint lukewarm water
5/8 oz. yeast
> *Mix 5-6 minutes.*

1/4 oz. salt
1/2 oz. sugar
2 oz. soybean oil
> *Add in. Mix 3-4 minutes.*

1-3/4 lb. high gluten flour

> *Add in. Mix 10-12 minutes. Cover dough with a towel and let rise in a warm place for one hour until doubled. Sprinkle working surface with flour and cut dough into 6 oz. balls. Flatten balls and open them to about 5" flat rounds. Cover and let them rise for one hour. Add desired toppings and bake them in 325° for 30-35 minutes.*

HERB MIXTURE: Equal pinches of oregano, thyme, basil, rosemary, tarragon, and garlic.
> *Brush tops of focaccia with olive oil. Sprinkle with herb mixture while hot.*

TOPPING SUGGESTIONS: Tomato and Feta; Olives and Feta; Tomato, Feta and Olives; Pesto Sauce; Garlic.

Seed Bread

2-1/4 cups warm water
1/4 oz. dry yeast
1-1/2 tbs. sugar

Blend sugar in 1/2 cup water. Dissolve yeast. Let sit 5 minutes.

3 cups unbleached flour
1 cup milk, warmed

Add in with remaining water. Cover dough and let rise in warm place until doubled.

2 tbs. vegetable oil
1 tsp. salt
1 egg
1/2 cup honey

Add in and knead.

1 cup cornmeal
3 cups whole wheat flour
1-1/2 cups rye flour
1 cup unprocessed bran

Add in and knead well.

1/2 cup golden raisins
1/2 cup walnuts, chopped
1/2 cup sunflower seeds
1/2 cup poppy seeds

Add in and knead. Place dough in a greased bowl and cover with damp cloth. Let rise until doubled. Divide dough into three pieces. Place in three greased 9" x 4" loaf pans and let rise until almost flush with pan tops. Bake at 350° for 55-60 minutes. Combine 1 egg white and 1 tsp. water and brush over loaves.

Sausage Bread

1 cup raisins

Simmer for 5 minutes and drain.

1 lb. mild sausage, chopped
1 cup pecans, chopped
1 tsp. ginger
1 tsp. pumpkin pie spice
1-1/2 cups brown sugar
1-1/2 cups sugar
2 eggs
3 cups flour
1 tsp. baking powder
1 cup cold coffee
1 tsp. baking soda

Blend in one at a time. Place dough in a lightly greased and floured 9" tube pan. Bake at 350° for 1-1/2 hours.

Fennel Bread

Bread

1/4 oz. dry yeast
1 cup warm water, divided
1 tsp. sugar

> *Mix with half of water. Let stand 5 minutes.*

2 tbs. salt
2 tsp. fennel seeds
2 tbs. butter, melted

> *Add in with remaining water.*

4 cups unbleached flour

> *Add in, mix to stiff dough.*

Bread Topping

1 egg
1 tsp. sugar
2 tsp. fennel seeds

> *Mix together. Knead dough on a lightly floured surface for 6-8 minutes. Place dough in a greased bowl, cover with damp cloth and let rise until doubled. Knead and shape into a loaf. Place on a baking sheet and cover. Let rise about one hour. Slice top of loaf side-to-side about 1/2" deep. Fill cuts with topping. Bake at 375° for 30-35 minutes.*

Pepper Cheese Bread

1/4 oz. dry yeast
1-3/4 cups warm water
1 tsp. sugar

> *Dissolve in 1/4 cup water. Let stand 5 minutes.*

2 tbs. butter, melted
1 egg
1/2 cup milk

> *Add in with remaining water.*

5 tbs. sugar
1 tsp. salt
1 tsp. black pepper
1/2 tsp. basil
5-1/2 cups flour

> *Mix until soft and elastic.*

1 cup sharp cheese, grated

> *Reserve cheese for later use.*

> *Place dough in a greased bowl and cover with a damp towel. Let rise one hour until doubled. Knead in grated cheese. Place dough in two 9" x 3" loaf pans. Brush tops with melted butter and let rise until doubled, for 1-1/2 hours. Bake at 350° for 50-55 minutes.*

Quick breads can also be made in individual sizes by using small baking forms.

Citrus Quick Bread

1/2 cup margarine
1 cup sugar
 Cream together.
2 eggs
1/2 cup milk
 Add in and mix well.
1-1/4 cups unbleached flour
1 tsp. baking powder
1/4 tsp. salt
3/4 cup grated walnuts
3 tsp. grated lemon rind
3 tsp. grated orange rind
 Add in and mix well. Pour batter into a 9" x 5" buttered pan and bake at 350° for one hour. Pierce several holes in top of bread. Combine juice of one lemon and 1/4 cup sugar and glaze top of bread.

Lemon Quick Bread

1/2 cup margarine
1 cup sugar
 Cream together.
2 eggs
 Beat egg yolks, one at a time. Add in.
1/4 tsp. salt
1/2 cup milk
Juice of one lemon
3 tsp. lemon peel
1-1/2 cups flour
3/4 cup walnuts
1 tsp. baking powder
 Add in and blend well. Beat egg whites until stiff and add in.
 Bake in a 9" x 5" buttered pan at 350° for one hour. Glaze with 1/4 cup sugar and juice of one lemon. Let bread cool for 20 minutes before removing from pan.

Nick Ligidakis is a cult favorite among locals.
Zagat Survey, 1989

Papaya Quick Bread

1-1/2 cups oil
4 eggs
 Beat together.
5 cups papaya, chopped
 Blend in.
1/2 tsp. lemon juice
1 cup raisins
1/2 cup milk
4 cups flour
2 tsp. cinnamon
3 tsp. baking soda
1/2 tsp. salt
4 cups sugar
1 cup walnuts
 Blend in well. Line a 9" x 5" pan with parchment paper. Pour in batter. Bake at 350° for one hour. Let bread cool for 20 minutes before removing it from the pan.

❧

Mango Rum Quick Bread

1/2 cup margarine
1 cup sugar
 Cream together.
2 eggs
 Beat egg yolks, one at a time. Add in.
2 cups fresh mango, chopped
 Add in.
1/2 cup milk
1 tbs. white rum
2 cups flour
1 tbs. baking soda
1 tsp. baking powder
1/2 tsp. salt
1/2 tsp. lemon juice
 Add in and blend well. Beat egg whites until stiff and add in.
 Line a 9" x 5" pan with parchment paper. Pour in batter. Bake at 350° for one hour. Let bread cool for 20 minutes before removing from pan.

Strawberry Quick Bread

1/2 cup margarine
1 cup sugar
1 tsp. almond extract
> *Cream together.*
2 eggs, separated
> *Beat yolks, one at a time. Add in.*
1-1/2 cups strawberries, chopped
> *Blend in.*
2 cups flour
1 tbs. baking soda
1 tsp. baking powder
1/2 tsp. salt
1/2 cup milk
1/2 tsp. lemon juice
> *Blend in. Beat egg whites until stiff. Add in.*
> *Line a 9" x 5" pan with parchment paper. Pour in batter. Bake at 350º for one hour. Let bread cool for 20 minutes before removing it from the pan.*

Zucchini Pineapple Quick Bread

1/2 cup margarine
1 cup sugar
> *Cream together.*
2 eggs, separated
> *Beat egg yolks, one at a time. Add in.*
1 cup zucchini, peeled, grated
1 cup pineapple tidbits
1/2 cup milk
1 tbs. pineapple juice
2 cups flour
1 tbs. baking soda
1 tsp. baking powder
1/2 tsp. salt
1/2 tsp. lemon juice
> *Add in and blend well. Beat egg whites until stiff and add in.*
> *Line a 9" x 5" pan with parchment paper. Pour in batter. Bake at 350º for one hour. Glaze with 1/4 cup sugar and juice of one lemon. Let bread cool for 20 minutes before removing from pan.*

Cinnamon Banana Quick Bread

1/2 cup margarine
1 cup sugar
> *Cream together.*

2 eggs, separated
> *Beat yolks, one at a time. Add in.*

2 cups banana
1 tsp. cinnamon
1/2 cup milk
1/2 tsp. salt
1 cup walnuts
2 cups flour
1 tbs. baking soda
1 tsp. baking powder
1/2 tsp. lemon juice
> *Add in and blend well. Beat egg whites until stiff. Add in.*
> *Line a 9" x 5" pan with parchment paper. Pour in batter. Bake at 350° for one*
hour. *Let bread cool for 20 minutes before removing it from the pan.*

❧

Raspberry Chocolate Quick Bread

1/2 cup margarine
1 cup sugar
> *Cream together.*

2 eggs, separated
> *Beat egg yolks, one at a time. Add in.*

1 cup white chocolate, melted
1 cup raspberries
1/2 cup milk
1 tbs. baking soda
1 tsp. baking powder
1/2 tsp. salt
2 cups flour
1/2 tsp. lemon juice
> *Add in and blend well. Beat egg whites until stiff and add in.*
> *Line a 9" x 5" pan with parchment paper. Pour in batter. Bake at 350° for one*
hour. *Let bread cool for 20 minutes before removing from pan.*

*C*alifornia gold prospectors depended on sourdough bread and biscuits, using a fermented starter dough from the previous day's bread as a leaven to make a new batch each day. The action of the yeast is continuously transmitted through successive amounts of dough. This was in 1850.

Sourdough bakers proliferated in San Francisco using starter dough brought to the city by the Basques from southern Europe.

SOURDOUGH STARTER

The authentic sourdough starter is a simple combination of milk and flour kept in a warm place until it begins to bubble from bacteria fermentation.

Place 1 cup of milk in a glass jar and allow it to stay 24 hours at room temperature, add 1 cup flour, stir. Let it stay uncovered in a warm place for two to four days.

When it is full of bubbles and has a sour aroma, it is ready to use. Too much heat will stop the fermentation, ideal temperature is 80° to 85°. Try to maintain 1-1/2 cups starter. Each time you use a part, replace it with equal parts of milk and flour. After the starter is full of bubbles, you can store it in the refrigerator. Every time you add new ingredients to the starter, leave it in a warm place until bubbles appear, then refrigerate. Starter becomes more flavorful with age.

Sourdough Bread

This is a 24-hour process.

1-1/2 cups warm water
1 cup sourdough starter (see above)
4 cups flour

Mix well, place in a non-metallic bowl. Leave at room temperature for about 18 hours, by then it should have doubled in size.

1 cup of flour
3/4 tsp. baking soda

Mix and stir in to the dough, turn out to a floured surface and knead.

1 cup of flour

Add as needed to knead dough, knead until smooth, about 8-9 minutes. Shape into loaves, two oblong or one round. Place on a lightly greased baking sheet, cover and let stand in a warm place for about 4 hours. Until nearly double the size, slash the top with a sharp knife. Bake at 400° for about 45 minutes until crust is golden brown.

To make a hard crust, place a shallow pan of hot water in the bottom of the oven. Brush loaves with water.

For tender crust, avoid the water in the oven. But brush unbaked loaves with vegetable oil instead of water.

❧

*T*he first frozen bread dough was introduced by Bridgford Foods in 1962. One of their bakers accidentally stored some already mixed dough in the freezer. After the dough was thawed out, he found that it baked up well. They experimented with the yeast when trying to create a product that would rise after being frozen for months.

*J*n 1830, French and Belgian bakers began using minute quantities of highly toxic copper sulfate as well as the less toxic alum to whiten bread.

In 1865, an Austrian named Charles Fleischmann, 31, visited Cincinnati to attend his sister's wedding. He discovered that poor yeast was responsible for poor quality bread in the USA, when bakers used a yeast made from potato water.

Fleischmann immigrated to America in 1868 and joined his brother Maximillian and a Cincinnati yeast maker, James Gaff, to produce commercially compressed yeast. He sold it to local housewives from a basket at first, then by a horse and wagon. The yeast was wrapped in tin foil and by 1870 it was shipped everywhere, and eventually became very popular with even conservative bakers.

In 1876, a model Viennese bakery was set up by these three partners. Fairgoers watched bread and rolls raising with compressed yeast right before their eyes. By 1920, Fleischmann yeast had the corner on the yeast market to most commercial bakers.

Brioch

This dough should be made the night before.

2-1/4 tsp. milk
1 tbs. sugar
1 tsp. salt
1-3/4 cup flour

> *Add in, mix well.*

1/4 oz. yeast
1 tsp. warm water

> *Mix well to dissolve, add to the flour mixture. Beat 2 minutes on low speed.*

2 eggs

> *Add in and continue to beat until dough is firm.*

1 egg

> *Add in, beat 10-12 minutes more, until dough is silky.*

1/2 lb. butter, softened

> *Place between two sheets of plastic wrap and beat with a heavy object to flatten. Break butter into pieces. Add butter in to the dough, mix at medium speed, about 2 minutes. Place the dough in a large bowl, cover with a towel. Let stand for about two hours at room temperature. The dough should have rose to twice its size. Punch it down, let it rise again, 2 to 2-1/2 hours until doubled again. Punch the dough down once more. Cover tightly and refrigerate overnight.*
>
> *To make a loaf, pour dough into a buttered bread form. To make individual brioches (will make about 8 brioches), butter individual molds lightly. Divide the dough into small equal pieces. On a lightly floured table, roll the dough into balls. Don't press hard when rolling. Place the balls in the molds. Let rise in a warm place for 1-1/2 hours. Preheat oven to 450°.*

1 egg beaten

> *Brush brioches with egg. Bake for about 12 minutes until golden brown. Turn out while warm.*

Filled Brioches

Brioch can be eaten plain, in the morning or for a snack, with coffee or tea. It is also delicious when filled. To fill, you must hollow it first. Remove the top with a serrated knife, cut out the inside and remove it. It is important not to damage the crust, so be careful. You can then fill it with any cream filling, or chocolate mousse, or fruits or your choice. You may also brush the inside with a dessert syrup. Use your imagination!

Tsoureki (Greek Easter Bread)

1 cup milk
> *Bring to boil, reduce heat.*

3/4 cup sugar
1/2 tp. salt
1/2 cup butter
> *Add in, stir well. Remove from heat.*

1/2 cup warm water
3/4 oz. yeast
> *Mix to dissolve, add to the milk mixture.*

3 cups flour
> *Add in, mix until smooth. Cover and let stand at room temperature for about one hour, until the mixture resembles a sponge.*

3 cups flour
2 eggs
2 egg yolks
1 tsp. lemon peel
1/2 tsp. ground mahlep (if available)
> *Mix well, cover, let double in size for about 1-1/2 hours. Punch down to flatten. On a lightly floured surface, knead the dough to a desired shape, round or oblong loaves, small or large. Place in a buttered baking sheet, cover, let rise to double in size. Brush with 1 beaten egg. You can use sesame seeds or sliced almonds for optional toppings. Bake at 350° for about 25 to 30 minutes.*

Flaky Puff Pastry

1-3/4 cups flour
2-1/2 tbs. soft butter
> *Beat for about 1 minute at low speed.*

1 tsp. salt
1/2 cup of water
> *Dissolve the salt in the water. Add to the flour, form a ball with the dough and cut the top crosswise with a knife. Refrigerate, covered, for two hours.*

1 cup cold butter
> *Place between two sheets of plastic wrap and flatten it slightly by hitting it with a heavy object. Roll the dough into a square on a floured surface. Place the butter in the center and fold the sides to enclose butter completely. Place the folded dough so the line is perpendicular to you. Flour lightly the surface of dough. Roll to a long rectangle, about 1/4" thick. Fold the dough into thirds, make sure you keep the working surface and your rolling pin lightly floured. Make sure the folded line is always perpendicular to you, you should never cross the line. Roll for the second time, refrigerate one hour, well covered, give the dough two more turns. Refrigerate one hour, covered. Before using the dough turn the dough two more times, refrigerate for one hour before rolling into desired shapes. Makes approx. 1-1/2 lbs. of dough.*

Flaky pastry is made by wrapping cold butter inside cold dough, then rolling and folding many times. This demands a great deal of care and patience. It is difficult but not impossible.

\mathcal{A} polish baker named Harry Lender started the first bagel bakery in 1927 in New York to produce bagels for sale through Jewish delicatessens.

The first recorded mention of bagels was in Poland. These round, chewy, hard glazed rolls of levened dough are dipped or poached in water that is close to the boiling point before they are baked. In fact, in many Polish communities, bagels were given to women at childbirth.

Lender's sons took over the bagel business and introduced flash-frozen bagels that can be shipped anywhere. Lender's became the largest U.S. bagel bakery. By 1984, Lender's bakery had grown to have 600 employees. Kraft Foods acquired the bagel company that year as well.

Bagels

1 package (1/4 oz.) yeast
1/2 cup of warm water
Place in a bowl, dissolve yeast, let stand for 5 minutes.
2-1/2 lbs. of flour
1/2 cup sugar
2 tsp. salt
Place in a large mixing bowl, mix well. Open a large hole in the middle.
Yeast mixture
1/8 cup vegetable oil
2 eggs, beaten
Mix together and add to the flour mixture, mixing to incorporate all ingredients. Turn on to floured surface and knead for about 10 minutes. Place dough in to a greased bowl, turning it around so it will be greased on all sides. Cover and let rise for about 1-1/2 hours. Punch down dough, let rise 30 minutes longer. Cut dough into 24 pieces. Roll each piece to a long rod, wrap around and connect the ends. Seal the ends with water. Make sure that the hole is large, about 3". Place on a greased baking sheet and let rise, covered for about 20 minutes. Heat a pot of water for boiling. With a slotted spoon, drop each bagel in to water and let boil for about 1-1/2 minutes, turn and let cook for 1-1/2 minutes longer. Drain on a paper towel and place on the greased baking pan. Bake in a 350° oven, 25 minutes until firm and lightly brown. Switch oven to broil and brown on both sides.

There are several bagel variations. For that simply add to the dough the flavor desired. Adjust flour for consistency.

Palmiers

6 oz. of flaky pastry dough
1/2 cup sugar

Sprinkle sugar on a working surface. Roll dough on the sugar into two strips, 6" x 12". Moisten the dough lightly with a brush. Fold the sides of the dough lengthwise until they touch the center. Fold again lengthwise in half, press down the dough lightly.

Refrigerate the strips for 15-20 minutes. Slice in to 1/4" strips. Place each strip on to a lightly buttered pan, do not place too close to one another because palmiers will spread out.

Bake in a preheated 400° oven for about 10 minutes.

For cinnamon palmiers, mix 1/2 cup of sugar with 1/8 cup of cinnamon to roll on the dough.

Pretzels

The history of pretzels is long. It goes back to the time of the Crusades.

The shape of the pretzel is said to symbolize crossed arms in prayer and that the three holes signify the Father, the Son and the Holy Ghost. The name originated in the monasteries of France where pretzeola, meaning three holes and it was given as a reward to the children.

The pretzel was brought to America by the Germans. The first pretzel baker was founded by Julius Sturgis, in Lititz, Pennsylvania in 1861. He eventually established a delivery route to keep up with the pretzel demand. Three drivers with horse and buggy delivered to a radius of one-day's distance from the bakery.

Pretzels are made with a kneaded yeast dough, small chunks of dough rolled into a thin, long, pencil shape and left to rise for about 1 hour. Then it is twisted so each long piece of dough will form a pretzel. Then the pretzels are left to rise a second time.

For soft pretzels:

Drop each pretzel in boiling water for about 10 seconds. Sprinkle wet pretzels with salt. Place pretzels in a greased, baking pan and bake in a 475° oven for about 10 minutes until brown.

For hard pretzels:

Bake pretzels on a greased baking pan in a 500° oven for about 10 minutes. Lower the temperature to 200° and bake for 2 hours longer.

Pretzels today are made with soft wheat flour, barley malt, yeast and water.

The tradition of eating pretzels with mustard started many decades ago at baseball games. Others eat pretzels with ice cream and many more enjoy it with a mug of beer!

Muffins

1-1/2 cups sifted flour
1/2 cup sugar
2 tsp. baking powder
 Sift together.
1 egg beaten
1/4 cup of vegetable oil
1/2 cup milk
 Mix well, fold in to the flour mixture. Bake in greased muffin cups, filled 3/4 full in 400° preheated oven for 20-25 minutes. Makes 10 large muffins.

VARIATIONS: When you are adding fillings to the muffins, you may have to adjust the flour to bring it to the right consistency.

Blueberry: *Add 1 cup blueberries.*

Raspberry: *Add 1/2 cup raspberry marmalade, 1/2 cup raspberries. Pour batter in to cups 1/4 full, spoon 1 tbs. of raspberry marmalade in it, fill cups with batter to 3/4 full.*

Zucchini Nut: *Add 3/4 cup of shredded zucchini and 3/4 cup of chopped walnuts.*

Pumpkin Cream Almond: *Add 3/4 cup of pumpkin puree and 3/4 cup of chopped almonds. Pour muffin batter in the muffin cup 1/4 full, spoon in 1 tbs. of cream cheese, fill muffin cups to 3/4 full with muffin batter.*

Cranberry Orange: *Add 3/4 cup orange marmalade, 3/4 cup cranberries.*

Pumpkin Cranberry: *Add 3/4 cup of pumpkin puree and 1/2 cup of cranberries.*

Banana Nut: *Add 3/4 cup of chopped bananas and 3/4 cup chopped walnuts.*

Almond Poppy: *Add 1 cup of poppy seeds and 3/4 cup chopped almonds.*

Lemon: *Add 2 tbs. lemon juice, fill muffin cups 1/4 full, spoon in 1 tbs. lemon pie filling, top with muffin batter to 3/4 full. Mix together juice of two lemons and 1/8 cup of sugar. Spoon over muffins after they are baked.*

Espresso: *Add 1 tbs. of lemon peel and 3 tbs. of strong coffee.*

Bran Muffins

1 cup whole bran flakes
3/4 cup of milk
 Mix, let stand until milk is absorbed, set aside.
1 egg
1/4 cup vegetable oil
 Mix well.
1 cup sifted flour
2-1/2 tsp. baking powder
1/2 tsp. salt
1/4 cup sugar
 Add in, mix well, add the bran mixture, mix lightly. Fill greased muffin cups 3/4 full. Bake in a preheated 400° oven for 20-25 minutes. Makes 8 large muffins.
Carrot Bran Muffins: *Add 1 cup of grated carrots.*

Buttermilk Scones

I like to make my scones in a round shape unlike the traditional triangle ones!

2 cups flour
1/3 cup sugar
1-1/2 tsp. baking powder
1/2 tsp. baking soda
1/4 tsp. salt

Mix in large bowl.

6 tbs. chilled unsalted butter

Cut into pieces and mix well in to the flour mixture with your fingertips.

2/3 cup buttermilk
2 eggs
1 tsp. vanilla extract

Whisk together, add to flour mixture gradually. Knead dough on a lightly floured surface. Do not overwork the dough, just knead to blend. Divide dough into 1/2 cup amount of balls, place on lightly buttered pan. Bake in a preheated 350° oven for about 25 minutes. For added flavor, add 1/2 tsp. ginger, if desired.

FRUIT SCONES: *Use the above scone recipe*

Strawberry Cream Scone: *Add 1/2 cup slices strawberries, mix well. After forming the scones, insert wth your thumb 1 tsp. cream cheese in the middle of each scone.*

Apple Cinnamon: *Add 1 cup sliced, peeled apples cut in to small pieces. Add 1/2 tsp. cinnamon, mix well.*

Apricot Ginger: *Add 3/4 cup apricots, cut in pieces and 1/2 tsp. ginger. Mix well.*

You may need to add a little more flour in to the fruit scones to bring dough back to its original consistency. Bake the same way as Buttermilk Scones.

Oatmeal Scones

3 cups flour
3 cups rolled oats
1/2 tsp. salt
1-1/2 tsp. baking soda
3 tsp. cream of tartar
3 tbs. sugar
1/4 cup finely chopped walnuts

Mix in a bowl.

3/4 cup butter, chilled

Cut into small pieces, mix with your fingers until thoroughly mixed with the dry ingredients.

1-1/2 cups buttermilk

Add in, mix well. Work the dough lightly on a floured surface with a 1/2 cup scoop of dough. Place rounds on a lightly greased baking pan. Bake at 400° for 15-17 minutes until brown.

__To make traditional wedges:__ open dough to 1/2" thickness, cut dough to wedges and bake the same way as above.

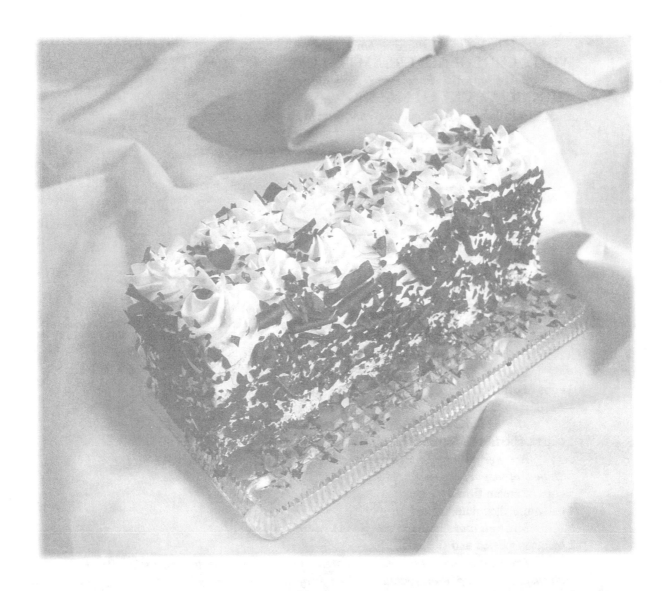

Bar Cakes

CREAM FILLNG
You will need this for the following recipes
1 quart of heavy cream

1 tsp. vanilla extract

Beat well with the wire beater of an electric mixer until cream is still.

1/2 cup of cake flour

Add in, beat well. Place in bowl.

WHITE CHOCOLATE CREAM FILLING

Add 6 oz. white chocolate to cream filling

CHOCOLATE CREAM FILLING

Add 6 oz, melted semisweet chocolate to the cream filling

The variety of syrups for the bar cakes are found on page 95.
Cake recipes begin on page 92.
The dark chocolate used in these recipes is semisweet chocolate.

Raspberry Banana Cake

Dark cake

Size of 12" x 4", slice it lengthwise to three equal slices

Raspberry Syrup

Brush the bottom slice of the cake with part of the syrup.

3 cups of cream filling

4 oz. of melted semisweet chocolate

Mix well and spread on the bottom cake.

1 cup raspberries (if fresh is not available, use frozen)

Arrange on top of chocolate cream. Cover it with the second cake slice. Brush with part of raspberry sauce.

3 cups of cream filling

4 oz. white chocolate, melted

Mix well and spread on the second cake slice.

2 bananas, peeled and sliced

Arrange on top of the white chocolate cream. Cover with the third slice. Brush with raspberry syrup. Run spatula on the side of the cake to smooth out any overlapping cream.

Icing
4 cups of cream filling

6 oz. of white chocolate, melted

Mix well, save 1/4 of the cream for decoration. With 3/4 of the cream, ice the sides and top of cake.

Decoration
Place the remaining 1/4 of cream filling in a pastry bag with a star tip. Make rossettes on the edges of the top of the cake. Decorate the sides of the cake with dark chocolate shavings. Sprinkle dark and white chocolate shavings on top of cake.

Amaretto Cream Cake

White cake
> *Size of 12" x 4", slice it lengthwise to three equal slices*

Grand Marnier Syrup
> *Brush the bottom slice of the cake with part of the syrup.*

6 cups of cream filling
8 oz. of white chocolate, melted
> *Mix well, divide into two parts.*

1 cup of sliced almonds, toasted
> *Mix with the one part, spread on top of bottom slice. Cover it with the second slice, brush with Grand Marnier sauce.*

2nd part of cream filling
1/4 tsp. almond extract
> *Mix well and spread on the second cake slice. Cover with the third cake slice, brush with Grand Marnier syrup.*

Icing

4 cups of cream filling
6 oz. of white chocolate, melted
1/4 tsp. almond extract
> *Mix well, spread all but 2 cups on the sides and top of the cake.*

Decoration

> *Place the two cups of icing in a pastry bag with a star tip and pipe it around the edges of the cake. Decorate sides with white chocolate shavings.*

1/2 cup of natural sliced almonds
> *Pour on top in the middle of cake between the piped cream.*

Blueberry Sauce

1 lb. of blueberries
3 tbs. lemon juice
1/2 cup sugar
> *Cook over a medium heat for 5 minutes, stirring occasionally. Puree in a blender for thick sauce or strain for thinner sauce.*

Orange Sauce

4 cups orange juice
> *Heat in a saucepan until reduced to about half.*

3/4 cup sugar
> *Add in, stir, remove from heat.*

1 tbs. lemon juice
1tsp. lemon zest
> *Add in, mix well.*

Apricot Mocha

Dark cake
> *Size of 12" x 4", slice it lengthwise to three equal slices*

Coffee Syrup
> *Brush the bottom slice of the cake with part of the syrup.*

3 cups of cream filling
4 oz. of dark chocolate, melted
> *Mix well, spread on top of the bottom cake slice.*

4 apricots, sliced
> *Arrange on top of filling. Cover with the second slice, brush with Coffee Syrup.*

3 cups of cream filling
4 oz. of dark chocolate, melted
1 tbs. of strong coffee
> *Mix well, spread on top of third slice, brush with Coffee Syrup.*

Icing

4 cups of cream filling
6 oz. of dark chocolate, melted
> *Mix well and spread the sides and top of the cake.*

Decoration

4 oz. of dark chocolate, melted
1/2 cup of heavy cream, warmed
> *Mix well, and pour evenly on top of cake. With a spatula, smooth out the sides of the cake from any dripping chocolate. Arrange dark shavings on the sides of the cake.*

Chocolate Rolls

These are easy to make, it just takes a little practice. Chocolate remains at a certain consistency for a short time, so you have to work quickly.

Melt semisweet chocolate and spread it with a spatula, thinly on a working surface, marble or glass works well. Form rolls by holding a wide spatula on an angle and scraping parts of chocolate from the surface. Chocolate will form rolls, place on a tray and refrigerate.

Chocolate Shavings

Scrape a sharp knife across a large piece of chocolate. If the chocolate is soft, the pieces will be larger. If the chocolate is hard, the pieces will be smaller.

Dark Cherry Cream

Dark cake
> *Size of 12" x 4", slice it lengthwise to three equal slices*

Cherry Syrup
> *Brush the bottom slice of the cake with part of the syrup.*

3 cups of cream filling
4 oz. of dark chocolate, melted
> *Mix well, spread on top of the bottom cake slice.*

1 cup cherry pie filling
> *Arrange on top of filling. Cover with the second slice, brush with Cherry Syrup.*

4 oz. cream cheese
> *Cream in a mixer.*

2 cups of cream filling
4 oz. white chocolate, melted
> *Add in, mix well and spread on top of cake. Cover with third slice, brush with Cherry Syrup.*

Icing
4 cups of cream filling
6 oz. of dark chocolate, melted
> *Spread all but 2 cups on top and sides of cake.*

Decoration
> *Use the two cups to make rossettes around the top edges of cake.*

1 cup cherry pie filling
> *Pour in the middle, between the rossettes. Arrange dark shavings on the sides of the cake.*

Butter Cream
1-1/3 cups sugar
1/3 cup water
> *Bring to a boil, reduce heat. Simmer for about 5-6 minutes. Set aside.*

12 egg yolks
> *Whip at medium speed, add the sugar-water a little at a time, let cool.*

1-1/2 lbs. butter, softened
> *Cut in to small pieces and add in. Beat at low speed for about 5 minutes. At this point, you can add the desired flavoring.*

Coffee Butter Cream: Add 2-1/2 tbs. instant coffee
Chocolate Butter Cream: Add 10 oz. melted chocolate
Almond Butter Cream: Add 1 cup of powdered almonds

White Mocha

White cake
> *Size of 12" x 4", slice it lengthwise to three equal slices*

Coffee Syrup
> *Brush the bottom slice of the cake with part of the syrup.*

3 cups of cream filling
4 oz. of white chocolate, melted
> *Mix well, spread on top of the bottom cake slice.*
> *Cover with the second slice, brush with Coffee Syrup.*

3 cups of cream filling
4 oz. of white chocolate, melted
1 tbs. of strong coffee
> *Mix well, spread on top of third slice, brush with Coffee Syrup.*

Icing

4 cups of cream filling
6 oz. of white chocolate, melted
> *Mix well and spread all over cake.*

Decoration

2 oz. of dark chocolate
1/2 cup of heavy cream, warmed
> *Mix well, until smooth. Spoon out mixture with a large spoon with holes and wave on top of cake, to make chocolate lines. Arrange white chocolate shavings on the sides of the cake.*

❧

VANILLA PASTRY CREAM

2 cups milk
1 tsp. vanilla extract
> *Bring to boil, set aside.*

6 egg yolks
2/3 cup sugar
> *Beat on medium speed, 4-5 minutes.*

4 tbs. flour
> *Add in, mix well, remove from mixer. Add the hot milk slowly, beating with a wire whip. Bring mixture to boil, stirring, boil for one minute. Remove, stir until smooth.*

CHOCOLATE PASTRY CREAM

6 oz. semisweet chocolate, melted
> *Add to the hot pastry cream, mix well.*

Kahlua Chestnut

Dark cake
> *Size of 12" x 4", slice it lengthwise to three equal slices*

Kahlua Syrup
> *Brush the bottom slice of the cake with part of the syrup.*

3 cups of cream filling
3 oz. of dark chocolate
2 oz. of chestnut puree
> *Mix well, spread on top of the bottom cake slice. Top with the second cake slice and brush with syrup.*

3 cups of cream filling
4 oz. of white chocolate, melted
1 tbs. of kahlua
> *Mix well, spread on top of third slice, brush with Kahlua Syrup.*

Icing

4 cups of cream filling
6 oz. of dark chocolate, melted
> *Mix well and spread all over cake.*

Decoration

Ladyfingers (approx. 16)
Chocolate icing
> *Dip a ladyfinger into the icing and place it on the side of the cake, starting from one corner and the chocolate dipped end upwards. Repeat with the rest of ladyfingers until all sides of cake are covered.*

4 cups of cream filling
4 oz. of dark chocolate, melted
> *Mix well and with a pastry bag with a star tip, pipe the middle of the cake between the ladyfingers. Sprinkle the top with white chocolate shavings.*

I took a bite of Sweet Chocolate Death and suddenly I was floating above our table, moving irresistibly towards a brilliant light filled with warmth and love I'd never known.

Java Magazine, Dec. 1977

Citrus Rum

White cake
> *Size of 12" x 4", slice it lengthwise to three equal slices*

Rum Syrup
> *Brush the bottom slice of the cake with part of the syrup.*

3 cups of cream filling
4 oz. of dark chocolate, melted
1/2 cup of lemon pie filling
> *Mix well, spread on bottom slice. Top with second slice, brush with Rum Syrup.*

3 cups of cream filling
4 oz. of white chocolate, melted
1 tbs. of orange peel
> *Mix well, spread on top of third slice, brush with Rum Syrup.*

Icing

3 cups of cream filling
6 oz. of white chocolate, melted
> *Mix well and spread on all sides of cake.*

Decoration

2 cups of toasted coconut
> *Arrange on the sides of the cake.*

2 cups of cream filling
2 oz. of white chocolate, melted
> *Fill a pastry bag with a star tip and make rossettes around the top edges of the cake. Place white chocolate shavings in the middle part of the cake between the rossettes.*

CUSTARD

6 cups milk
1 cup sugar
> *Bring to boil in a large saucepan.*

1 tbs. flour
> *Add in, stir to melt, remove from heat.*

6 eggs
1/2 cup sugar
1 tsp. vanilla extract
> *Beat in a mixer at medium speed until frothy, fold slowly in to hot milk, stirring with a wire whisk.*

1 cup semolina
6 tbs. cake flour
> *Add in, mix well. Place in a bowl to set.*

LEMON CUSTARD: Follow the custard recipe, add 3/4 cup lemon pie filling.
STRAWBERRY CUSTARD: Follow the custard recipe, add 1/2 cup strawberry jam.
> *You can flavor the custard recipe with the flavor of your choice.*

Orange Espresso

White cake

Size of 12" x 4", slice it lengthwise to three equal slices

Grand Marnier Syrup

Brush the bottom slice of the cake with part of the syrup.

6 ladyfingers

Dip them into the Grand Marnier syrup and arrange on top of cake.

3 cups of cream filling

1 tsp. cocoa

2 oz. of dark chocolate

Mix well and place on top of ladyfingers. Top with the second slice of cake and brush with Grand Marnier syrup.

3 cups of cream filling

4 cups of white chocolate, melted

Spread on top of cake, cover with third cake layer, brush with Grand Marnier syrup.

Icing

4 cups of cream filling

6 oz. of white chocolate, melted

1 tbs. orange peel

Mix well and spread on all sides and top of cake.

Decoration

Ladyfingers (Approx. 16)

Chocolate Icing

Dip a ladyfinger into the icing and place it on the side of the cake, starting from one corner and with the chocolate dipped end upwards. Repeat with the rest of the ladyfingers until all sides are covered.

4 cups of cream filling

2 oz. of white chocolate, melted

1/2 tbs. of cocoa powder

Mix well and with a pastry bag with a star tip, pipe the cream in the middle of the cake, between the ladyfingers. Sprinkle dark chocolate shavings on top.

Forget everything you ever thought about puddings and try Nick's Jack Daniel's Pudding, with bittersweet, semisweet chocolates, whipped cream and Jack Daniels whiskey combined into one heavenly mixture. The Cheesecake Brownie was creamy beyond belief. The Cinnamon Stick Cake had a base of a wonderfully tangy cheesecake with just a hint of cinnamon with layers of golden, buttery filled pastry a la Baklava. If we thought eating that was a Sinful Act, we were ready to repeat when we finished the last gooey bit of the dark chocolate cake, white chocolate creamcake, rasp-berries and chamboard almond crust that together comprised a cake called a Sinful Act. Undaunted, we proceeded on our orgy of indulgence to Sweet Chocolate Death, a layering of chocolate meringue, chocolate mousse, chocolate cake, chocolate icing and almonds. What a way to go! The only fitting sequitur, at this point, could be After Death, another original compilation containing walnut meringue, white chocolate mousse, almond cream, banana mousse with bits of golden raisins, all bathed in a white chocolate frosting coated studded with a coat of chopped hazelnuts. It, too, was to die for!

The Western Express, 1991

Strawberry Banana

White cake
> *Size of 12" x 4", slice it lengthwise to three equal slices*

Rum Syrup
> *Brush the bottom slice of the cake with part of the syrup.*

3 cups of cream filling
4 oz. of white chocolate, melted
> *Mix well and spread on top of bottom cake slice.*

8 strawberries
Cbocolate icing
> *Dip strawberry tops in icing and arrange on top of cream filling. Cover that with the second cake slice, brush with Rum Syrup.*

3 cups of cream filling
4 oz. of white chocolate, melted
> *Mix well, spread on top of second cake slice.*

1 banana, cut into pieces
Chocolate icing
> *Dip part of banana piece into the icing and arrange on top of cream filling. Top with the third cake slice and brush with Rum Syrup.*

Icing

4 cups of cream filling
6 oz. of white chocolate, melted
> *Mix well and spread on all sides and top of cake.*

Decoration

> *Arrange white chocolate shavings on the sides of the cake. With the chocolate icing warmed, with a large spoon with holes, shake on top of cake to create chocolate lines.*

White Passion Cake with macadamia cream filling;

Mango Mousse and Kiwi Chocolate;

Whipped Cream Cheesecake with pecans, walnuts, fillo dough and cinnamon syrup;

Layered Citrus Cake with berry sauce; Orange Honey Biscotti and

Creme de Cafe Mousse - Fatal Obsession.

Reading Nick's dessert menu is better than erotic poetry.

Arizona Republic, 1993

Hazelnut Rum

White cake
 Size of 12" x 4", slice it lengthwise to three equal slices

Rum Syrup
 Brush the bottom slice of the cake with part of the syrup.
3 cups of cream filling
4 oz. of dark chocolate
1/2 cup of grated hazelnuts
 Mix well and spread on top of bottom cake slice. Cover this with the second cake layer and brush with Rum Syrup.
3 cups of cream filling
4 oz. of white chocolate, melted
 Mix well, spread on top of second cake slice. Cover with the third cake slice, brush with Rum Syrup.

Icing
4 cups of cream filling
6 oz. of white chocolate, melted
 Mix well and spread on all sides and top of cake.

Decoration
 Arrange white chocolate shavings on the sides of the cake. Sprinkle grated hazelnuts on top of cake.

❧

SWEET PASTRY DOUGH
6 tbs. butter, cut into small pieces
2 tbs. sugar
1/2 tsp. vanilla extract
3 tbs. powdered almonds
Pinch of salt
1 cup flour
 Mix gently.
1 egg
 Add in, mix.

 This recipe makes approx. 10 oz. of dough. Do not overmix this dough because it will break. Refrigerate overnight before rolling out.

Raspberry Truffle Cake

Dark cake
> *Size of 12" x 4", slice it lengthwise to three equal slices*

Raspberry Syrup
> *Brush the bottom slice of the cake with part of the syrup.*

4 cups of cream filling
6 oz. of dark chocolate, melted
> *Mix well and spread on top of bottom cake slice.*

1 cup of raspberries
> *Arrange on top of filling. Cover with the other cake slice and brush with the* Raspberry Syrup.

Icing
4 cups of cream filling
6 oz. of dark chocolate
> *Mix well and spread on all sides and top of cake. Arrange dark chocolate shavings on top and sides of cake.*

Decoration
Chocolate icing
> *Spread on top of cake while warm. Run your spatula on the sides of cake to smooth out dripping chocolate. Arrange dark chocolate shavings on the side of the cake.*

※

Almond Mousse

Dark cake
> *Size of 12" x 4", slice it lengthwise to three equal slices*

Simple Syrup
> *Brush the bottom slice of the cake with part of the syrup.*

3 cups of cream filling
6 oz. of dark chocolate, melted
> *Mix well and spread on top of bottom cake slice.*

1 cup of toasted sliced almonds
> *Arrange on top of filling. Cover with the second cake slice and brush with the* Simple Syrup.

3 cups of cream filling
4 oz. of dark chocolate, melted
> *Mix well, spread on top of cake and cover with the third cake slice, brush with* syrup.

Icing
3 cups of cream filling
6 oz. of dark chocolate, melted
> *Mix well and spread on all sides and top of cake. Arrange natural sliced almonds on top and sides of cake.*

Berry Rhapsody

Dark cake
> *Size of 12" x 4", slice it lengthwise to three equal slices*

Raspberry Syrup
> *Brush the bottom slice of the cake with part of the syrup.*

3 cups of cream filling
4 oz. of dark chocolate, melted
> *Mix well and spread on top of bottom cake slice.*

1 cup of raspberries
> *Arrange on top of filling. Cover with the other cake slice and brush with the Raspberry Syrup.*

3 cups of cream filling
4 oz. white chocolate, melted
> *Mix well, spread on top of cake.*

1 cup of boysenberries
> *Arrange on top of filling. Cover with the third cake slice, brush with Syrup.*

Icing

3 cups of cream filling
6 oz. of dark chocolate, melted
> *Mix well and spread on all sides and top of cake. Arrange dark chocolate shavings on the sides of cake. Arrange white chocolate shavings on top of cake.*

Kiwi Mango Cake

White cake
> *Size of 12" x 4", slice it lengthwise to three equal slices*

Rum Syrup
> *Brush the bottom slice of the cake with part of the syrup.*

3 cups of cream filling
4 oz. of white chocolate, melted
3 kiwis, peeled, cut into small pieces
> *Mix well and spread on top of bottom cake slice. Cover with the second cake slice, brush with syrup.*

3 cups of cream filling
4 oz. of white chocolate, melted
2 mangos, peeled, cut into small pieces
> *Mix well, spread on top of cake and cover with the third cake slice, brush with syrup.*

Icing

4 cups of cream filling
6 oz. of white chocolate, melted
> *Mix well and spread on all sides and top of cake. Arrange toasted coconuts on the sides of the cake and white chocolate shavings on the top of the cake.*

Commercial kiwi fruit cultivation began in New Zealand in 1906. The berry is a woody vine native of China's Yanzi Valley. It is grown from plants collected by a British botanist and brought to the West at the turn of the century.

In antiquity, before there was sugar, people made their desserts with honey.

꧁꧂

European Nut

White cake
Size of 12" x 4", slice it lengthwise to three equal slices

Frangelico Syrup
Brush the bottom slice.
3 cups of cream filling
6 oz. of dark chocolate, melted
1 cup of hazelnuts, cut into small pieces
Mix well, spread on top of the cake, cover with the second cake slice, brush with Syrup.
3 cups of cream filling
4 oz. of white chocolate, melted
1 cup of pistachios, cut into small pieces
Mix well, spread on top of cake and cover with the third cake slice, brush with syrup.

Icing
4 cups of cream filling
6 oz. of dark chocolate, melted
Mix well and spread on all sides and top of cake. Arrange grated hazelnuts on top of cake and white chocolate shavings on the sides of cake.

꧁꧂

Almond Paste
1-1/2 cups powdered almonds
1-2/3 cups powdered sugar
Mix well.
2 egg whites
Add in, mix well. Smooth.

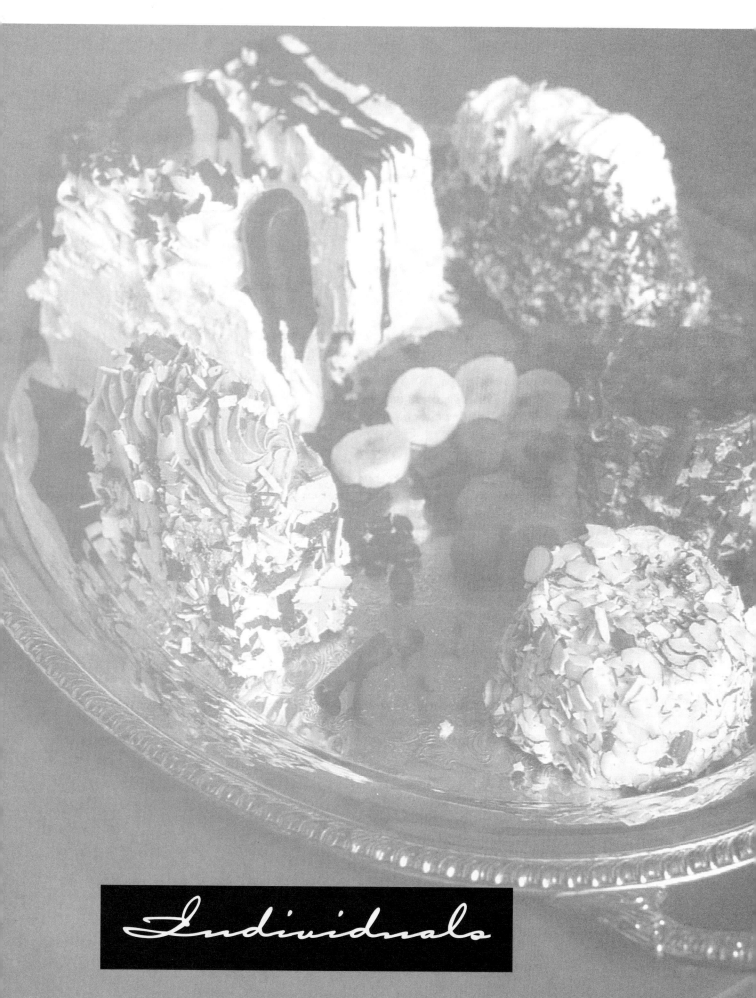

There is something special about a dessert for one person. It is a personal gift, made with just you in mind.

Small treats can be made of any size or shape, and when a variety of these are offered on a tray, it is an impressive presentation of various tastes and designs.

In the following recipes, I purposely will guide you back to using recipes from cakes and pies in this book. My reasoning: that I want you to use your imagination and use the leftovers from mousse, creams, icings, etc. to create something else.

Mini Mousse Cake

Chocolate cupcakes

Pour chocolate cake batter in buttered large muffin cups (approx. 3" diameter) and bake like you would muffins (350º for approx. 30 minutes). Remove, let cool.

Chocolate Mousse (recipe, pg. 96)

Slice chocolate cupcakes in half, horizontally, spoon approx. 1/2 cup of mousse on the bottom part. Cover with the other half.

Icing
Chocolate Icing (recipe, pg. 96)

With a spatula, spread on cake smoothly. Refrigerate until cooled. Warm up icing until it becomes liquidy. Place mini mousse cakes on a screen. With a large spoon, pour icing on top of cake so it rolls all over cake. Refrigerate. You can make several mini mousse cakes at a time. They keep very well in the refrigerator.

<p align="center">❧✦❧</p>

Banana Rum Mousse Cake

White cupcakes

Pour white cake batter in buttered large muffin cups (approx. 3" diameter) and bake like you would muffins (350º for approx. 30 minutes). Remove, let cool. Cut a thin slice from the top of cake. With a short sharp knife, cut a hole in the middle of the bottom cake.

Rum Syrup (recipe, pg. 95)

Brush the bottom cake, inside the hole.

Banana Mousse (recipe, pg. 119)

Fill the hole of the cake, cover with the thin slice of cake.

White Chocolate Icing (recipe, pg. 119)

Spread all over the cake. Cover the sides of the cake with white chocolate shavings.

Mini Rhapsody

Half recipe of Chocolate Chambould Cake (recipe, pg. 121)
Half recipe of White Chocolate Cream Cake (recipe, pg. 121)
Butter lightly large muffin cups (approx. 8 cups). With a small ice cream scoop, place on scoop of chocolate cake in each cup. Top this with a scoop of white chocolate cream cake and on top of this place another scoop of chocolate cake. Bake in 275° oven for about 45 minutes. Refrigerate overnight. Remove filling from the cups.

White Icing
8 oz. of white chocolate, melted
4 oz. of sour cream
Mix well, spread on top of cake and on sides. Cover all of cake with natural sliced almonds.

Mini Carrot Cake

Make half of the Carrot Cake Recipe (recipe, pg. 107)
Pour filling in buttered large muffin cups. Bake at 350° for about one hour. Cool and remove from cups.

Icing (recipe, pg. 107)
Make half of the icing recipe. Spread smoothly around and on top of cake. Makes approx. 10 mini cakes.

All bar cakes, (previous section) can be made into individual cakes. After assembling the bar cake, simply cut the bar cake into about two inches of individual pieces, then use the same icing and decoration to cover the cut ends of the cakes.

Mini Raspberry Truffle

Chocolate cupcakes

Pour chocolate cake batter in buttered large muffin cups (approx. 3" diameter) and bake like you would muffins (350º for approx. 30 minutes). Remove, let cool.

Raspberry Syrup (recipe, pg. 95)

Cut chocolate cup cakes in half lengthwise, brush with syrup the bottom of cake.

Quick Chocolate Mousse

4 cups of cream filling (recipe, pg. 212)

8 oz. of dark chocolate, melted

Mix well. Spread approx. 1/4 of a cup on bottom chocolate cup cake, top that with the other half of the cake.

Icing

4 cups of cream filling (recipe, pg. 212)

6 oz. of dark chocolate, melted

Mix well and spread all over the cake.

Decoration

4 oz. of dark chocolate, melted

1/2 cup of heavy cream, warmed

Mix well and pour a spoonful on the top of the cake to just cover the top part of the cake. With a spatula, smooth out the sides of the cake. Cover the sides with dark chocolate shavings.

<div align="center">⚜</div>

CHOCOLATE CUPS - and Other Chocolate Shapes, Dark or White

Melt 2 lbs. of semisweet dark chocolate or white chocolate

You will need a paper cup (styrofoam works best) and cellophane paper.

Cut the cellophane into a square and place the paper cup in the middle of the paper, pull up the edges of the paper and tuck it in to the cup. Continue with all the edges of the paper until they are all tucked in loosely. If you want to make a straight chocolate cup, smooth out the paper around the paper cup. If you like to make a shell-like chocolate cup, make pleats with the paper around the paper cup. Make sure that the pleats are not closely together. If the folds are closely together or they are too sharp, the cup will break.

Hold the paper cup from the top, dip its bottom into the melted chocolate, about 3" deep or to the size desired for your chocolate cup to be. Remove and let excess chocolate drip back in to the melted chocolate. Set the chocolate cup on a baking sheet lined with parchment paper. Refrigerate and allow to harden. Remove paper cup and the cellophane. Chocolate cups are very delicate and break easy. Avoid handling them with your hands too much and keep them refrigerated as much as possible.

If you are making a coffee cup shape, to make handle, simply pipe the melted chocolate with a pastry bag and a straight tip on parchment paper the shape of a cup handle and refrigerate. After it is cooled, dip the edges of the handle into the melted chocolate and glue it on the side of the cup.

For other shapes: hearts, shells, etc, shop at your local cake decorating store and look for shapes to inspire ideas and create something new, something unique.

2 lbs. of chocolate makes approximately 12 cups.

Orange Cappuccino Cup

Chocolate Coffee Cup

Half Recipe of Cappuccino Mousse (recipe, pg. 99)
Fill cups with mousse.
Half Recipe of Topping of Cappuccino Mouse (recipe, pg. 99)
Fill a pastry bag with a waving tip and pipe on top of mousse to appear like cream foam.
Cinnnamon
Sprinkle on top.

❧

Strawberry Mousse Cup

Chocolate Souffle Cup

Half Recipe of Chocolate Mousse (recipe, pg. 96)
Mix with 8 strawberries in an electrc mixer until smooth. Refrigerate to cool a bit with a pastry bag and a star tip, pipe the mousse in to the cup with a circular motion of your hands. Sprinkle top with white chocolate shavings.

❧

Chocolate Peanut Butter Cups

Half Recipe of Chocolate Pie mixture (recipe, pg. 144)
1/2 cup of creamy peanut butter
Mix well, refrigerate to harden a little. With a pastry bag and a straight tip, pipe a layer of creamy peanut butter in the bottom of a chocolate souffle cup.
With a pastry bag and a star tip, pipe the chocolate-peanut butter filling into the souffle cup, making a circular motion with your hands, forming a peak in the center and over the rims of the cup.

❧

Hazelnut Cappuccino Hearts

Half Recipe of Chocolate Mousse (recipe, pg. 96)
1 tsp. Frangelico liqueur
1 tsp. finely grated hazelnuts
Mix well. Place in a pastry bag with a small star tip and pipe into a chocolate heart making small stars on top.
Dark chocolate, melted
With a large spoon with holes in it, shake the chocolate over the hearts to make chocolate lines.

Chestnut Chocolate Hearts

Chestnut Chocolate (recipe, pg. 231)
>*Place in a pastry bag with a star tip and pipe it in to the chocolate heart making small star picks on top.*

White chocolate, melted
>*With a large spoon with large holes, shake the chocolate over the hearts to make white lines.*

**You can make chocolate hearts with milk chocolate, using heart molds, available in cake decorating specialty stores. Chocolate hearts for filling are half hearts with an open cavity.*

<p style="text-align:center">✦✦✦</p>

Butter Pecans

Pecan Bars (recipe, pg. 184)
>*Cut pecans bars into squares, approx. 3"*

Chocolate Icing (recipe, pg. 96)
>*Place squares on screen and pour icing on top while warm. Make sure you place a pan under the screen to catch the drippings. Cover the bars completely.*

<p style="text-align:center">✦✦✦</p>

Caramel Peanuts

Chocolate Mousse (recipe, pg. 96)
>*Refrigerate until firm, divide into three parts using pastry flour on a working surface, open the chocolate to large strips.*

1/2 cup caramel sauce (recipe, pg. 115)
3 cups roasted peanuts
1/2 cup of honey
>*Mix well, divide into three parts, place each part on the middle of each strip. Fold filling into the strips, refrigerate again until firm. Cut strips into 4" pieces.*

Chocolate Icing
>*Place the pieces on a screen with a pan under it to catch the drippings and spoon warm icing over the pieces.*

White chocolate icing (recipe, pg. 119)
>*Pour in a pastry bag with a small straight tip and make lines on the top of the chocolate bars.*

Chocolate Sfoliata

3 pieces of puff pastry, approx. 6" x 3"
> *Bake in a hot oven for a few minutes until pastry is golden brown.*

1/2 cup of cream filling (recipe, pg. 212)
3 oz. of semisweet chocolate, melted
1 tsp. of instant coffee
> *Mix well and spread on the bottom of pastry. Cover filling wth another pastry strip.*

1 cup of cream filling (recipe, pg. 212)
4 oz. of white chocolate, melted
> *Spread half of this filling on the pastry and cover with the remaining pastry strip. With the remaining filling, spread the sides and top of sfoliata*

Chocolate icing
> *While warm, shake a large spoon with holes in it on top and on the sides of cake.*

Chestnut Chocolate

6 oz. chocolate mousse (recipe, pg. 96)
6 oz. chestnut puree (recipe, pg. 64)
1/8 cup whipping cream
1/4 lb. butter, soft
1/2 cup sugar
1 egg yolk
> *Mix well. Serve in a chocolate cup.*

Strawberry Chocolate Ravioli

1 puff pastry square, 8" x 8"
> *Bake until golden brown. Break into pieces.*

Half Recipe of Chocolate Mousse (recipe, pg. 96)
> *Mix well with the pastry pieces, let cool for a few hours. When mixture is firm, scoop out a part of the mixture with a small ice cream scoop. Using pastry flour on a working a small surface, open the mousse into a square.*

1 tbs. cream filling
1 tsp. white chocolate, melted
> *Mix well, place in the middle of one of the squares.*

1 strawberry, sliced
> *Place on top of filling. Cover with the second chocolate square. With a fork, press gently around the edges to form a ravioli.*

White chocolate, melted
> *With a large spoon with holes in it, shake chocolate over ravioli to form white lines.*

Chocolate Cherry Turnovers

1 puff pastry square, approx, 8" x 8"
>*Bake until golden brown, break into small pieces.*

Half Recipe of Chocolate Mousse (recipe, pg. 96)
>*Mix well with the pastry pieces, let cool for a few hours. When mixture is firm, scoop out parts of mixture with an ice cream scoop. Using pastry flour on a working surface, mold mixture into a square shape.*

1 tbs. chocolate icing (recipe, pg. 96)
>*Place in the middle of the square.*

1 tbs. cherry pie filling
>*Place on top of icing. Fold the square to an oblong shape. With a fork, push gently the edges of the turnover.*

White chocolate vemicelli
>*Spinkle on top.*

Chocolate Croissants

1 puff pastry square, approx. 8" x 8"
>*Bake until golden brown, break into small pieces.*

Half Recipe of Chocolate Mousse (recipe. pg. 96)
>*Mix well with the pastry pieces, let cool for a few hours. When mixture is firm, scoop out parts of mixture with an ice cream scoop. Using pastry flour on a working surface, mold mixture into a triangle.*

1 tbs. cream filling (recipe, pg. 212)
1 tsp. white chocolate, melted
>*Mix and place on the bottom of the triangle, roll like a croissant (pg. 242).*

Sprinkle sliced almonds on top.

White Hazelnut Mocha

1/4 lb. butter
1/2 cup sugar
>*Cream together well.*

2 eggs
>*Add in, mix well.*

1 tbs. strong coffee
1 tsp. cocoa
1/2 cup grated hazelnuts
8 oz. white chocolate, melted
>*Add in and mix well. Place filling in a pastry bag with a star tip and pipe in to a chocolate cup or glass to serve.*

Cream Puffs

Recipe for **cream puff pastry** (recipe, pg.128)

Fill the pastry bag with a star tip and drop rounds of approximately 2" of dough onto a baking sheet lined with parchment paper. Bake in a 425° oven for about 25 minutes.

With **Chocolate Cream Filling** (recipe, pg. 212)

Fill a pastry bag with a straight tip with the chocolate cream, and punch a hole in the bottom of the pastry dough with the tip of the bag. Squeeze the bag to fill the inside of the pastry.

Chocolate Icing (optional) (recipe, pg. 96)

Dip the top of the cream puff in the icing.

With **White Chocolate Cream Filling** (recipe, pg. 119)

Follow the same process except use the white chocolate filling and the white chocolate icing (optional) pg. 119.

Use the recipe of Cream Puff Pastry (page 128) to also make a Round Shell that you can fill with cream or an oblong shape one that you can slice in half and fill with cream.

Metaxa Balls

1 lb. semisweet chocolate, grated
1/4 cup Metaxa brandy
1 lb. grated walnuts

Mix ingredients well. Form into walnut-sized balls and roll in confectioners sugar.

❧❧❧

During one of my sister Sophia's infrequent visits to the Unites States, she made a simple chocolate sweet. I liked it so much that I shamelessly included it.

❧❧❧

White Chocolate Balls

1 lb. semisweet chocolate, grated
1/4 cup Frangelico
1 lb. hazelnuts, grated

Mix ingredients well. Form into walnut-sized balls and roll in confectioners sugar.

❧❧❧

Inspired by Sophia's Metaxa Balls, I created my own recipe.

❧❧❧

Ladyfingers

5 egg yolks
1/4 cup sugar
1 tsp. vanilla
> *Whisk in a bowl by hand until eggs are pale in color. Set aside.*

5 egg whites
1/4 tsp. cream of tartar
> *In a mixing bowl, beat at medium speed until soft peaks form.*

1/4 cup sugar
> *Add in the mixing bowl, gradually, beat on high speed until stiff.*
> *Fold in part of the egg white to the yolk mixture with a rubber spatula and mix gently.*

3/4 cup sifted cake flour
> *Shift half of the flour into the mixture and mix gently with the spatula. Add the remaining egg whites and add the remaining flour and mix.*
> *Preheat oven to 400°. Scrape the batter into a pastry bag with a #8 plain tip. Place the parchment paper on the baking sheet. Pipe parallel ladyfingers on the paper. Bake for about 12 minutes until golden in color. Ladyfingers will touch each other during baking.*

**You can trace the parchment paper to about 6" long, 1-1/2" wide, 1/4" apart. Turn paper upside down, so the tracing is on the bottom, it will still be visible on the top.*

❧

In 1577, Apple Pie was a prize dessert in England along with Mince Pie, Worchestershire Black Pudding, Yorkshire Pudding, Gloucestershire Bag Pudding, Devonshire White Cloud Pudding as well as several tarts.

Some customers ask for rice or vanilla puddings, but such traditional recipes bore me. I want to make every recipe something I can call my own. Puddings are simple to make, so I challenged myself to add the flavor of alcohol to each. Since alcohol is only a taste in my mind, not on my lips, it made the challenge even more difficult.

For the following pudding recipes, you can use a Chocolate Souffle Cup or simply use a glass with a long stem.

Grand Marnier Pudding

3/4 lb. cream cheese
1/2 cup sugar
>*Cream well together.*

2 eggs
>*Add in.*

1-1/2 cups Amaretto cookies
1/4 cup strong coffee (espresso)
2 tbs. rum
1/8 cup Grand Marnier
>*Add in and mix well.*
>*Spoon into chocolate cups or a glass and refrigerate until firm.*
>*Decorate with an Amaretto cookie.*

Jack Daniels Pudding

1/8 cup butter
1/4 cup sugar
>*Cream together.*

3 eggs
>*Add in and mix well.*

1 cup whipping cream
>*Add in, mix for 2-3 minutes.*

4 oz. semisweet chocolate, melted
1 tbs. cocoa
1/8 cup Jack Daniels
2 tbs. rum
1/8 tsp. vanilla extract
1/4 cup chocolate wafer crumbs
>*Add in and blend well. Spoon into chocolate cups or glasses and refrigerate until firm. Decorate with white shavings on top.*

Kahlua and Cream Pudding

1/4 lb. butter
1/2 cup sugar
>*Cream together.*

2 eggs
1 cup whipping cream
1/8 cup Mexicana cafe
1/4 lb. white chocolate, melted
1/8 cup Frangelico liqueur
1/8 cup Kahula
>*Add in and blend well. Spoon into chocolate cups or glasses and refrigerate until firm. Decorate with dark shavings on top and a white wafer in the pudding.*

Mocha Alexander Pudding

1/8 cup butter
1/4 cup sugar
1 cup whipping cream
2 eggs
>*Cream together.*

6 oz. chocolate wafers soaked in 1/8 cup Mocha coffee
>*Blend well.*

1 tbs. cocoa
4 oz. semisweet chocolate, melted
1/8 cup Cognac
1/8 cup Creme de Cocoa
>*Add in and blend well. Spoon into chocolate cups or glasses and refrigerate until firm. Decorate with a chocolate round wafer and coffee vermicelli.*

Frangelico Pudding

1/8 cup butter
1/2 cup sugar
1 cup whipping cream
3 eggs
>*Cream together.*

4 Cointreau cookies soaked in 1/8 cup Frangelico liqueur
1/2 cup grated hazelnuts
1/2 cup sour cream
1/4 lb. white chocolate, melted
2 tbs. Cointreau
>*Add in and blend well. Spoon into chocolate cups or glasses and refrigerate until firm. Decorate with a white chocolate round wafer and dark vermicelli.*

Courvoisier Pudding

1/4 cup butter
1/2 cup sugar
1 cup whipping cream
3 eggs
>*Cream together.*

1/3 cup Courvoisier liqueur
1 cup semisweet chocolate, melted
1 tbs. rum
>*Add in, mix well. Spoon into chocolate cups or glasses and refrigerate until firm. Sprinkle with dark chocolate shavings.*

Peach Bread Pudding

Pudding

9 slices white bread
1 cup peaches, pureed
1 cup milk
1/2 cup heavy cream
1/4 cup honey
1/2 cup brown sugar
2 large eggs
1-1/2 tsp. ground cinnamon
1 tsp. vanilla extract

Sauce

1/2 cup sugar
2 tbs. water
1-1/2 cups pecans

Bring sauce to a boil. Reduce heat and simmer for 5-6 minutes.

Butter bread on one side and cut into small pieces. Layer two-thirds of bread pieces along the bottom and sides of a pie dish. Mix remaining ingredients well and layer half the mixture on top of bread. Layer remaining bread and top with rest of mixture. Let dish stand for about 20 minutes. Bake at 350º for 15 minutes. Pour sauce over pudding.

Papaya Fruit Pudding

Cream Filling

3/4 cup butter, melted
Blend together with 3/4 cup butter. Reserve.
2 cups milk

1 tbs. chopped ginger
3 tbs. cornstarch
1 tbs. grated orange peel
1/2 cup sugar
Blend in a saucepan over medium heat until mixture thickens. Remove from stove.
3 tbs. Grand Marnier
Add to cornstarch mixture along with remaining butter and chill.

Papaya Filling

2 papayas, peeled
2 tbs. lemon juice
1/2 cup sugar
Reserve eight thin slices of papaya. Chop remaining fruit into small cubes, and toss with lemon and sugar.

1-1/2 cups ginger snap cookie crumbs
In a tall glass, layer parts: papaya filling, cream filling, ginger crumbs. Repeat. Top with whipped cream and garnish with papaya slices.

Rice Pudding - The Greek Way

6 tbs. rice, long grain
1 cup of water
Boil for about 15 minutes.
6 cups milk
Add in, let simmer for about 30 minutes, stirring occasionally.
2 tbs. cake flour
4 tbs. water
Mix well, add to the milk-rice mixture.
3/4 cup sugar
Add in, stir well.
1 tsp. vanilla extract
Add in, stir, remove. Place on serving plates. Sprinkle rice pudding with cinnamon.

Bread Butter Pudding

8 oz. of white bread
Remove the crust and slice very thin.
Butter
Lightly butter the bread slices on one side, cut the slices in to triangles. In an oven, brown the buttered side of the bread. Place bread, toasted side up in an oval baking dish in overlapping pieces.
2 cups milk
1 tsp. vanilla extract
Bring to a boil, remove from heat.
3 eggs
2 egg yolks
1/2 cup sugar
Beat well, slowly pour the hot milk into egg mixture, stirring constantly. Pour mixture over the bread, holding bread slices in place with a spatula. Place a baking dish into a larger baking dish. Pour hot water into the larger dish to fill halfway. Bake in preheated oven, 425°, for 30 minutes. Allow to cool. You can serve it with a sauce of your choice.

One of the most special parts about Nick is that he continually experiments to come up with complex original recipes to add to his already stunning selection of hundreds of recipes.

Western Express, 1989

Fate is Wishing for Small Miracles

Earlier this year, I drove to Los Angeles. I was on my way to attend the Book Expo 1999. I used my driving time to think about the cover of my new dessert book. My mind raged in arts, in history, in classical and contemporary times, I thought of museums, of architecture, of painting, of statues, of jewels, trying to find the proper artistic forum to partner with my cakes. The trip ended without a concept that really moved my imagination.

Inside the convention center, I searched for ideas, but the majority of book covers seemed so boring, so plain!

On my way back to Phoenix, the torment of the mind, searching for a picture, continued. I was only a few miles from Phoenix when I imagined it: my cakes and pies in a sculpturing studio, around special art, around art of someone that had carved the marble with love and passion. That was going to be the cover of this book! And by way of magic the back cover appeared in my mind: I will be painting a cake on a canvas, on a seashore, by a lake, in a forest, somewhere magical, somewhere peaceful.

The idea excited my senses. But there was a minor problem. I knew no one who was a great sculpturer. And the only magical and peaceful place I had in mind was a Greek island. The next morning I went to work. The idea kept seducing my mind throughout the day.

The evening came. The guests began to arrive for dinner, the familiar faces, those who had ftequented my restaurant for years, only their names escaped me. I always had this difficulty remembering names. There are so many, so much to remember, just like the couple that walked in that evening. I escorted them to their table. The man set a magazine on the tabletop. The title of the magazine read "Sculpturing News".

"What are you doing with this magazine?" I asked.

"I am a sculpturer," he said.

This man had been my guest for so long, but I did not know who he was. He was no other but the well-known sculpturer Jerry Cox, an artist who was passionately forming art for fifty years. Jerry allowed me to use his studio to shoot the photographs.

Another friend and frequent guest, photographer Gregg Mastorakos, produced the great photographs, exactly as I had created in my mind.

Gregg also helped with the idea of creating the picture of the back cover. We used a park with a lake and trees.

By the magic and skills of JoAnn Kotyk and Madalyn Johnson, I became a sculpturer and a painter.

Jerry Cox has the unique ability to capture life in his sculpture with each piece telling a story. Each sculpture is a portrait describing with unusual sensitivity, our lives and memories. Jerry creates his magic in his Paradise Valley studio and his art is displayed in several galleries throughout the states.

My wish for this beautiful cover came through, and the way it happened was like a small miracle.

Croissants

Makes approximately 30 croissants

3/4 oz. yeast
1-1/2 tbs. warm water
In a bowl, dissolve the yeast in the water. Set aside.
1/2 cup water
1/2 cup milk
3 tbs. butter
3-1/2 tbs. sugar
1 tsp. salt
1-1/2 tbs. milk
Mix well in the bowl of a mixer. Add warm milk mixture. Beat for about 1 minute. Add the yeast mixture and beat for about 1/2 minute.

Cover bowl with a towel and let it rise for about 1 hour until the dough is doubled in size. Place the dough in a lightly floured pan and refrigerate for about 1/2 hour.

ROLLING THE DOUGH

1-1/4 cups butter, cut into large pieces
On a lightly floured working surface, roll the dough into a rectangle. Place half of the butter in 2/3's of the dough and fold into fifths starting with the side that is not buttered. Roll out the dough once and fold into thirds. In this stage, cover and refrigerate the dough for about 1 hour. Follow the same process again using the other half of the butter.

Roll the dough into a rectangle approximately 8" or 10" and refrigerate for 30 minutes longer.

Roll the dough to about 1/8" thickness and cut. Form a rectangle about 12" wide and 36" long. Cut the rectangle lengthwise to have two strips. From each strip you must make 15 triangles. (If you like a bigger croissant, you can make the dough strips wider).

To roll the triangles into croissants, first make a small cut in the center of the bottom of the triangle and roll from the base towards the point of the triangle. Bend the edges inwards to make crescent shapes. Place the croissants in a lightly buttered baking sheet, leaving enough space between them to rise. Cover and let rise for about 1 hour.

1 egg beaten
Brush the croissants lightly.
Bake in a preheated 400° oven for about 15-18 minutes.

You can freeze the croissants in the stage you have shaped the rescents into before you rise them to be baked.

To bake the frozen croissants, let them stand in the refrigerator for about 24 hours then allow it to rise for about 1 hour at room temperature.

If you do not wish to freeze the dough, you can use it for the following recipes.

For the following recipes, instead of cutting the two strips of dough into triangles cut them into diamond shape. Place the filling given in the recipes below and fold the edges as if you were closing an envelope. Let rise for one hour at room temperature. Brush with a beaten egg and bake in a 400° oven for 15-18 minutes.

CHOCOLATE CROISSANTS

Place two strips of semisweet chocolate in the middle of the dough and fold.

TURKEY AND SWISS CROISSANTS

Place 2 slices of turkey breast and 2 slices of swiss cheese in the middle of the dough and fold.

HAM AND SWISS CROISSANTS

Place 2 slices of ham and 2 slices of swiss cheese in the middle of the dough and fold.

SPINACH AND FETA CROISSANTS

Place 2 tbs. of cooked spinach and 1 tbs. of feta cheese in the middle of the croissant and fold.

❧

How many of you would say you were introduced to cooking by beating a pan of fudge, by licking a spoon, drifted by sweetness?

Dessert making at home is a child's fondest memories. It is a lost art, lost in the demanding lifestyle, in the television, in the computers, into the loneliness of a child.

The satisfaction that comes out of making your own candy is great. It is an event that can involve whole families and believe me, everyone will be glad that they did spend the time to create their own. Here is a simple fudge recipe. Start with this one and who knows? Someday you too may write a book of your own experiences.

Fudge

2 cups sugar
2 oz. unsweetened chocolate
1 tbs. corn syrup
Place in a double boiler and mix until chocolate melts.
2 tbs. butter
1/2 tsp. vanilla extract
Add in, let cool without stirring. When mixture is lukewarm, mix for about 2-3 minutes. Pour into a buttered 10" x 6" baking pan. Let stand for a few minutes, cut to squares.

Cinnamon Rolls

In the last ten years or so I have tried to master the dough for cinnamon rolls. Despite the compliments of my guests for each of the improved recipes, I was never satisfied with the results. Until one day I decided to use the croissant dough for cinnamon and other rolls.

I can give you several recipes for these rolls but I will not even bother to do so because I know that once you have tried this you will agree with the me that they are the best you ever had.

Croissant Dough

After the process of rolling the dough, open it to approximately 1/8" thick and make a strip of 6" x 24".
1 cup butter, melted
Pour butter on top of dough.
1-1/2 cups sugar
3/4 cup cinnamon
Mix well and sprinkle on top of dough.
Roll the dough lengthwise into a large roll. Slice into 2" rolls. Place the rolls with one cut end down on a lightly buttered 18" x 12" baking pan, about 1-1/2" deep.
Cover and let rise for about 1 hour. Bake in a 375° oven for 18-20 minutes. Let rolls cool.

Icing
1-1/2 cups powdered sugar
1 tbs. water
Mix well.
3 oz. white chocolate, melted
1 tbs. sour cream
Add in and mix well. Spoon icing on top of the rolls.

The Raspberry-Stuffed Toast, composed of small round slices of white bread, stuffed with raspberries and cream cheese, dipped in egg batter and fried, then topped with an orange almond sauce.
Phoenix Magazine, 1996

Pecan Rolls

Follow the same process of cutting the rolls (previous page). Before you place the rolls into the 18" x 12" baking pan, pour into the baking pan the following syrup:

5 oz. butter

2 oz. water

> *Melt in saucepan.*

1 lb. brown sugar

4 oz. corn syrup

> *Mix and pour into the baking pan. Mix and pour into the baking dish.*

3 cups pecans

> *Place the pecans in the 12 spots which the rolls are to be placed. Cover and let rise for about 1 hour. Bake in a 375° oven for 18-20 minutes. While the rolls are still warm, turn the baking pan upside down into another pan. Now the syrup and the pecans are on the top of the rolls.*

※

Raisin Rolls

Use the same process as the cinnamon roll technique (previous page) but before rolling the strip of dough with the buter-sugar-cinnamon filling, place 2 cups of raisins on it.

Before you pour the white chocolate icing on top, place 1 tsp. of raisins on top of every roll.

※

Chocolate Nut Rolls

Use the same process as the cinnamon roll technique (previous page) but before rolling the strip of dough with the butter-sugar-cinnamon filling, place 1-1/2 cups chocolate chips and 1 cup finely chopped walnuts on it.

Before you pour the icing on top, place 1 tsp. of chocolate chips on top of every roll.

\mathcal{T}he first automatic espresso coffeemaker was patented by Italian inventor Achille Gaggia in 1946.

The machine was introduced in Europe in the 1950s enabling Europeans to enjoy good coffee in public places.

\mathcal{T}he world's first coffeehouse opened in Constantinople in 1456 under the name Kiva Han. Muslim fanatics persecuted coffee drinkers.

\mathcal{V}enice got its first coffeehouse in 1460. The city is a major sugar refinery center, using raw sugar imported through Lisbon.

\mathcal{E}ngland had its first coffeehouse in Oxford in 1652. Londoners got their first taste of coffee, tea, and cocoa in a shop. The growing popularity of these drinks increased the demand of sugar and since sugar was grown with slave labor, it produced a rise in the slave trade.

\mathcal{I}n 1672 the first coffeehouse in Paris opened at Saint-Germain Fair. An Armenian named Pascal did well at the fair and opened a coffeehouse in the Quai de L'Ecole.

\mathcal{E}ngland's Charles II issued a proclamation on December of 1675 for the suppression of the coffeehouses. Charles claimed that the multitude of coffeehouses within the kingdom were frequented by idle and disaffected people, producing much evil and dangerous situations. Charles ordered the coffeehouses shut down and supressed.

Charles' attempt to suppress talk that may have lead to the kind of rebellion that caused his father's execution in January, 1649.

His proclamation prompted an outcry among the merchants and other patrons of the coffeehouses.

\mathcal{N}escafe was introduced in Switzerland in 1938 by Nestle. This company had been asked by the Brazilian government to help find a solution to Brazil's coffee surpluses. Nestle had spent eight years in research developing the instant coffee product that frappé coffee is made from. Frappé has become Europe's beloved iced coffee.

\mathcal{I}rish coffee was introduced in 1953 at San Francisco's Buena Vista Café. A columnist of the Chronicle, named Stanton Deleohane, discovered the recipe in Ireland and gave it to the cafe's proprietors. The drink soon accounted for 40% of Buena Vista's business.

Coffees

Coffee Recipes - From Breakfast to Dessert

*C*offee drinking is a ritual to many cultures around the world. To many, the day does not start without the rich aroma of coffee and to most, coffee continues to be a part of their day and even a part of their night.

Coffee accompanies breakfast, newspaper reading, intellectual conversations, social gatherings and it has a special affinity with dessert. In other words, coffee lovers will find any excuse to consume their favorite beverage.

The following are some recipes for different occasions.

ESPRESSO
Espresso is made in a special machine that forces the hot water through tightly packed ground espresso coffee. Use about 1-1/2 tablespoons of finely ground espresso coffee to about 1-1/2 ounces of liquid. Espresso is often served with a twist of lemon.

CAPPUCCINO
Cappuccino is made with espresso coffee that is blended with steamed and foamed milk. Make an espresso then use about 4 oz. of milk and steam it until it is foamed. It should be about 140° F. Pour the steamed milk into the bottom 1/3 of a cup, add the shot of espresso and then spoon the foamed milk on top. It is usually served with cinnamon or cocoa powder sprinkled on top.

CAFE LATTÉ
Use one shot of espresso coffee and 6 oz. of scalded milk. Pour the hot steamed milk into the espresso.

CAFE MOCHA
Use one shot of espresso coffee and drop in 1/2 tsp. of chocolate chips. Stir well until the chocolate melts. Froth 4 oz. of milk, pour into the hot coffee and then spoon the foamed milk on top.

GREEK KAFEDAKI
Pour 1 demitasse cup of water into a briki or a small saucepan and add 1 tsp. Greek coffee (available in specialty shops) and 1 tsp. sugar. Stir and let the coffee boil. Remove from heat immediately. For more bitterness or sweetness, adjust the amount of sugar.

CAFE FRAPPÉ
In a blender, place 6 ice cubes, 1 cup milk, 1 tbs. Nescafé Frappé (available in specialty shops) and 1 tsp. sugar. Blend until it becomes frothy.

CAFE BRULOT
In a saucepan place 1 tbs. brown sugar, a strip of lemon peel, a strip of orange peel, 5 whole cloves, 1/2 vanilla bean, 1 cinnamon stick and 2/3 cup brandy. Heat gently until the sugar dissolves then ignite brandy with a match and let it burn for a few seconds. Use 4 cups hot, strong coffee, each 3/4 full. Pour the brandy mixture into them.

ARABIAN COFFEE
Pound 6 cardamon pods in a mortar and place them in a small saucepan with 1/4 cup water and 1 tbs. dark roasted coffee, coarsely ground. Simmer on very low heat for about 10-12 minutes.

COFFEE MILK SHAKE
In a blender place 1 pint of milk, 3 tbs. sugar, 8 ice cubes and 1 tbs. instant coffee. Blend until frothy.

Miscellaneous

Antonin Caréme, the first great French chef, died in Paris in January of 1833, at the age of 48. Among the accomplishments in his brief but distinguished career, he is credited with creating the original recipe of Chocolate Soufflé.

Basic Soufflé

3/4 cup milk
> *In a saucepan, bring to a boil.*

1/3 cup sugar
1/3 cup flour
1/4 cup milk
> *Mix well in a bowl with a wire whisk, add a little of the boiling milk to the bowl and mix well. Pour mixture into boiling milk, boil for 2-3 minutes. Remove from heat.*

1-1/2 tbs. butter
> *Add to the saucepan, cool for about 15 minutes.*

4 egg yolks
> *Stir in, one at a time, mixing well.*

4 egg whites
1-1/2 cups sugar
> *Beat the egg whites until stiff, fold gently into milk mixture.*

Butter
Sugar
> *Coat souffle mold. Fill the mold 3/4 full, dust with powdered sugar. Bake in 350° oven for 20 minutes. Makes one 8" souffle or 4 individual ones.*

Chocolate Soufflé

3 oz. of semisweet chocolate
1/4 cup sugar
3 tbs. milk
> *Heat in a double boiler and mix well. Remove from heat, cool for a few minutes.*

2 egg yolks
> *Add in, beating constantly.*

3 egg whites
1-1/2 tbs. sugar
> *In a mixer, beat until very stiff. Fold into the chocolate mixture.*

Butter
Sugar
> *Coat the souffle mold, pour in mixture. Bake in a preheated oven of 350° for 20 minutes.*

Powdered sugar
> *Sprinkle top with powdered sugar. Serve immediately. Makes 4 servings.*

Lemon Soufflé

1 lemon
> *Cut the lemon peel into strips, cut the lemon into slices.*

6-1/2 tbs. water
> *Add lemon peel and slices.*

1/3 cup sugar
> *Add in, simmer for about 15 minutes. Remove and save the peels. Chop the lemon slices very fine.*

Prepare Basic Souffle
> *Add chopped lemon before adding the egg whites in the basic recipe. Decorate with lemon peels and sprinkle with powdered sugar.*

Chestnut Soufflé

3/4 cup milk
> *In a saucepan, bring to a boil.*

2 tbs. sugar

3 tbs. cornstarch

1/4 cup milk
> *Mix well in a bowl with a wire whisk. Add a little of the boiling milk to the bowl and mix well. Pour mixture into boiling milk, boil for 2-3 minutes. Remove from heat.*

1-1/2 tbs. butter
> *Add to the saucepan, cool for about 15 minutes.*

1 cup chestnut cream

2 tsp. rum
> *Add in, mix well.*

4 egg whites

1-1/2 tbs. sugar
> *Beat until egg whites are stiff. Fold gently into milk mixture.*

Butter

Sugar
> *Coat souffle mold, fill the mold 3/4 full, dust with powdered sugar. Bake in 350° for about 20 minutes. Makes one souffle or 4 individual ones.*

Coconut Soufflé

1/2 cup milk

In a saucepan, bring to a boil.

2-1/2 tbs. sugar

1-1/2 tbs. cornstarch

1/4 cup milk

Mix well in a bowl with a wire whisk. Add a little of the boiling milk to the bowl and mix well. Pour mixture into boiling milk, boil for 2-3 minutes. Remove from heat.

1-1/2 tbs. butter

Add to the saucepan, cool for about 15 minutes.

3 egg yolks

Add in, whisking the mixture.

2/3 cup grated coconut

1-1/2 tbs. rum

Add in, mix well.

4 egg whites

1-1/2 tbs. sugar

Beat until egg whites are stiff. Fold gently into milk mixture.

Butter

Sugar

Coat souffle mold, fill the mold 3/4 full, dust with powdered sugar. Bake in 350° for about 20 minutes. Makes one souffle or 4 individual ones.

❧

In 1967, New York chef Charles Ranhofer created Baked Alaska - a brick of ice cream enclosed in a meringue and quickly baked in the oven.

Baked Alaska

Ice cream of your choice: Vanilla, chocolate, strawberry

Fill a small round form with it. Place it in the freezer to become very hard.

Sponge cake

Cut a slice of the same size of the ice cream form. Place it on a baking sheet.

3 egg whites

6 tbs. sugar

1 tsp. vanilla extract

Beat until eggs are stiff. Remove ice cream from freezer and from the round form and place it on the cake. Cover ice cream with the egg white mixture. Sprinkle toasted sliced almonds on top.

Preheat oven to 400°. Place alaska into the oven for just a few minutes, until meringue is colored a little. Serve at once.

Ice Cream

*T*he ice cream cone was introduced in 1904 at the St. Louis Exposition by Syrian immigrant, pastry maker Ernest Hamwi. He sold wafer-like pastries at a fairground concession, serving them with sugar and other sweets. When a neighboring ice cream stand ran out of dishes, Hamwi rolled some ice cream in his wafers, and sold them to the other ice cream concessaionaire. An ice cream cone mold patent had been issued earlier in the year to Italian immigrant, Italo Marchiony, who claimed that he had been making ice cream cones since 1896. Other claimants also challenged Hamwi's right to call himself the ice cream cone originator.

*T*he first wholesale ice cream business was founded in 1851 by Baltimore's milk dealer, Jacob Fussel, who received milk in steady supply from farmers. Fussel was faced with an oversupply problem in the late spring and early summer months. He used up the excess of milk by making ice cream which he sold at half price. His plant was so successful that he soon opened another one in 1856 in Washington, D.C., in 1862 in Boston and in 1864 in New York.

Strawberry Ice Cream

1-1/2 cups milk
3 cups heavy cream
Heat in a saucepan.
1/2 tsp. vanilla extract
Add in, bring to a gentle boil, reduce heat. Simmer for five minutes, remove from heat.
8 egg yolks
1 cup of sugar
Whisk together to smooth. Add a little hot milk into the eggs, whisk well. Pour egg mixture in to milk whisking well. Return saucepan to low heat, whisk until thickens, refrigerate to chill.
1 pint of strawberries, crushed
Combine them with the chilled mixture. Transfer to ice cream maker and freeze according to the ice cream maker's instructions. Makes 1-1/2 quarts.

Espresso Granita

1/2 cup sugar
3 cups brewed espresso
Stir together, pour into a metal pan, cover. Refrigerate for about 3 hours, until crystals begin to form. Remove. Break the crystals, refrigerate again. Repeat the process every half hour until mixture is slushy.
1-1/2 cups heavy cream
Pour into a bowl and beat until thick.
3 tbs. sugar
2 tsp. cinnamon
Beat until soft peaks. To serve: Place a little cream on the bottom of a glass, top with a little of the granita, top with more cream. Makes 5-6 servings.

Pistacho Gelato

2-1/2 cups pistachios
>*Roast in a 350° oven for 7-8 minutes, chop coarsely.*

3-1/2 cups heavy cream
1-1/2 cups milk
>*Bring to a boil.*

2 cups of chopped pistachios
>*Add in, remove from heat, let sit for about 2 hours. Strain through a fine sieve, pressing on nuts to extract as much flavor as possible. Return to heat.*

1/2 cup sugar
>*Add in, bring to boil, stirring, reduce heat.*

7 egg yolks
1/2 cup sugar
>*Whisk in a bowl, add a little of the hot milk, stir. Whisk eggs into the hot mixture. Cook over medium heat 4-5 minutes until mixture thickens, cool quickly. Pour into ice cream maker and freeze according to the manufacturer's instructions. Fold in the remaining nuts just before gelato is set.*

❧

Mango Sorbet

1/2 cup water
1/2 cup sugar
>*Bring to boil, simmer for 5-6 minutes, let cool.*

2 cups mango, pureed
>*Strain through a sieve , add to the syrup.*

2 tbs. lime juice
>*Add in. Using an ice cream maker, chill until frozen.*

❧

Vanilla Ice Cream

6 egg yolks
1-1/2 cups sugar
>*Beat in a saucepan.*

2 cups of milk
>*Stir in, heat slowly until sugar dissolves. Pour into a bowl, chill until cold.*

2 cups milk
2 cups heavy cream
2 tbs. vanilla
>*Stir in. Transfer to an ice cream maker and freeze according to the ice maker's instructions. Makes 2-1/2 quarts.*

Sourdough English Muffins

1/2 cup sourdough starter (recipe, pg. 204)
1 cup milk
2 cups flour

Mix together, cover, let sit for about 8 hours.

1 tbs. sugar
1/2 tsp. salt
1/2 cup flour
1/2 tsp. baking soda

Mix with dough. This dough should be very stiff. Knead for a few minutes on a working surface with 1/4 cup flour, until no longer sticky. Roll dough to 3/4" thickness. With a 3" cutter, cut out the muffins. (Approx. 12).

Cornmeal

Sprinkle a little on a baking sheet. Place muffins on it, about 1" apart. Sprinkle muffins with a bit more cornmeal. Cover. Set aside for about one hour. Place muffins on a lightly greased frying pan over medium heat. approx. 8 minutes on each side. Serve warm or refrigerate, split and toast.

English muffins were introduced in New York in 1880 by Englishman baker Samuel Bath Thomas, who opened a retail bakery and delivered to hotels and restaurants with a pushcart.

In 1895, Crêpes Suzette supposedly were invented at Monte Carlo's Café de Paris by Henri Charpentier, 16, who had apprenticed under master-chef Auguste Escoffier. He prepared the dish of thin pancakes with liqueur sauce at a luncheon given by the visiting Princess of Wales, whose party included Suzette, the young daughter of one of the guests.

The invention was ascribed by others long before Charpentier's claim of fame. In 1667, french chef Jean Redoux published his cookbook, Parfait Confiturieur, which included a recipe for Crêpes Suzettes. Redoux was credited for creating this dish but Chardentier would insist, until his death in 1962, that he was the originator and that the flaming sauce caught fire quite by accident.

Crépes Suzette

BATTER

5-1/2 tbs. butter
> *Cook until lightly brown.*

1-3/4 cup flour
1/4 cup oil
1/4 cup sugar
6 eggs
2 tsp. Grand Marnier
1 tsp. rum
1 cup milk
> *Mix in a mixing bowl. Add the butter, beat until smooth.*

PASTRY CREAM

2 cups milk
1/2 tsp. vanilla extract
> *Bring to boil, remove, cover, keep hot.*

6 egg yolks
2/3 cup sugar
> *Mix well on medium speed.*

4 tbs. cornstarch
> *Stir in gently. Pour milk into the egg mixture, bring to a boil again, stirring constantly. Boil for one minute, stirring vigorously, pour into a bowl, let cool.*

SYRUP

2/3 cup butter
> *Melt in a saucepan.*

2/3 cup sugar
> *Add in, stir.*

Juice of two oranges
1/4 cup Grand Marnier
> *Bring to boil, remove from heat.*

> *Make the crepes in a crepe pan, cooking one minute on each side. Keep them warm. You can use 2 pans for faster cooking. Fill each crepe with 1 tbs. of pastry cream and roll, keep warm, covered with aluminum foil. Spoon a little of the syrup over the serving platter. Heat the remaining syrup in a large frying pan and place the rolled crepes in the syrup. When crepes are hot, pour over 1/4 cup of Grand Marnier and light with a match. Serve crepes quickly.*

Section 8

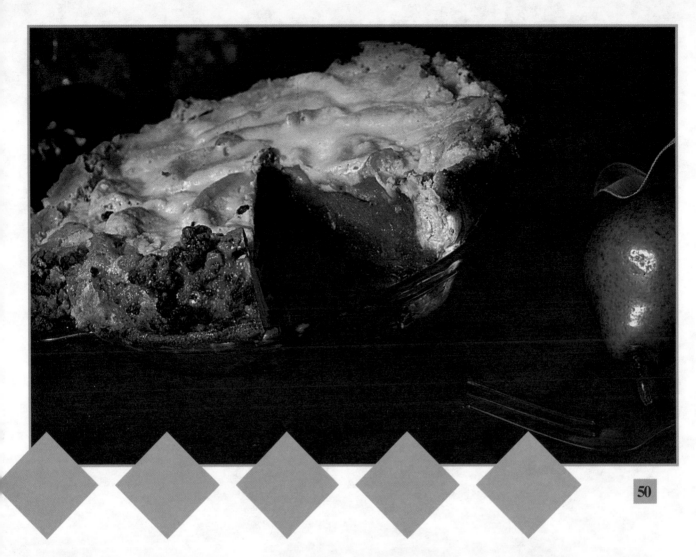

50

51

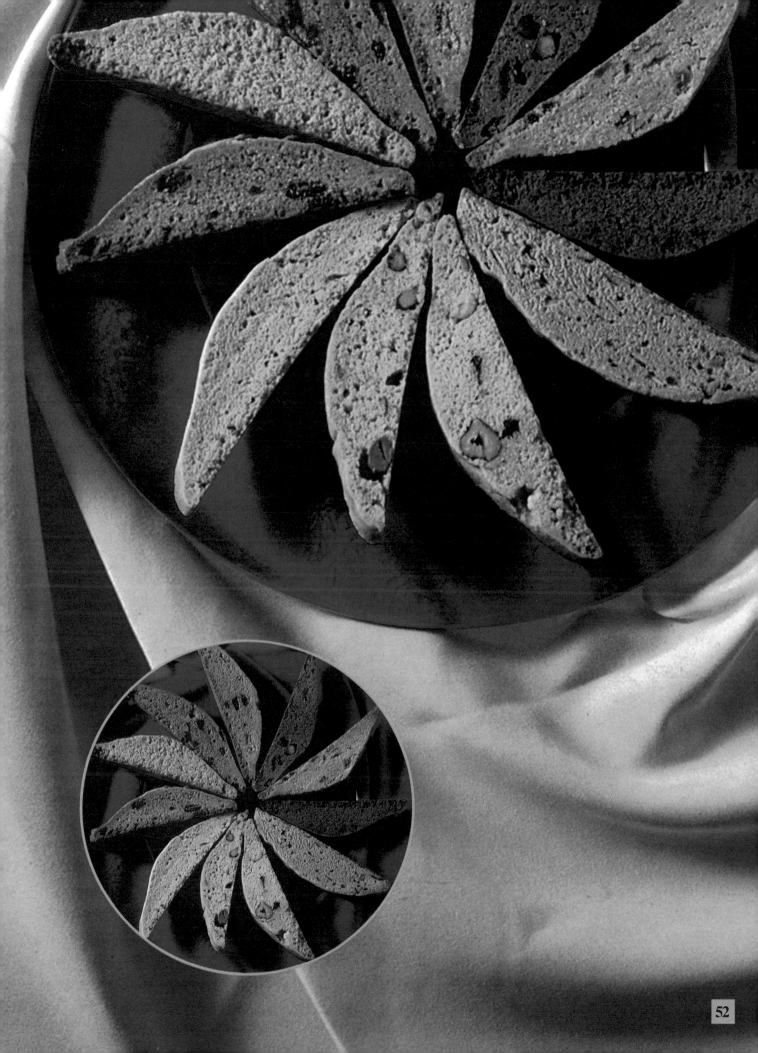

53

54

55

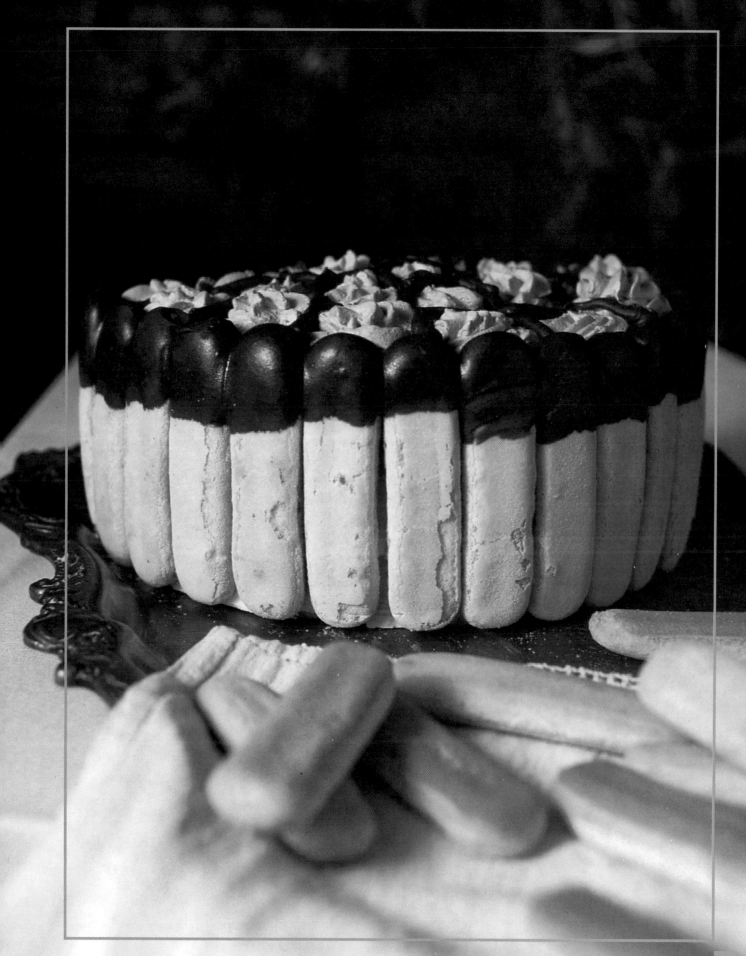

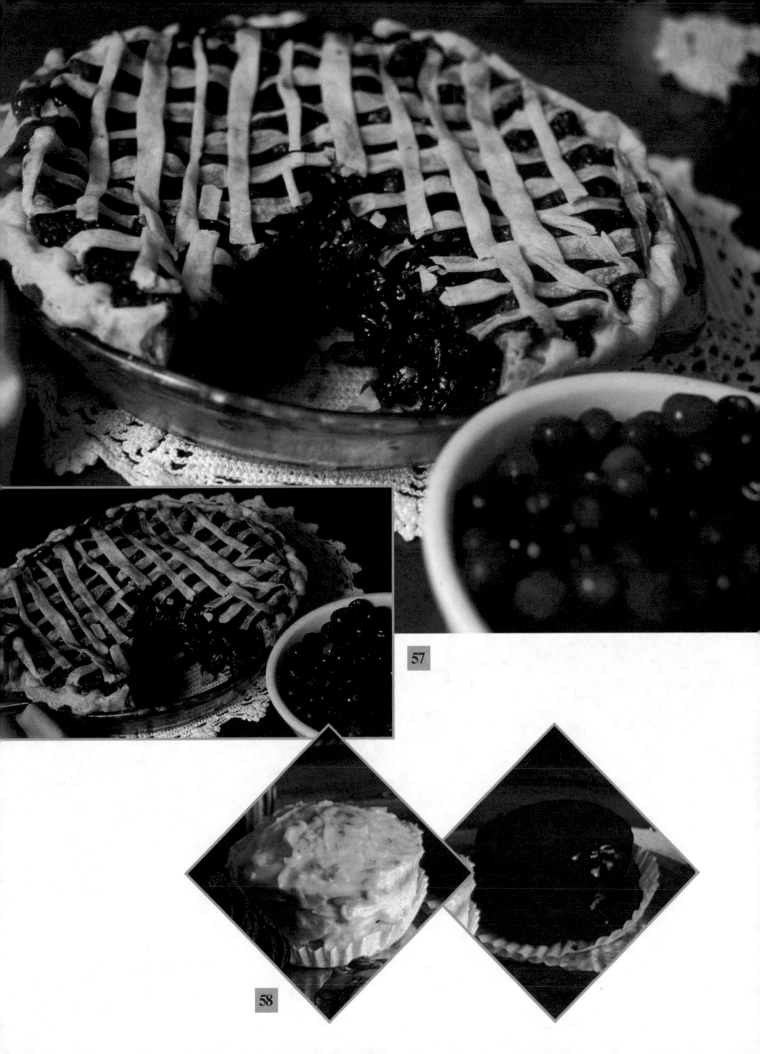

57

58

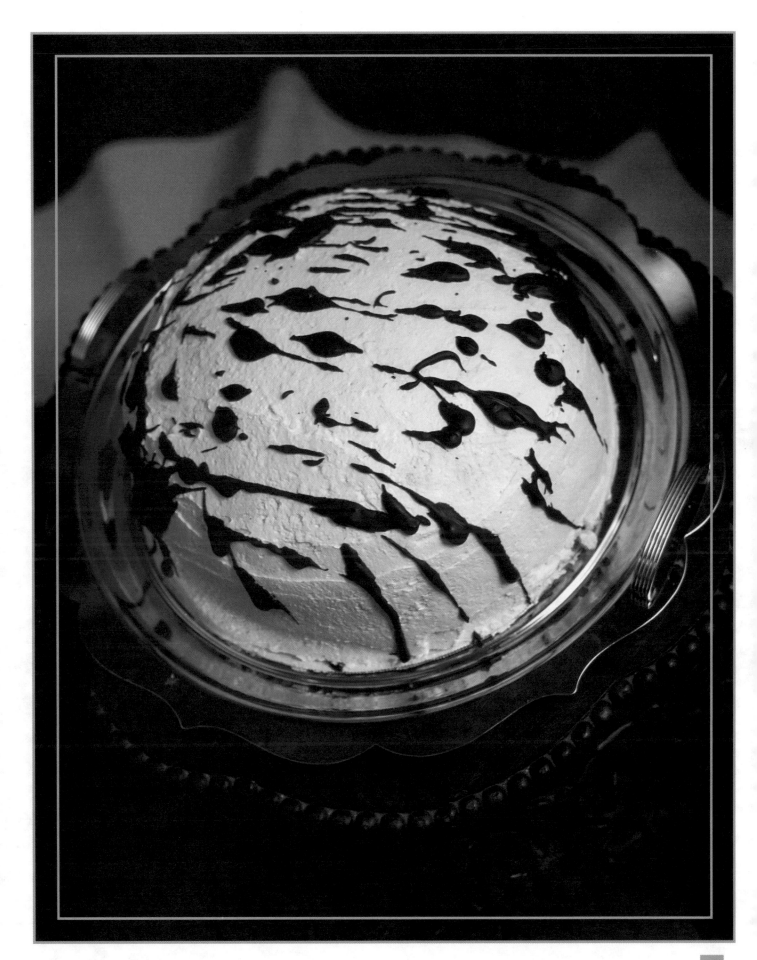

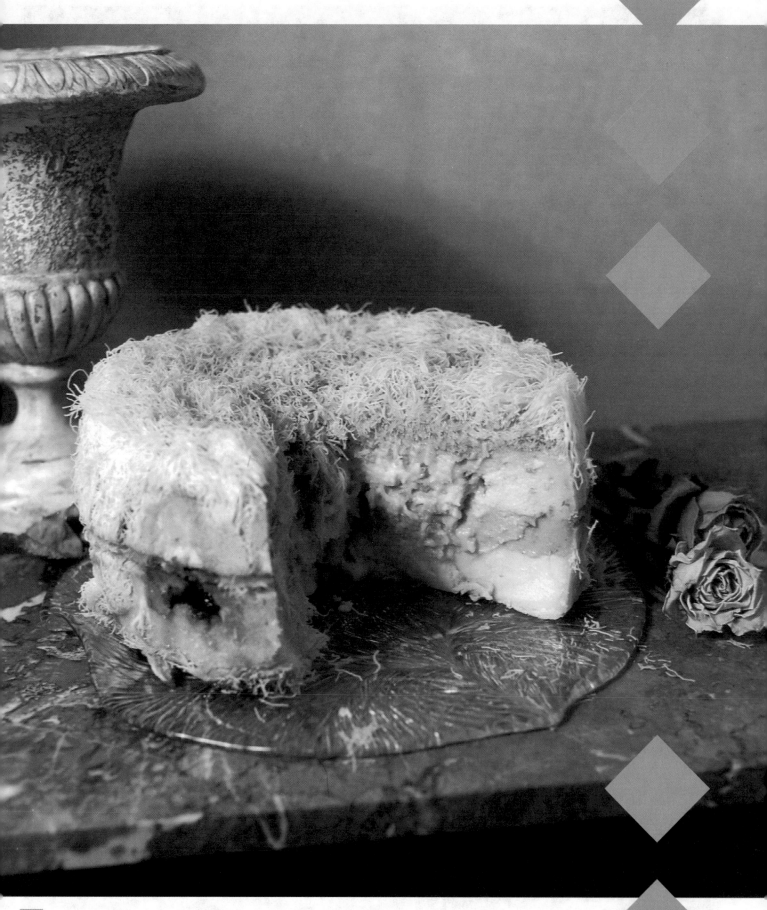

61

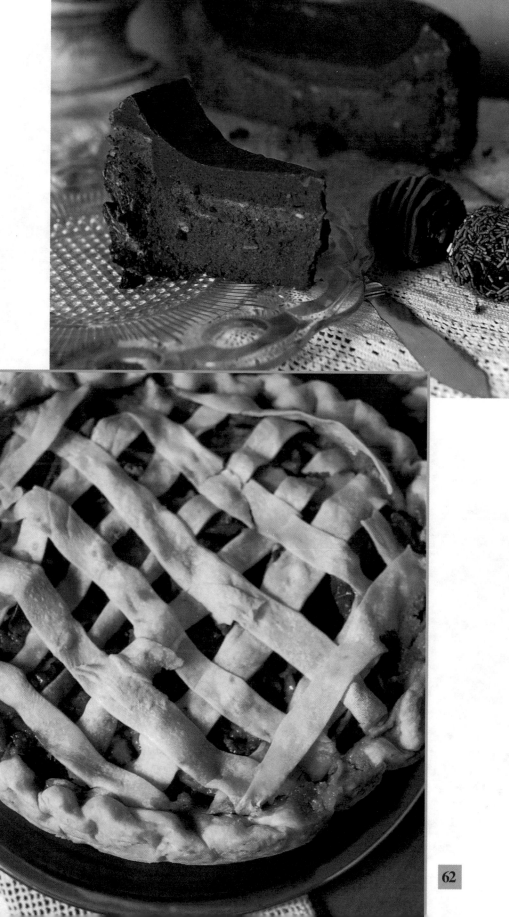

62

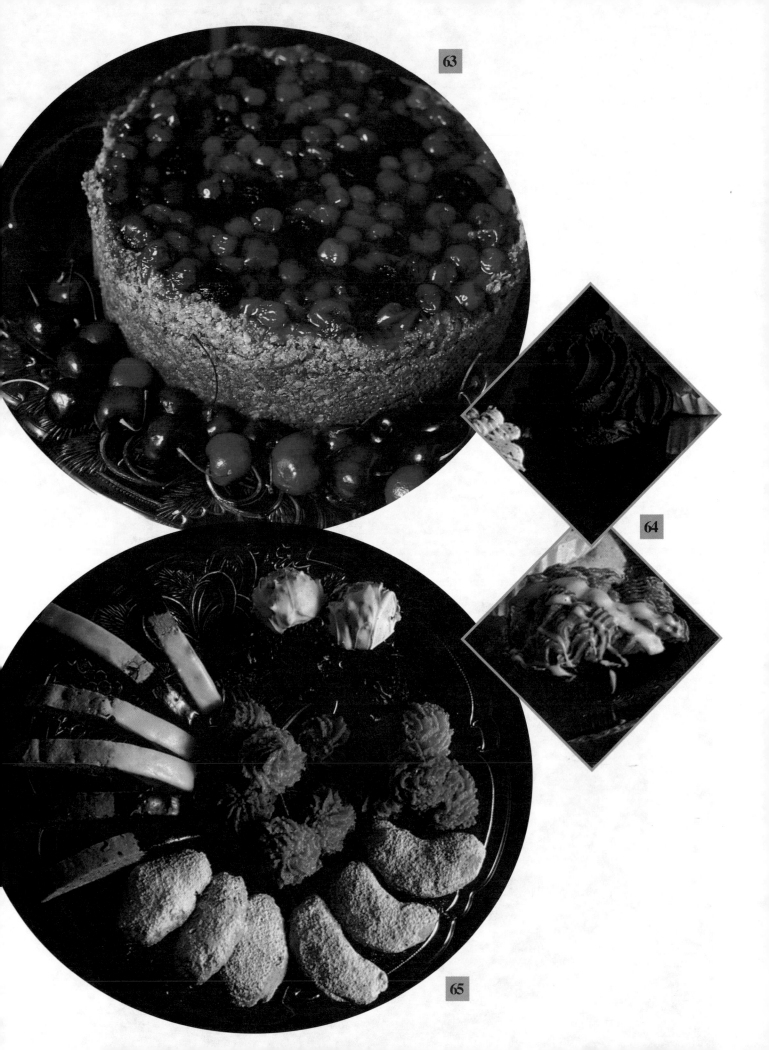

63

64

65

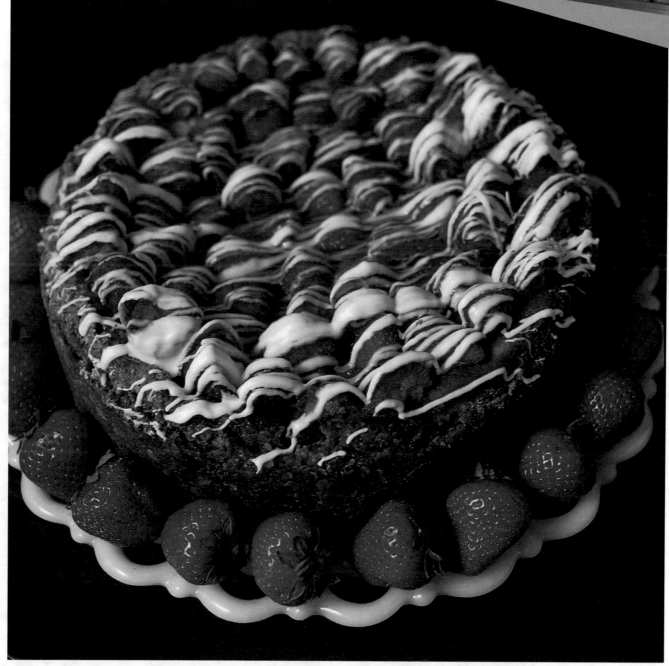

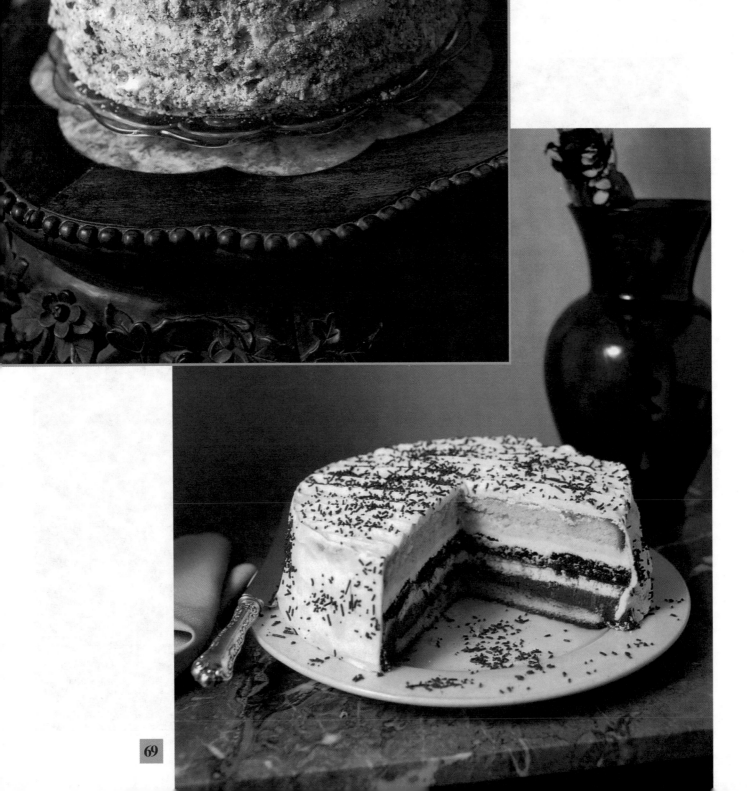

68

69

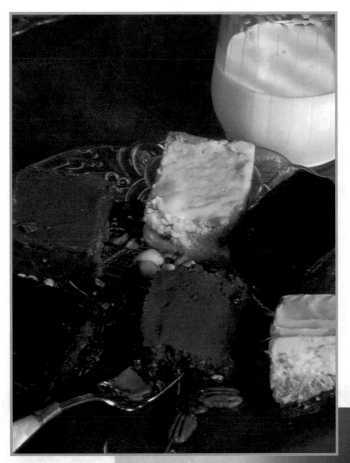

70

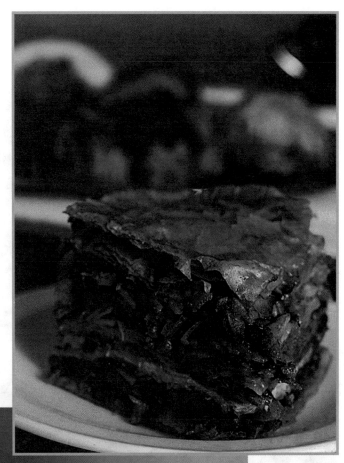

71

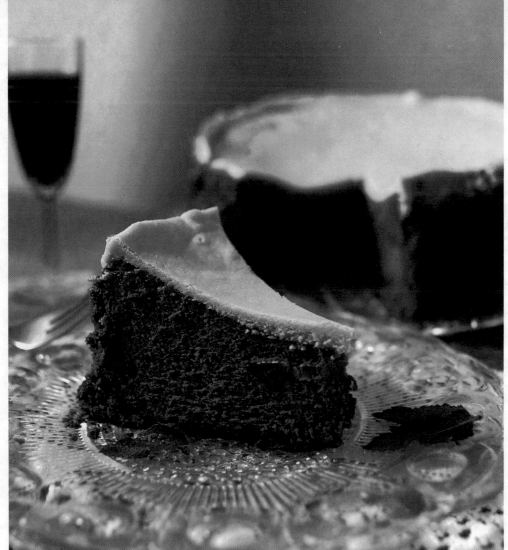

72

73

74

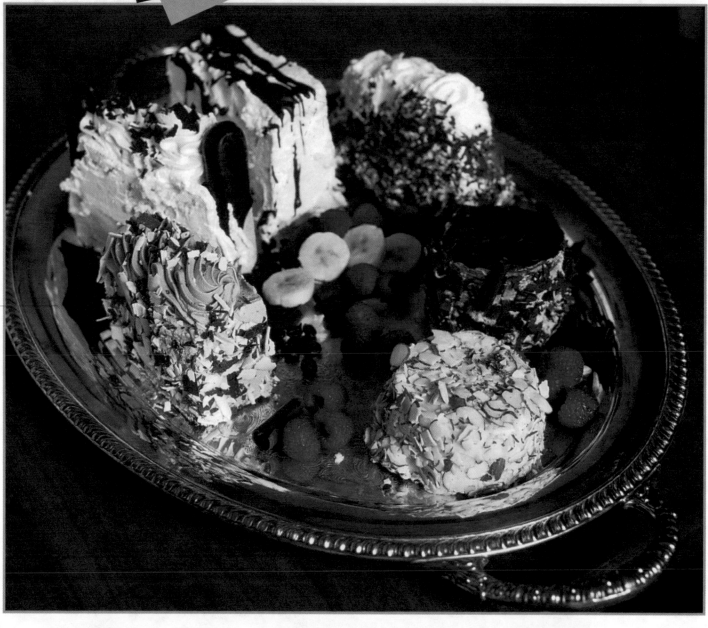

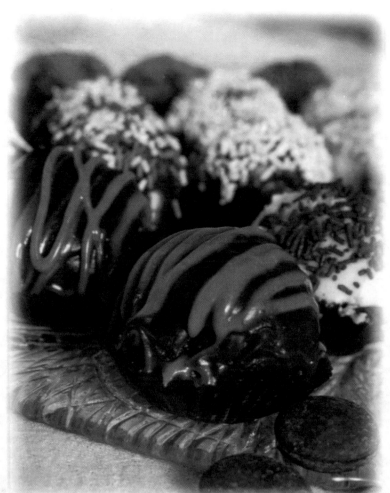

75

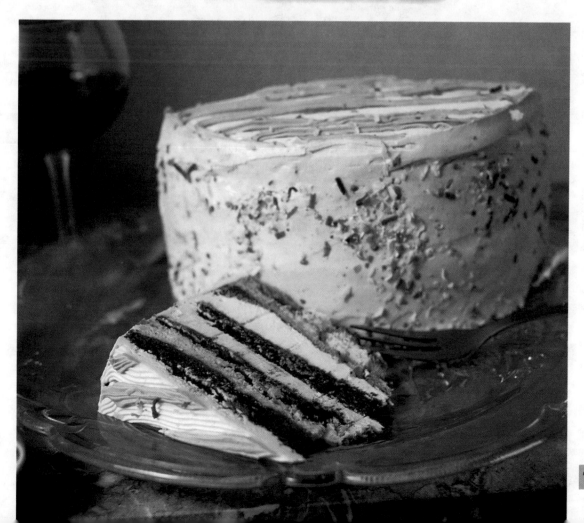

76

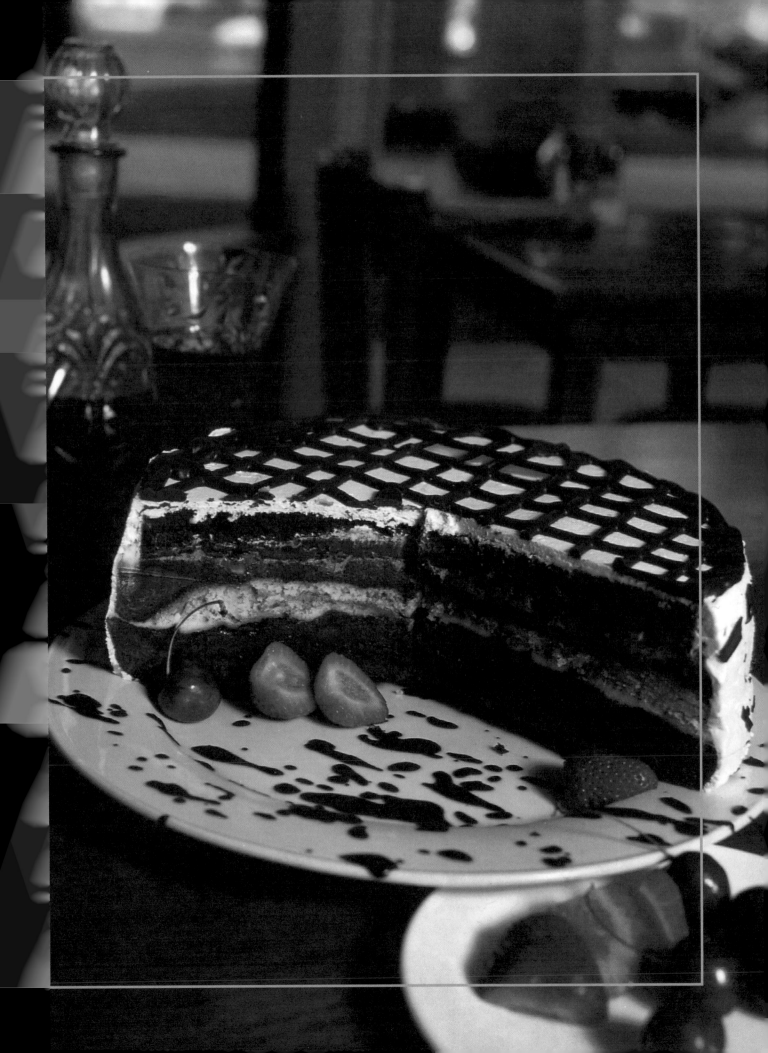

The first ring doughnut was introduced in Camden, Maine by apprentice baker Gregory Hanson, 15, a schoolboy who complained to his mother that her deep fried cakes were undercooked in the middle. He knocked the soggy center out.

Doughnuts were mentioned back in 1819. New York author Washington Irving, in his sketch book, contains the legend of Sleepy Hollow which describes "an enormous dish of balls of sweetened dough fried in hog's fat" and called doughnuts. Sweetened fried dough is as old as 5000 B.C. when the ancient Greeks fried the dough and sweetened with honey.

In 1912, a doughnut cutter was patented by inventor John Blondell of Thomason, Maine. This has a spring propeller rod to push out the dough of a center tube. The doughnut business boomed after 1920, when Russian baker Arthur Levitt, 45, began frying doughnuts in a New York bakery. Levitt and an engineer developed a machine that Levitt envisioned. After building 11 machines that did not work, finally one was made that worked. In 1921, Levitt placed the machine in the window of his Time Square bakery. The machine stopped traffic. Levitt's company leased a factory in Elliott City, MD to produce the first fully prepared doughnut mix in America, for the automatic machine. Levitt's success inspired competitors such as Dunkin' Donuts, Mr. Donut and Winchell's.

<div align="center">❧</div>

Loukoumades – *The Great Greek Doughnut*

1 oz. yeast
1 cup water

Mix to dissolve the yeast.

1-1/2 cups flour

Add in, mix with a wire whip. Until smooth. Cover with a towel, let it rise for about one hour.

1 tsp. salt
1 cup flour

Add in, mix well. Cover again and let it sit for about 1-1/2 hours.

Oil for frying

Heat to about 350°. With your left hand, take a fistful of dough (dough should be dense and not runny) and squeeze. With a soup spoon, scoop out the excess dough that comes out from your fist and drop it in the hot oil. Repeat to make little doughnuts balls. Wet the spoon with water so the dough does not stick.

Honey
Cinnamon

Mix together, drop loukoumades in it after you remove them from the oil.

Banana Doughnuts

5 cups flour
1 tsp. baking soda
4 tsp. baking powder
1 tsp. salt
1 tsp. nutmeg
 Sift together. Set aside.
1/4 cup margarine
1 cup sugar
 Beat until creamy.

3 eggs
 Add eggs, beat well.
3/4 cups bananas, mashed
1/2 cup buttermilk
1 tsp. vanilla extract

Add in, blend well. Add dry ingredients and mix until smooth using part of the dough. Turn it on a floured working surface and roll it to about 1/2" thickness. Cut with 2-1/2" doughnut cutter. Repeat to use the rest of the dough. Fry in 375° until golden brown, turning to brown on both sides. Sprinkle with sugar if desired.

I know that many of you love Lemon Meringue Pie. You have asked me to make it in the past for special occasions. Since I am too busy nowadays to make it for you, I thought I'd give you the recipe so you can make it at home.

Lemon Meringue Pie

12 oz. sweet pastry dough
 Roll out and line a 9" pie plate. Bake in a 425° oven for 25 minutes. To keep the dough down before baking cover it with a parchment paper and fill it with dry beans or lentils. Cool.
3 egg yolks
2 tsp. sugar
 Beat 2-3 minutes at medium speed.
3 tbs. cornstarch
 Add in, mix well. Pour milk into egg mixture, slowly beating constantly. Boil for one minute.
Juice of 3 lemons
1 tbs. lemon peel
 Add in, mix well. Let cool and pour in pie plate.

Meringue

3 egg whites
 Beat until stiff.
1 tbs. sugar
 Add in halfway thru the egg beating.
1/2 cup sugar
3 tbs. water
 Bring to a boil. Cook for 5 minutes, cool. Add to the egg white mixture. Beat on low speed for 5 minutes. Fold 1/3 of mixture over the pie. Place the rest in a pastry bag wth a star tip and squeeze it into little peaks to cover the top of the pie. Sprinkle with confectioners sugar and place under a broiler for 2 minutes or until golden brown.

The Senses and The Flesh

All beautiful memories are associated with the awakening of the senses,
With the weakness of the flesh,
The unmistakable scent of eucalyptus,
The amorous perfume of violets,
The seductive recollection of honey spiced with cinnamon,
The courtship with hot crusty bread and cheese,
The music of Vivaldi running through the veins like warm chocolate,
The flames from the fireplace caressing your flesh like sweet wine.

What pictures lay beyond our sight?
What senses we know but we do not speak about?
We resist the scents that try to find the pathway to the soul.
The awakening of the senses is an indication of good health.
I love to hear a story you had never told anyone before, one that you made up just for me.
I love to makeup a taste that you never experienced before, one that I made up just for you.

The following seven cakes have been created just for you, the reader of this book, hoping to open your senses and awaken your flesh.

Nine One One

CHOCOLATE CHESTNUT

1 lb. semisweet chocolate
1/4 lb. butter
> *Melt together.*

1/4 cup chestnut puree
1/8 cup sugar
4 eggs
> *Add in, mix well. Pour in a 10" buttered springform pan. Bake at 300° for one hour. Turn oven off, leave chocolate in for half hour longer. Refrigerate overnight.*

HAZELNUT CHOCOLATE

1/2 cup butter
1/2 cup sugar
> *Cream together.*

2 eggs
1 tsp. vanilla extract
> *Add in, mix well.*

8 oz. semisweet chocolate, melted
1/2 cup grated hazelnuts
> *Add in, mix well. Pour on top of chocolate chestnut. Refrigerate 2-3 hours.*

MOCHA CHOCOLATE

3 egg whites
1/4 cup sugar
> *Beat on high speed for 2-3 minutes.*

8 oz. semisweet chocolate, melted
> *Add in, mix well.*

3 egg yolks
> *Add, one at a time.*

1/8 cup strong coffee
1/8 cup cocoa
> *Add in, mix well. Pour on top of hazelnut chocolate. Refrigerate to set, 2-3 hours.*
Remove cake from pan.

ICING

1/2 lb. cream cheese
2 tbs. sugar
> *Cream together.*

4 eggs
1/2 cup whipping cream
> *Add in, blend well.*

1/4 cup sour cream
1 tsp. Kahlua
3/4 lb. white chocolate, melted
1/4 lb. dark chocolate, melted
> *Add in, mix well. Spread on the sides and top of cake and sprinkle with following:*

1/2 cup dark chocolate shavings, crumbled
1/2 cup hazelnuts, finely chopped
1/4 cup coffee vermicelli

Chocolate Attack

MERINGUE

4 egg whites
1/4 cup sugar
1 tsp. of cream of tartar
Mix on high speed for about 10 minutes, until eggs are stiff.
2 tsp. cocoa
Add in, mix gently. Spread in a 10" buttered springform pan. Bake at 175° for 2 to 2-1/2 hours. Remove, cool.

BERRY MOUSSE

4 egg whites
1/4 cup sugar
Beat well for 4-5 minutes.
3/4 lb. semisweet chocolate
Add in, mix well.
3 egg yolks
Add in, mix well.
1/2 cup boysenberries
Add in, mix well. Pour on top of meringue.

One chocolate cake
Cut in two slices, lengthwise, place one slice on top of mousse.

Vanilla Simple Syrup
Brush this on cake.

Chocolate Cream

1-1/2 cups of heavy cream
Beat with a wire whip until stiff.
8 oz. melted milk chocolate
Mix with the cream. Place on top of cake, cover with the second slice. Brush with syrup, let stand.

Icing

12 oz. milk chocolate, melted
1-2/3 cups whipping cream, heated
Mix well, cover cake.
1 cup white chocolate shavings
1 cup dark chocolate shavings
Crumble to small pieces, mix together. Arrange on top and sides of cake.

Passion Creamcake

CRUST
3/4 cups oats
1/3 cup sugar
1/2 cup graham cracker crumbs
1/2 cup melted butter
1/2 cup grated macadamia nuts
Mix well and place in the bottom only of a 10" buttered springform pan.

FRUIT FILLING
3 large mangos, peeled and cut into large pieces
2 papayas, peeled, seeded, cut into large pieces
2 kiwis, peeled, cut into large pieces
1 cup toasted coconut
2 tbs. rum
1/4 tsp. cinnamon
1/4 tsp. ground cloves
1/4 tsp. nutmeg
1-1/2 cups brown sugar
3/4 cup cornstarch
Mix well and place in the pan.

Cream Filling
1-1/2 lbs. cream cheese
1/2 cup sugar
Cream together.
3 eggs
1 cup sour cream
Juice of 1/2 lemon
1 tsp. vanilla extract
1/4 cup whipping cream
1/4 cup flour
2 tbs. cornstarch
Add in, mix well. Pour on top of filling. Bake for one hour at 350°. Turn oven off, leave cake in oven for 30 more minutes. Refrigerate overnight before removing cake.
Cinnamon
Sprinkle top of cake

Dream Lover

One 10" Sponge cake
Cut into three horizontal slices.
Strawberry Syrup
Brush one slice.
6 oz. milk chocolate, melted
3/4 cup whipping cream, heated
Mix and pour on top of cake. Cover with second cake slice.
Vanilla Syrup
Brush cake.

Chocolate Filling

2 cups heavy cream
1 tsp. vanilla
Beat on high speed until stiff.
2 oz. semisweet chocolate, melted
6 oz. white chocolate, melted
Add in, mix well. Spread on top of cake.
16 strawberries, cleaned

CHOCOLATE SAUCE

4 oz. milk chocolate
1/2 cup whipping cream
Heat together in double boiler until chocolate melts. Dip strawberries in, arrange strawberries on top of the chocolate filling, pushing them slightly to sink into the filling. Cover with the third slice. Save remaining sauce.

Champagne Syrup
Brush cake.
4 cups heavy cream
Beat until stiff.

ICING

1 cup sour cream
8 oz. white chocolate, melted
Mix with the stiff heavy cream, spread all but 1-1/2 cups on sides and top of cake.

DECORATION

1-1/2 cups remaining cream
Place in a pastry bag with a star tip and make rosettes around the edges of cake.

Topping

8 strawberries, cleaned, cut in half
3/4 cup strawberry jam
2 tbs. orange peel
Mix well and spread in the middle of the cake.
White chocolate shavings
Arrange around the sides of cake.
10-12 strawberries
Dip them in the remaining chocolate sauce and arrange them on top of cake, inside the rossettes in a circle.

Amaretto Moussecake

One sponge cake
> *Place in a 10" springform pan, uncut.*

Amaretto Syrup
> *Brush cake until completely soaked.*

12 ladyfingers
> *Soak in amaretto syrup and arrange on top of cake.*

Almond Mousse
4 egg whites
1/4 cup sugar
> *Mix well.*

12 oz. semisweet chocolate, melted
> *Add in, mix well.*

3 egg yolks
> *Add in, one at a time.*

1/4 cup grated almonds
1/2 tsp. almond extract
> *Add in, mix well. Spread on top of cake.*

Topping
3 cups of heavy cream
1 tsp. vanilla extract
> *Beat on high speed until stiff.*

8 oz. white chocolate, melted
1 cup sour cream
> *Add in, mix well.*

1 tbs. cocoa
> *Add in, mix well. Place topping in a pastry bag with a star tip. Save 1 cup of topping for icing. Make rosettes on top of cake to cover the surface of the cake. Spread the remaining 1 cup of topping around the cake.*

1 cup of toasted almonds
> *Sprinkle around the sides of the cake.*

**Cakes and pies to Nick,
they are like marble to Michalangelo;
just a starting point to White Passion Cake
souped up with kiwi and wild mango mousse.**

Java Magazine, Dec. 1997

Cloud Walker

Baked White Chocolate Cake
1 lb. white chocolate, melted
1 egg
1/4 lb. butter, melted
1/8 cup sugar
> *Mix well.*

1/2 cup sour cream
1 tsp. vanilla extract
1 tsp. flour
> *Add in, mix well.*

1/2 banana, mashed
> *Add in, mix well. Pour in a 10" buttered springform pan, bake at 350° for 1-1/2 hours. Refrigerate overnight to set. Remove from springform pan.*

One 10" white sponge cake
> *Sliced in three pieces horizontally.*

Rum Syrup
> *Brush the cake.*

6 oz. white chocolate, melted
2 cups sour cream
> *Mix well. Spread half of this mixture on top of cake. Place the baked white chocolate cake on top and spread it with the remaining mixture. Top it with the second cake slice and brush with rum syrup.*

Orange Hazelnut Filling
1/4 lb. butter
1/4 cup sugar
> *Cream together.*

3/4 cup whipping cream
> *Add in, mix well.*

1/4 cup grate hazelnuts
10 oz. melted white chocolate
> *Add in, mix well.*

Juice from 1/2 orange
> *Add in, mix well. Pour on top of cake. Cover with the third slice, brush with rum syrup.*

Icing
1/2 lb. white chocolate
1/4 lb. sour cream
> *Blend together, cover the entire cake.*

White chocolate shavings
> *Arrange around the sides and top of cake.*

281

Citrus Meringue Cake

Cocoa Meringue

8 egg whites
1/2 cup sugar
1 tsp. cream of tartar

Beat on high speed until eggs are stiff, about 8-10 minutes.

2 tbs. cocoa

Add in, mix well. Divide meringue into two parts and place each part into two 10" springform pans. Bake in 175° oven for 2 to 3 hours. Turn oven off and leave meringue in the oven for a few more hours.

Orange Espresso Filling

2 cups of heavy cream

Beat on high speed until stiff.

6 oz. white chocolate, melted

Add in, mix well.

1 cup sour cream
1 tbs. instant coffee
1 tsp. orange peel

Add in, mix well. Spread filling on top of meringue, cover with the second meringue.

4 oz. white chocolate, melted
1/4 cup sour cream

Mix well, spread on top of second meringue.

One sponge cake

Cut into two slices horizontally. Place one slice on top of meringues.

Orange Syrup

Brush cake.

Lemon Filling

1 cup milk
1 tsp. vanilla extract

Bring to boil, turn heat off.

3 egg yolks
2 tbs. sugar

Beat 2-3 minutes at medium speed.

3 tbs. cornstarch

Add in, mix well. Pour milk into the egg mixture slowly, beating constantly. Place mixture back on the heat, bring to boil beating constantly, boil for one minute.

Juice of 3 lemons
1 tbs. lemon peel

Add in, mix well. Let cool and pour on top of cake. Cover with the second slice.

Orange Syrup

Brush cake with syrup.
Refrigerate to set.

Icing

4 cups heavy cream

Beat on high speed until cream is stiff.

8 oz. white chocolate, melted
1 tsp. lemon peel
1/2 cup sour cream

Add in, mix well. Spread all but 1/2 cup of icing around and on top of cake. Place the 1/2 cup icing in a pastry bag with a small star tip and make small peaks on top of cake.

1/2 cup hazelnuts, chopped
1/2 cup of white chocolate shavings, crumbled

Mix together and sprinkle on sides and top of cake.

Nick Ligidakis *The Man Behind The Apron*

Or, more accurately, the great chef without the apron, or starchy, too-tall cap. In the five years I have known Nick, I have never seen him wear the traditional, pretentious dress of a master chef, although he truly is one of the finest cooks I've known in my years of restaurant reviewing and food writing.

Instead, Nick has always been – and always will be – as delightfully charming and comfortable as his cooking. Nick is the man you'll see behind the kitchen grill day and night, happily working on an amazing number of complicated dishes all at once.

He's the chef greeting you by name in his intimate dining room, his "uniform" jeans dusted with flour and smudged in a mosiac of today's ingredients. He's the restaurantuer who returns calls for recipe requests personally, and knows his customers well enough that he'll check on their welfare if he hasn't seen them in a while.

He's also the chef who spends thousand of hours and dollars every year for his annual Thanksgiving Feast, feeding 13,000 less-fortunate citizens in 1992 alone. Proceeds from this book are donated to the cause. And, I'm happy to say, that in 1993 Nick won a coveted J.C. Penney Golden Rule Award for his outstanding charitable contributions.

But there's more to Nick that perhaps even his loyal customers don't know. Most people understand his passion – they taste it in every bite of his cooking. But they may not realize how much passion affects his entire life, in his beliefs for human equality, peace, and the hope that someday this world will bring so much joy for everyone that drug and alcohol abuse will be non-existent.

Why is this important to this cookbook? Because beliefs like those have enabled Nick to conquer the personal and financial challenges he has faced over the years, and shaped his cooking philosophy. While is proud of his survival, he talks of his struggles not to gloat, but with the hope that others will be inspired to face challenges head on, and with clear minds.

"Many people say they are awe-struck or intimidated by the creativity of my cooking and recipes," he says. "But I think everyone can create wonderful things, if they concentrate on the good in life."

Customers read his huge menu, and smile at the sage quotes sprinkled liberally throughout – thoughts from Sophocles, Socrates, Plato, the Bible and more. Do these belong in a restaurant? Of course, because Nick so strongly believes in spiritual and emotional nourishment, as well as physical nourishment. If you dine in his restaurant, he says, you are choosing the best food available for your body. So he suggests some of the best nourishment he knows for your mind and soul.

Many people comment on the expansiveness of Nick's menu – more than 200 items, with 85 topping choices for pizza alone. And yes, he is always creating new recipes, without discarding past successes. Isn't enough, enough, they wonder? No, says Nick, because life is about growing and change, yet you never forget your beginnings. His menu is almost a growth chart, from his first recipe to his most recent creation.

"As long as I can still ensure all ingredients are the freshest and best possible," he says, "and can offer personal attention and superior service, I will continue to grow."

As you read this cookbook, you may find yourself puzzling over the complexity of many of the desserts. What a dizzying array of ingredients, you may think. One cake alone can be a blending of several different cakes, mousses, exotic syrups and chocolates. Many take quite a dedication of time to create.

But the best never comes easy, says Nick. Deep thought and love of flavors created

the recipes, and such concentration is required by the chef who brings each dessert to life. After making just one recipe, he guarantees, and taking your first bite, you will understand how wonderful the creative effort is. These recipes may be difficult, but none of them are "work".

Pretty deep matter for a cookbook, yes? But understanding the man behind the "apron" will help you understand the book, and make sure you're never intimidated. Start with a simple apricot bar or peanut butter cookie, then challenge yourself to a brownie or cheesecake. Soon, you'll be ready to tackle the impressive Sinful Act Cake or After Death Cake. Maybe you'll be inspired to create your own recipes, in a way you might not have thought possible.

And if you think the way Nick does, you'll be able to apply your positive thinking to every area of your life. Start with one simple goal, and before you know it, you'll be able to accomplish your greatest dreams.

And what better way to grow than with a cookbook as your primer? It's one of the only times in life you'll get to eat your mistakes, and love it!

Carry Sweet, editor of "My Golden Collection"
Nick's first dessert book

Sweet Union

What is the most unusual event you witnessed while dining in a restaurant? What about a wedding ceremony!

It was Friday, Dec. 10th, about eight o'clock when Michael and Tracy stood in front of my dessert cases and in the presence of judge Ivy Kushner bonded their lives. My dining guests interrupted their dinner to watch, some with surprise, others with joy. The two young people, with eyes sparkling with love and happiness, united themselves while surrounded by chocolate, honey and sugar.

The ceremony was short and simple. For me was a meaningful act because of the reason - my restaurant had a special meaning to these young newlyweds and their families. Afterwards, their guests squeezed in to the small dining room. They enjoyed the champagne, they ate and ate the food, they drank the wine and hungrily ate the wedding cake.

Stewart and Sandi, Michael's parents, could not have been happier. The guests admitted that this was the best time that they had for in a long while. Midnight came and it was time to move on, to the next day, in to a new life. Before leaving, Michael and Tracy, made me promise that I would be the Godfather for their first child. After I promised them that I would, I began to worry: when the time comes, are they going to ask me to baptize the child in chocolate?

My biggest dilemma will be which kind: dark or white?

EPILOGUE:

*I started authoring my first dessert book, **Golden Collection**, in the summer of 1990, on the Greek Islands of Milos where I visited with my sister, Sophia, and her husband, Stavros. The little family retreat in the village of Kilma is arguably the most charming place I ever have been for summer holidays.*

There is a cluster of about 70 waterfront homes, once fitted with cozy ports for overnight fishermen. Today, they have been converted into summer homes treasured by families.

Here, I find a combination of old and young generations, and a delicious blend of stories and traditions. This village is one of the world's rare, relaxing places occupied by truly nice people.

To me, Klima makes tangible the pleasure I hope my new dessert book brings. Nestled along the side of the horseshoe-like port of Milos, Klima offers a beach pure of autos, stores or human intrusion. It is a primitive village, its people vitalized by fresh fish captured daily out of the beautiful blue waters of the Aegean Sea.

Klima is a village which, when the sun sets, rivals nature's finest colors and beauty, and inspires the passion so many others feel for a ten million dollar check. For myself, material wealth pales by comparison when I am in this precious village. Thank you Stavros and Sophia, for sharing that unforgettable summer with me.

"What is a dessert? To many, it is a daily luxury celebrating some of nature's finest culinary gifts. To unfortunate others, it is a sinful act of indulgence, guilty calories and sadly un-treasured pleasure. To me, dessert is a great challenge, with success measured only by a plate scraped clean. To combine flavors that create a smooth, pleasant taste finale to a perfect meal is a great art."

BACKGROUND ON CHEF NICK LIGIDAKIS, A Success Story

Nationally recognized chef Nick Ligidakis, 54, chef/owner of Café Nikos, is a native of Greece, who has gained national acclaim for combining the full, tantalizing flavor of the Mediterranean region with imaginative American style presentation. The result: a cuisine that is at once both exotic and familiar.

With a menu of more than 200 items, Nick draws primarily from inspiration to create his dishes. Many of his recipes are original, and even traditional favorites like pizza are enhanced with his signature ingredients and flair. Some of his favorite recipes have come to him in his dreams, and like any great artist, he has sacrificed many a night's sleep in pursuit of the perfect creation.

Diners of all ages and backgrounds have come to love Nick's cooking. Served in a comfortable café setting, menu choices range from a tantalizing Feta Gyros Pita with grilled lamb and beef, artichoke hearts, feta cheese and feta sauce; to a sumptuous Goat Shrimp, jumbo shrimp stuffed with feta cheese and sun-dried tomatoes, wrapped in bacon and sautéed in olive oil, garlic, lemon and herbs.

Nick's love affair with cooking began at an early age. His mother and father owned a taverna in his hometown of Kiaton, Greece, and he spent much of his childhood studying the kitchen, watching his parents and cultivating his imagination for cooking and fanciful use of ingredients.

Nick is truly a success story. Although he has no formal restaurant training, he has blended his own gift for cooking with a perseverance that enables him to overcome numerous challenges in his life. Indeed, when he first arrived in America in 1969, his goal was to stay and play professional soccer. His plans fell apart and he was stranded in Chicago with no money. Instead of wiring home for a return plane ticket, Nick decided to realize his dreams in America, teach himself English and get a job. He spent nine years in Chicago and five years in California, building his career in the restaurant business.

In 1984, Nick arrived in Arizona to be with his children. A small restaurant on East McDowell Road caught his eye, and armed with only $52.50 and a great sincerity, he convinced its owners to let him work towards the purchase of "Golden Pizzeria". Penniless but inspired Nick worked from 8 a.m. to 2 a.m. seven days a week for 18 months, sleeping on an air mattress in the back of the trailer-sized eatery. As word of mouth spread about Nick's exciting cooking, Golden Pizzeria thrived, and in 1989, Nick opened Nick Ligidakis' Golden Cuisine of Southern Europe in a new, much larger location on East Thomas Road.

This location and its expansive kitchen allowed Nick to experiment more with his cuisine, and his enormous menu took shape. His creativity took wing, and he hosted evening dinner theater performances by local actors in a banquet area, offered cooking classes, developed an extensive grocery with exotic ingredients and his own private label foods, and started supplying other restaurants and grocery stores with bakery items. He was approached with lucrative offers for mass marketing his products, but turned them down because it would be necessary to add preservatives to his made-from-scratch foods.

During this time Nick opened a small restaurant in Mesa called the Pita Shop, which served his much-adored gyros and original Pita creations, appetizers and desserts. He also became a local celebrity of sorts, appearng on numerous cooking shows with Rita Davenport, host of "Cooking with Rita".

In 1987, Nick produced his first cookbook, "Nick's Creative Cooking Made Easy", featuring more than 160 original recipes. It is now in its fourth printing and has sold over 20,000 copies. It is partnered with his exciting original recipe dessert cookbook, "My Golden Collection", and his new story cookbook, "5024 E. McDowell".

In 1991, Nick found Golden Cuisine's location was too large and its facilities too old for his needs and he closed his Tower Plaza eatery. Six months later he opened Nick's Cuisine of Southern Europe on East Indian School Road. After three years there, Nick moved his restaurant to downtown Phoenix. He was forced to close Nick's On Central after a difference of beliefs with the new owners of the San Carlos Hotel. Now, a year later, Nick has opened his sixth new restaurant, Café Nikos, in Scottsdale. In that year away from the restaurants, Nick wrote and published two books, *"5024 E. McDowell, A Man's Journey"* and his extraordinary book about his parents, *"The Heroes of My Thoughts."*

Through Nick's increasing successes, he has never gotten rich. Because as his success increases, so does his generosity. A one-time charity feast that fed 250 homeless in 1985 has turned into an obsession to help others. Now in its fifteenth year, the project is funded by donations, proceeds from Nick's cookbooks and his own money. In 1993, on the tail of an economic depression and with numerous financial challenges facing the restaurant, Nick preserved and fed 15,000 homeless. He then fed 22,000 in 1994 and 32,000 in 1995.

Nick's is a tortuous schedule, fueled by a love for things more spiritual than material. The Arizona Republic said it best, perhaps, in a June 27, 1993 editorial: "The restaurant is here because Nick wants it to be. His restaurant is his mission ... it would never work as franchises ... How do you franchise someone's feelings? Someone's character?"

A LIFETIME OF GIVING

Nick Ligidakis never planned his Thanksgiving Project to turn out the way it has. A one-time whim to contribute to the Valley's less fortunate turned into an obsession, now in it's 15th year.

In 1985, Nick decided to share some of his success with less fortunate. The first result was a Thanksgiving Feast for 250 of America's homeless. By 1993 that number swelled to 15,000 homeless, elderly, battered women, abused children, AIDS patients and homebound citizens who enjoyed a Thanksgiving meal cooked and prepared in Nick's restaurant and delivered to shelters and private homes all across the Valley. By 1995, the project grew to enormous proportions – 32,000 of the Valley's less fortunate received a meal from Nick's kitchen.

Although Nick has never been homeless or hungry, he has faced many challenges, especially with his business in the past few years. But he never gave up. With the help and confidence of others that believed in his dream, the Thanksgiving Project grew larger every year. Nick's on-going Thanksgiving Project has been profiled numerous times on all the Valley's television stations (Ch. 3, 5, 10, 12, 15, 33), lauded in virtually every print publication in the greater Phoenix area and received awards for his charity work including the 1990 Golden Rule Award, a national event sponsored by J.C. Penney, and the 1995 Humanitarian Award by the City of Phoenix.

Instead of turning that fame into a personal moneymaking vehicle, Nick uses the exposure to generate more donations, more volunteers and greater support for his annual cause. Each year Thanksgiving seems to come earlier and earlier for Nick. His staff begins their annual Thanksgiving preparations in August, manning the phones to round up volunteers and donations, and coordinating with more than 300 charity organizations and individuals.

In an effort to raise funds early, Nick schedules cooking classes, fundraising dinners and other events. Since 1987 when he wrote his first book and today on his fourth book, *"The Heroes of My Thoughts"*, Nick has been donating the proceeds to his Thanksgiving Project.

After 16 years and five popular restaurants, Nick was forced to close "Nick's On Central" which almost put an end to his tradition of feeding thousands of unfortunate citizens. Instead of giving up, Nick worked day and night to create *"5024 E. McDowell"* a book chronicling the dishes that made his restaurant so popular. This same book traces his professional experience, the success and the mistakes. "This book is an inspiration to the ones who have nearly given up after failing once or twice in life," says Nick.

At the same time Nick wrote and published *"The Heroes Of My Thoughts"*, a beautiful hardcover book which is a tribute to his parents. "True heroes will make you believe in yourself," says Nick. Proceeds from his latest book will help poor and abused children through his new organization "Authors for Social Responsibility". The organization is made up of a group of writers who want to make a difference through their word and work. Part of the proceeds of the authors group are donated to Nick's children's foundation, "A Child's Hero". The foundation helps children and their families out of despair and on to hope and victory.

CHARITY HONORS: Appreciation awards from Taste of Chocolate Fundraising, 1990 Golden Rule Award, a national event sponsored by J.C. Penney, Community Treasure Award, a national event sponsored by Jack in the Box, Community Service Award by Roosevelt School District, 1995 Humanitarian Award by the City of Phoenix.

Foolishness

The exact day, I don't remember
Only faintly, I remember faces of teenaged boys and girls,
I have met hundreds of them,
I have seen thousands more,
From Europe and from Africa,
From Latin America and from Asia.

They are young people who abandoned their country, their family, and have taken a trip over the borders of another land, one that is blessed with richness and prosperity,
They came to this land with the sole purpose to help their loved ones,
So they can have a plate of food,
So they can survive life,
Young people, eager to work, thirsty to learn.
Most of them got lost in this social structure we call justice,
In the four decades I have been in the restaurant trade, I have seen thousands of foreigners,
I remember their hands tirelessly washing the dishes,
I've seen them moping floors and busing tables
Few of them are still with me today, one of them, has been working with me for 15 years.
The exact day I hire these people I don't remember
I can only remember faces, begging for work, for a change.
You see I was lost in the task of surviving myself, in the process of learning another culture,
I was fighting social battles of my own I did not have the time to look beyond my own selfishness.
I never saw the pain in their faces, those who had abandoned their land, who were forced to work for survival.
I was in that position once.
I was looked upon as a dumb foreigner, one who could not speak the language, who did not know the way of life of another culture.
All around me there were arrogant people, arrogant and strange,
They spoke another language,
They had different holidays,
They believed in a different god,
They saluted a different flag,
They looked at me with contempt as if they were veritable saints, and lofty intellects, and fonts of wisdom.
Very few took the time to understand that they were shutting down someone's humanity and intellect.
No one realized that I was a lover of culture,
That I listened to Vivaldi and Tchaikovsky,
That I read Plato, Kant, Tolstoy
That I admired Kennedy, King, Gandhi, and Mandela,
That I too laughed at the comedy and cried at the tragedy,
That I tried to understand, despite their treachery and foolishness,
And I, who refuse to reveal myself to strangers, kept to myself the silent waves of pain that roared inside of me, determined to overcome the difficulties, to overpass the egotistical attitude that separated men.
I refused to recount images that others had created,
I could only be bonded with the reflection of my own imagination,

Those that I can see,
Those that I can feel.

Soon I began to find my way to escape from exile, to steal from reality, to mold, to correct, to re-create, to see the characters that life had created,

I wanted to find someone, to talk to, to debate, but it was impossible to slow down the people who were rushing to the streets of life, as if a human being was not important enough to take time and listen, to understand someone's feelings.

People passed by like herds, they just nodded their heads and pretended to understand everything.

I always thought that those who pretend to understand everything and everyone are cynics,

Because those who believe in everything and everyone believe in nothing,

To my way of thinking, rationality is the only way to distance us from cynicism,

Rationality kept me believing in man, it is the structures, the systems, the powerful, the hungry vultures, those who turn man against man.

But what's the use?

The story will remain unchanged and unchangeable, yesterday, today, tomorrow. It will always be the same, the story about man's mind, saying one thing and doing another.

I replied that no, I was not like the others, that I was not about to treat people like the others, even though they spoke another language, celebrated different holidays, believed in a different god.

I promised to myself, to remember that, whether we are made of words and paper, whether we are made of flesh, life lasts no longer than a desert flower.

One that blossoms at day break and withers at sunset.

See how life is,

Too, too short to waste it,

Too, too short to be made of words and paper and not of flesh and feelings.

Now, years later, I look at those teenaged boys who have grown to men, they have become chefs and restaurant owners, and I feel good about myself, because I have learned not to shut down someone's humanity, someone's intellect, I can only be thankful to them, especially to the ones who are still with me after all these years, those who have tolerated my own treachery and foolishness.

Recipe Index

Photo Index

Section One, Pages 33 to 48

Photo Index

Section Two, Pages 145 to 160

Photo Index

Section Three, Pages 259 to 274

What the critics have said about Nick's cooking:

Purists rave about Nick Ligidakis' Golden Cuisine in Phoenix ... a magical blend of Italian and Greek dishes served in healthy portions.
Wine Country International, 1990

This culinary haven is a tribute to the chef / owner's skills, innovative spirit and dedicaton to freshness with the use of quality ingredients.
Destinations of the Southwest, 1988

Nick's is, out of the hundreds of eating houses I have written about, the single restaurant about which I have received the most "thank you" notes for sharing with my readers.
Shop Talk, 1988

Nick Ligidakis' Golden Cuisine of Southern Europe offers a magnificent selection of delicacies for an unbelievable experience.
New Times, 1989

Ligidakis talkes about cooking like some men talk about courting a beautiful woman ... as if each dish were a beloved child.
Echo Magazine, 1992

Nick is a man who marches to his own culinary drummer. According to him, there are three ways to prepare a dish: the right way, the wrong way, and his way.
Best of Phoenix Restaurant Guide, 1993-94

Fans rejoiced when Nick's relocated to a brighter spot ... for the best of Southern Europe is a la Nick Ligidakis.
Travel & Leisure, 1992

Nick's restaurant has a following so loyal it could be called a cult.
Phoenix Gazette, 1990

The restaurant is here because Nick Ligidakis wants it to be. His restaurant is his mission and it's not for the faint-hearted.
Arizona Republic, 1993

Ligidakis is a legend locally, both for his selfless charitable involvement and his very idiosyncratic restaurant.
Tribune Newspaper, 1995

Nick's cuisine and philosophy are both a delight.
Scottsdale Progress, 1993

Chef Nick Ligidakis' creations are out of this world ... sumptuous and big enough to feed a hungry army.
Tempe Tribune, 1990

Seems only newcomers and visitors to the Valley are unfamiliar, and then only briefly, with the food of Nick Ligidakis. Dazzling Phoenix dinners since the mid-80's at various Valley locales. 'Standing room only' best describes the scene for Nick's Cuisine.
Phoenix Downtown, 1995

Nick creates dishes the way Mozart made music, all in his head, able to picture the final result witbout writing it down or testing it first.
Arizona Republic, 1993

His fans speak of Nick Ligidakis with a reverence customarily reserved for Michelangelo's statute of David.
Phoenix Gazette, 1987

I looked around at Nick's beautiful new eatery and realized that he is a true champion, one that they're never going to be able to keep down. He's going to hang in there until he wins the fight.
Java Magazine, 1998

Like saguaros, Camelback mountain and red-tile roofs, Nick Ligidakis seems to be a permanent part of our desert landscape.
New Times, 1999

Nick's restaurant has won eight Best of Phoenix awards throughout the years.

"5024 E. McDowell" is Nick's newest story cookbook which contains about 600 original recipes and a heart warming story of a man that never gives up. To order call, (480) 315-9636 or write to: 3370 N. Hayden Rd., #123-276, Scottsdale, Arizona 85251.
E-Mail: specialty@home.com
Websites: www.selfplublishers.com
www.cafenikos.com

Notes

Notes

Notes

Notes